GET REAL
REAL TIME + ART + THEORY
+ PRACTICE
+ HISTORY

GENERAL EDITOR
MORTEN SØNDERGAARD

EDITORS
PERTTU RASTAS
BJÖRN NORBERG

GEORGE BRAZILLER, INC.
NEW YORK, NEW YORK

Originally published in Denmark in 2005 by Informations Forlag, in association with The Museum of Contemporary Art, Staendertorvet 3D, DK-4000 Roskilde.
First published in the United States of America by George Braziller, Inc., in 2005.

TEXTS © 2005	the authors and The Museum of Contemporary Art in Roskilde
IMAGES © 2005	the artists, photographers and The Museum of Contemporary Art in Roskilde
FILM/DVD © 2005	the artists, Splintermind and The Museum of Contemporary Art in Roskilde
GET REAL PROJECT © 2005	KIASMA. Museum of Contemporary Art in Helsinki, Finland. www.kiasma.fi Splintermind/nonTVTVstation in Stockholm, Sweden. www.splintermind.com The Museum of Contemporary Art in Roskilde, Denmark. www.mfsk.dk
GET REAL EXHIBITION	Curated by Björn Norberg and Morten Søndergaard Assistant Curator in Denmark: Tanya Lindkvist

All rights reserved

No part of this publication may be reproduced in any form or by any means without prior permission from the publisher.

For information, please address the publisher:

George Braziller, Inc.
171 Madison Avenue
New York, NY 10016
www.georgebraziller.com

Library of Congress Cataloging-in-Publication Data

Get real: Real Time + Art + Theory + Practice + History / general editor, Morten Sondergaard ; editors, Perttu Rastas, Bjorn Norberg.— 1st American paperback ed.
p. cm.
ISBN 0-8076-1564-1 (pbk.)
1. Multimedia (Art) 2. Real-time data processing. 3. Time in art. 4. Interactive art. I. Søndergaard, Morten, 1964- II. Rastas, Perttu, 1952- III. Norberg, Bjorn. IV. Title.

N6494.M78G47 2005
700'.1—dc22 2005008073

USA: ISBN 8076-1564-1
DK: ISBN 87-7514-110-8

PUBLISHED IN USA BY	GEORGE BRAZILLER, INC.
PUBLISHED IN DK BY	INFORMATIONS FORLAG THE MUSEUM OF CONTEMPORARY ART IN ROSKILDE
DESIGN	SIGRID GRY LAURSEN / MEDIEFABRIKKEN
PRINT	CLEMENSTRYKKERIET A/S
SUPPORTED BY	THE NORDIC CULTURAL FUND IASPIS (INTERNATIONAL ARTISTS STUDIO PROGRAM IN SWEDEN) THE DANISH ARTS AGENCY / THE VISUAL ARTS CENTRE / THE DANISH ARTS FOUNDATION

PRINTED IN DENMARK 2005

GET	REAL	TIME	REAL	ART
GET	REAL	TIME	REAL	ART
GET	REAL	TIME	REAL	ART
GET	REAL	TIME		ART
GET	REAL	TIME	REAL	ART
GET	REAL	TIME		ART
GET	REAL	TIME	REAL	ART
GET	REAL	TIME		ART
GETGETGET	REAL	TIME	REAL	ART
GET	REAL	TIME	REAL	ART
GET	REAL	TIME		ART
	REAL	TIME		ART
GET	REAL	TIME	REAL	ART
GET	REAL	TIME		ART
GET	REAL	TIME	REAL	ART
GET	REAL	TIME		ART
GET	REAL	TIME	REAL	ART
GET	REAL	TIME		
GET	REAL	TIME	REAL	
GET	REAL	TIME		ART
GET	REAL	TIME	REAL	ART
GET	REAL	TIME		ART
	REAL	TIME	REAL	ART
	REAL	TIME		ART
GET	REAL	TIME	REAL	ART
GET	REAL	TIME		ART
GET	REAL	TIME	REAL	ART
GET	REAL	TIME		ART
GET	REAL	TIME	REAL	ART

GET	REAL	TIME	REAL	ART
GET	REAL	TIME	REAL	ART
GET	REAL	TIME		ART
GET	REAL	TIME	REAL	ART
GET	REAL	TIME		ART
GET	REAL	TIME	REAL	ART
GET	REAL	TIME		ART
GETGETGET	REAL	TIME	REAL	ART
GET	REAL	TIME	REAL	ART
GET	REAL	TIME		ART
	REAL	TIME		ART
GET	REAL	TIME	REAL	ART
GET	REAL	TIME		ART
GET	REAL	TIME	REAL	ART
GET	REAL	TIME		ART
GET	REAL	TIME	REAL	ART
GET	REAL	TIME		
GET	REAL	TIME	REAL	
GET	REAL	TIME		ART
GET	REAL	TIME	REAL	ART
GET	REAL	TIME		ART
	REAL	TIME	REAL	ART
	REAL	TIME		ART
GET	REAL	TIME	REAL	ART

GET REAL REAL TIME + ART

GET	REAL	TIME	REAL	ART
			REAL	
GET	REAL	TIME		ART
GET	REAL	TIME	REAL	ART

CONTENTS

MORTEN SØNDERGAARD

GENERAL EDITOR'S PREFACE

This anthology has been written and edited in English — only one text was translated (by Perttu Rastas) — and since the primary language of most of the authors is not English, I have given the matter of language serious consideration. Take the term "real time": what is the appropriate form: Realtime, real-time, real time? The variations show that the term does not, indeed, label a defined field of research. This could be a nightmare for an editor. British English tended towards the form "real-time," whereas American English tended towards "realtime." However, Jack Burnham, writing in 1968, used a third form, "real time": a conceptual constellation that reflects, I assume, Burnham's analysis of the systemic and social impact of life on art. The differences in conceptualizing real time do not, then, merely reflect the English "tribe" to which you belong. So I had to choose. Jack Burnham's version "won," simply because his are some of the earliest thoughts on real time presented in this anthology, and because the use of the two terms real and time, separately and together, feels right. The choice of the open compound "real time" does not negate the use of other versions, of course. But, hopefully, my explanation of the choice of "real time" will bring about an awareness and discussion, not only of the term itself, but of many of the other key concepts in this book of uncertain linguistic definition. This is something which most certainly will be reflected in the discussion of the transdisciplinary nature of contemporary art.

GET	REAL TIME	REAL	ART
GET	REAL TIME	REAL	ART
GET	REAL TIME		ART
GET	REAL TIME	REAL	ART
GET	REAL TIME		ART
GET	REAL TIME	REAL	ART
GET	REAL TIME		ART
GETGETGET	REAL TIME	REAL	ART
GET	REAL TIME	REAL	ART
GET	REAL TIME		ART
	REAL TIME		ART
	REAL TIME	REAL	ART
008	REAL TIME		ART
GET	REAL TIME	REAL	ART
GET	REAL TIME		ART
GET	REAL TIME	REAL	ART
GET	REAL TIME		
GET	REAL TIME	REAL	
GET	REAL TIME		ART
GET	REAL TIME	REAL	ART
GET	REAL TIME		ART
GET	REAL TIME	REAL	ART
GET	REAL TIME		ART
	REAL TIME	REAL	ART
GET	REAL TIME		ART
		REAL	
GET	REAL TIME		ART
GET	REAL TIME	REAL	ART

MARIANNE BECH + PERTTU RASTAS + BJÖRN NORBERG + MORTEN SØNDERGAARD

PREFACE

The issue of real time and art is multifaceted and complex. It is not just another case of a new medium entering art, but just as importantly, is a reiteration of the oldest aesthetic questions: What is the relation between art and reality? How does art reflect, as it were, the norms of this relation?

Nevertheless, real time is also a media art issue. As it is often the case with media art, "old" issues of aesthetics and art are amplified and reinvestigated. Perhaps some would call this process a deconstruction of "outdated" art forms and (yet another) death of the avant-garde. But we would not jump to that conclusion.

In fact, this anthology does not jump to any conclusion. It is based on a vast array of questions and discourses that we find important. It is rooted in a deep heuristic curiosity about what may appear if we asked some of the (in our opinion) most influential theorists, historians and artists that work within this field, to describe and perhaps even define real time+art! The result is a kaleidoscopic play of ideas and possible art forms that define a wide range of issues in art.

The aim of this anthology is to present real time as a transdisciplinary art form, which is still in, sometimes close, contact with traditional art forms and genres. They, in turn, are amplified and placed into contrast with each other by the media-practice and media-consciousness of artists.

We want to reflect this accretive and all-inclusive character of a vastly expanding field by organizing the material in the anthology so that the transdisciplinary meeting of

media and art is considered. The anthology is testing the media + art relation by adding theory, practice and history — showing the relational, cognitive and deeply philosophical character of the transdisciplinary field of real time art. Also, the anthology attempts to highlight the important artistic works in real time by documenting them on the enclosed DVD. Finally, this anthology is part of a real time platform that includes an exhibition, an international seminar, performances and events. This anthology will still be "on-line" in the good old analog sense (you may actually read it again) after most of the more fugitive parts of the platform are gone. Thus, hopefully, this anthology will create subsequent discussions about the status of the real time culture and society that we inhabit.

In its totality, *Get Real* is a platform that has been made possible by the succesful cooperation among artists, critics, curators and institutions. To begin with the latter, *Get Real* is the result of a collaboration among three institutions: Splintermind in Stockholm (which took the initiative), KIASMA in Helsinki, and The Museum of Contemporary Art in Roskilde. We cannot thank enough the artists and critics who have contributed to the making of *Get Real*

Finally, the process involved a lively dialog across varied disciplines and fields, and not least between Björn Norberg and Morten Søndergaard as the curators of the *Get Real* exhibition. Much of this dialog took place on-line via e-mails between Stockholm and Copenhagen. Therefore, it is appropriate to let the discussion between Norberg and Søndergaard introduce this anthology and open a debate about real time and art.

BJÖRN NORBERG + MORTEN SØNDERGAARD

INTRODUCING GET REAL
A PLATFORM FOR REAL TIME ART

Björn Norberg (BN): Before we go any further I think you'll agree that we have to settle on what real time art can be. This is the tricky part and will decide the form of the exhibition as well as the anthology. We have to find a definition that is not too broad. I want everyone who leaves the exhibition to feel in their stomachs what we mean by real time art. At the same time, it is important not to be too narrow. If we do that, there will be no interesting and challenging works. We're walking a thin line.

Morten Søndergaard (MS): I agree! Let's walk a thin line!

BN: My idea about real time art is art created and distributed live, in real time. It is also art that includes a process that changes over time. I have been very much occupied with subatomic physics for the last few years — actually I am in a project with a couple of professors, particle physicists, that is funded by the Swedish research council — and it contributes to my view on art at the moment.

When, as a physicist, you want to observe subatomic particles, you have some difficulties. You can't pinpoint an exact position for a small particle. It seems to be at a certain place at certain times. To observe particles, you have to isolate them using an accelerator. Doing that, you affect the particle since everything in the universe, even the smallest particle, woven together dynamically and is always in transformation. In this context, everything affects everything else. This means that you cannot ever study particles like objects, and as a scientist you have to live

with that. The actual situation in a particle experiment means that you lift the particle from one context into another; then the interpretation of the particle is affected. In my opinion this is very similar to contemporary art theory and culture theory. And it also has a lot to do with my idea of real time art.

Here is my definition: Real time art is art that is dynamic in itself. It has built-in transformative properties. It's created in real time and consumed by the spectator in real time. Real time is crucial for the work of art. Without it, a work of art cannot function.

Some of the examples that you have suggested are programmed works of art that need the spectator's interaction. Will these works automatically be regarded as real time art according to my definition? Not necessarily. One problem is that the relation between art and the object always includes a certain amount of interaction. In my opinion, there is no fixed interpretation of a piece of art. Every interpretation is caused by the circumstances, the context. A running digital program can be mechanical; it will follow the same routines when the spectator makes certain moves. To me it is the same as when you look at a minimalist sculpture, for example. Real time should be something different. It is a process. When you look at the work a second time it will be changed and transformed because of dynamic parameters, the effect of the environment or distant influences. An interactive work of art, even on the Internet, can be very static.

MS: If I understand you correctly, you use a metaphor from microphysics, or from its methods, or from the methodical discussions of microphysics, to describe the problems of describing a work of art outside real time? If so, I totally agree. I am convinced that the category "works of art" is dissolving. A new practice is evolving. (In fact this was what the exhibition "Under Cover — Sound/Art in Social Spaces" was about; see www.samtidskunst.dk/undercover/). Here, I argue that art is using everyday spaces (and experiences) as "canvases" (to paraphrase Marcel Duchamp) or screens and that the work receives its content in real time dialog with its spectator. Maybe that is why there are so many interactive works among my proposals... !

BUT, I also think that the issue of real time art points towards an art that uses the spaces of live(d) experienced time. The crucial thing about the art we are discussing is this connection to time as it is experienced. The question is, what does real time mean? Philosophically, Kant, Bergson, Einstein and Deleuze deliver very different versions — and if we build upon the metaphors from microphysics (where Einstein seldom positioned himself), then a fifth definition will occur. Here, real time is a question of probability. Hence, it is not a question of perceiving time in a phenomenological sense at all. One could operate with an objective time and a subjective (mental) time. But read Bergson or Deleuze and you will see how complex it is to differentiate, let alone explain, what

"objective" and "subjective" mean in this case.

Maybe this is going too far, but it seems to me that a basic philosophical/ conceptual discussion of real time is needed.

You write: "Real time art should be something different. It is a process that changes over time. When you look at the work a second time, it will be changed and transformed because of dynamic parameters, the effect of the environment or distant influences. An interactive work of art, even on the Internet, can be very static."

First of all, I agree that real time art should be (or is) different from minimalist sculpture.

But you operate with a distinction between art and object that I do not fully understand. Also, your idea that something is changing while you are looking at it suggests an on-line tableau of some kind, that transforms according to parameters given by the environment. You have to explain this to me in greater detail.

I suppose that real time art is something that already exists (not something we have invented). We have projects that meet our definition. Artists such as Joseph Beuys, Nam June Paik and the Fluxus movement make real time art. Here, we are talking about a happening, or performance art, right? Sometimes it is transmitted, live, via satellite. But what is transmitted exists in the moment, and afterwards can be experienced only from documentation or relics.

This kind of real time art is fugitive, and it could be said that the history behind real time art starts here, and eventually becomes part of the new media circuit.

Therefore, I think we are talking about not only real time reception (i.e., real time consumption), but also real time production. Real time is about artistic practice.

This is crucial. Because the new media are creating hybrid forms of production, where a network of experienced relations are replacing the autonomous unity of the "work of art."

So, I would suggest that we, in our conceptual framework of the exhibition, should take into consideration 1) the theory of real time in and of media art; 2) real time in media art practice; and 3) the history of real time in media art.

But I also think that our discussion should focus on what artists we want to show at the exhibit — and whether they should produce something entirely new for the exhibition? Should their form of practice and modes of production be a part of the exhibition?

A production platform would make it possible to have art that is taking place outside the museum (i.e., in real life — on the street, in a shop), but being transmitted live into the museum.

The museum becomes an index of art production, rather than a place where art is presented in a non-variable form.

BN: I bring in physics to get another view of the topic. I also think you can use the

microphysics as a model when discussing art theory, any kind of art, and especially when discussing real time art.

Science and art have a lot in common, and I think contemporary theories of art have their origin in the physics research done in the early 20th century. In "A real time consideration," an essay that I wrote two years ago, I develop this idea further.

The *Under Cover* project interests me and I agree that works of art, as a category, are dissolving and that a work receives its content in real time through a dialog with its spectator. Contemporary art strives to move against the object and show a process instead. This can be frustrating for the spectator since he or she sees only parts of the process. Here the reference to the physicist can be used again: physics research has formed and will continue to form our view of the world. I also think it's possible to apply this metaphor to all art, even painting. Every meeting with a piece of art creates a new content. A picture from the 16th century gets a new interpretation, as valid as any, in meeting with a 21st-century spectator.

I strive to not divide subject from object. The object becomes the subject. That becomes problematic in the dynamic among spectator/object/art.

Another problem: several different art media involve time — film, for example. Can a film made without any cuts be regarded as a real time work? Time is certainly experienced. In my opinion, this is more a documentation of time than a real time piece.

For me, real time art definitively works on-line. It evolves as it is affected by the environment. This could happen in several ways, but always includes the element of chance. A good interactive example is the one that the Mexican-Canadian artist Lozano-Hemmer created in Rotterdam, where a large lamp invited passers-by to create shadow figures. (As you see we are constantly dealing with the question of copy vs. original and this work illustrates it perfectly — it could be central). Other artists have chosen to build sculptures or installations, such as Nam June Paik's video sculpture, which includes video feedbacks. Artists can use nature or the Internet for real time inputs when creating art; the inputs can be distant. (This is something that really interests me since I see that this model is used not only by artists, but also in industry, health care and other fields, where it is called real time information. It is used more often than historical analysis). Performances and happenings are, of course, one of the major real time forms.

My definition of real time includes real time reception as well as real time production, and that is crucial. I like several of your formulations a lot. For example, you say, "New media in itself is creating hybrid forms of production where a network of experienced relations are replacing the autonomous unity of the 'work of art.'" Using the metaphor of physics I would say new media art (and real time art) consist of a web of relations that create the art. Art has a tendency to exist at a certain time at

certain places, but it's not necessary to look for an object. This might be why many museums and traditional art historians have problems with real time art.

Another consideration: If we concentrate on new media, are video sculptures, conceptual projects and performances excluded?

I really like the idea of the museum as a platform for art that takes place elsewhere. I think the exhibitions at Kiasma and in Roskilde will have to work like that.

I have seen exhibitions where the process of creation itself was the subject. The problem is that they tend to be difficult for an audience to experience. A lot of the process is conceptual, in a way, without anything happening. It would be fine if some — but not all — of the works we choose for the exhibition are conceptual. I also think that a mix of works would be interesting. Some would use the museum as a platform; others, such as installations and sculptures could deal with interactions and computers in the museum itself. In that case the museum will still work as an index of art production rather than as a place for showing static art pieces.

MS: Obviously, today real time is a new media art issue. But the focus of the exhibition is on how artists are using the possibilities new media are giving them, both in terms of new formal strategies and a conceptual reworking of "art". And then there is the contextual discussion of how the new media culture influences the way art is produced and consumed.

Now, although the most obvious thing is for us to choose works of real time media, the other issues of cultural contexts, and formal and conceptual artistic behavior in media are important, too. (These media reduce the distance, perhaps annull it, between real world events and their reception around the globe; they disturb or remove the layer of interpretation between the sender and the receiver. At least for the receiver there is less time to judge and take a stand.) So there are some issues at hand that are also real time art issues but not necessarily in the sense that artists are working solely within real time media. They are concerned more with the contextual, formal and conceptual issues to which this media culture gives rise.

The question is really about our and art's connection to reality. It is the other end of the real time tube. *Get Real* is also about that at some level — but at what level? That is the question!

LEV MANOVITCH

FROM DV REALISM TO A UNIVERSAL RECORDING MACHINE

If Mike Figgis' remarkable *Timecode* (2000) exemplifies the difficult quest of digital cinema for its own unique aesthetics, it demonstrates equally how these emerging aesthetics borrow from cinema's rich past, from other media, and from the conventions of computer software. *Timecode* splits the screen into four quadrants to show us four different actions taking place simultaneously. This is, of course, something that has been common in computer games for a while; we may also recall the ability of computer users to open a new window into a document, which is the standard feature of all popular software programs. In tracking the characters in real time, *Timecode* follows the classical principles of the unity of space and time. At the same time, since we are presented with video images, which appear in separate frames within the screen and provide different perspectives of the same building, the film also makes a strong reference to the aesthetics of video surveillance. At the end, we may ask if we are dealing with a film that is borrowing strategies from other media; with a "reality TV" program that adopts the strategies of surveillance; or with a computer game that relies heavily on cinema. In short, is *Timecode* still *cinema* or is it already *new media*?

This essay will address one of the key themes which informs both the evolution of new media technologies during its four-decade-long history and the current ongoing trend of cinema to become computer-based in all aspects of its production, post-production and distribution. This theme is "realism." The introduction of every new modern media technology, from photography in the 1840s to virtual reality in the

1980s, has always been accompanied by the claims that the new technology allows us to represent reality in a new way. Typically, it is argued that the new representations are radically different from the ones made possible by older technologies; that they are superior to the old ones; and that they allow a more direct access to reality. Given this history, it is not surprising that the shift of all moving-image industries (cinema, video, television) in the 1980s and 1990s towards computer-based technologies, and the introduction of new computer- and network-based moving image technologies during the same decade (for instance, webcams, digital compositing, motion rides) has been accompanied by similar claims. In this essay I will examine some of these claims by placing them within a historical perspective. How new is the "realism" made possible by DV cameras, digital special effects and computer-driven webcams?

Instead of thinking of the evolution of modern media technology as a linear march towards more precise or more authentic representations of reality, we may want to think of a number of distinct aesthetics — particular techniques of representing reality — that keep reemerging throughout modern media history. I do not want to suggest that there is no change and that these aesthetics have some kind of metaphysical status. In fact, it would be an important project to trace the history of these aesthetics, to see which ones already appeared in the nineteenth century and which only made their appearance later. However, for my purposes here, I assume that the major technological shifts in media, such as the current shift towards computer- and network-based technologies, not only lead to the creation of new aesthetic techniques, but also activate certain aesthetic impulses already present in the past.

I will focus on two different aesthetics that at first blush may appear to be unique to the current digital revolution, but that, in fact, accompany moving image media throughout the twentieth century. The two aesthetics are each other's opposites. The first treats a film as a sequence of big budget special effects, which may take years to craft during the post-production stage. The second gives up all effects in favor of "authenticity" and "immediacy," achieved with the help of inexpensive DV equipment. I will trace these two aesthetics back to the very origins of cinema. If Georges Méliès was the father of special effects filmmaking, then the Lumière brothers can be called the first *DV realists*. To use the contemporary terms, the Lumière brothers defined filmmaking as production (i.e. shooting), while Méliès defined it as post-production (editing, compositing, special effects).

The fact that not only the theme of "realism" itself, but also the particular stategies for making media represent reality "better" that keep reappearing in the history of media should not blind us to the radical innovations of new media. I do believe that new media reconfigures a moving image in a number of very important ways. I trace some of them in *The Language of New Media*: the shift from montage to compositing;

the slow historical transition from lens-based recording to 3-D image synthesis; the new identity of cinema as a hybrid of cinematography and animation. For me, pointing out that some claims about the newness of new media are incorrect (such as tracing the historical heritage of certain realist aesthetics in this essay) is the best way of figuring out which claims are correct, as well as discovering the new features of new media, which we may have overlooked. In short, the best way to see what is new is to first be clear about what is old. Here, the act of dismissing the originality of digital special effects and digital "immediacy" allows us to notice a truly unique capacity of digital media for representing "the real," which I will address in the last section of this essay.

This unique capacity can be summed up as the shift from "sampling" to "complete recording." If both traditional arts and modern media are based on sampling reality, that is, representing/recording only small fragments of human experience, digital recording and storage technologies greatly expand how much can be represented/recorded. This applies to the granularity of time, the granularity of visual experience and also what can be called "social granularity" (i.e., the representation of one's relationships to other human beings.)

With regard to time, it is now possible to record, store and index years of digital video. I don't mean simply video libraries of stock footage or movies-on-demand systems. I am thinking of recording/representing the experiences of individuals: for instance, the point of view (POV) of a single person as she goes through her life, the POVs of a number of people, etc. Although it presents the combined experiences of many people rather than the detailed account of a single person's life, the work by Spielberg's Shoah Foundation is relevant here. It shows what can be done with the new scale in video recording and indexing. The Shoah Foundation assembled and now makes accessible massive amounts of video interviews with Holocaust survivors: it would take one person forty years to watch all the video material stored on Foundation's computer servers.

The examples of new finer visual granularity are provided by projects of Luc Courchesne and Jeffrey Shaw, which both seek continuous 360° moving image recordings of reality.[1] One of Shaw's custom systems, which he called Panosurround Camera, uses 21 DV cameras mounted on a sphere. The recordings are stitched together using custom software, resulting in a 360° moving image with a resolution of 6000 x 4000 pixels.[2]

Finally, the example of new "social granularity" is provided by the popular game *The Sims*. This game, better referred to as "social simulator," models ongoing relationship dynamics among a number of characters. Although the relationship model itself can hardly compete with the modelling of human psychology in modern narrative fiction (since *The Sims* is not a static representation of selected moments in the characters'

1 For Courchesne's Panoscope project, see http://www.din.umontreal.ca/courchesne/. For Jeffrey Shaw's projects, see http://www.jeffrey-shaw.net. Both discuss their projects in relation to previous strategies of "experience representation" in panorama, painting and cinema in *New Screen Media: Cinema/Art/Narrative*, edited by Martin Rieser and Andrea Zapp (London: BFI and Karlsruhe: ZKM, 2001).

2 Private communication between Shaw and the author, 4 July 2002.

lives *but a dynamic simulation running in real time*) we can at any time choose to follow any of the characters. While the rest of the characters are off-screen, they continue to "live" and change. In short, just as with the new granularity of time and the new granularity of visual experience, the social universe no longer needs to be sampled but can be modelled as one continuum.

Together, these new abilities open up vast new vistas for aesthetic experimentation. They give us a wonderful opportunity to address one of the key goals of art — a representation of reality and the human subjective experience of it — in new and fresh ways.

DIGITAL SPECIAL EFFECTS

By the middle of the 1990s, the producers and directors of feature and short films, television shows, music videos and other *visual fictions* have widely accepted digital tools that range from digital compositing to CGI to DV cameras. According to the clichés used in Hollywood when discussing this digital revolution, filmmakers are now able "to tell stories that were never possible to tell before," "achieve a new level of realism," and "impress the audiences with previously unseen effects." But do these statements hold up under closer scrutiny?

Let's begin by considering the first idea. Is it really true that Ridley Scott would not have been able to make *Gladiator* without computers? Of course computer-generated shots of the Roman Colisseum are quite impressive, but the story could have been told without them. After all, in his 1916 film *Intolerance*, Griffith showed the audiences the fall of Babylon, the latter days of the life of Christ and the St. Bartholomew's Day Massacre — all without computers. Similarly, the 1959 classic *Ben-Hur* took the viewer to the ancient Rome, again without computers.

Shall we then accept the second idea that, armed with computers, filmmakers can now get closer to reality than ever before? I don't accept this idea, either. More often than not, when you watch special effects shots in films, you are seeing something you never saw before, either in reality or in cinema. You have never before seen prehistoric dinosaurs (*Jurassic Park*). You have never before seen T2 morphing into a tiled floor (*Terminator 2: Judgment Day*). You have never before seen a man gradually become invisible (*The Hollow Man*). So while in principle filmmakers can use computers to show the viewers ordinary, familiar reality, this almost never happens. Instead, they aim to show us something extraordinary: something we have never seen before.

What about situations when the special effects shots do not show a new kind of character, set or environment? In this case, the novelty consists of showing familiar reality *in a new way* (rather than simply "getting closer to it"). Take, for instance, a special effects shot of a mountain climber who, high up in the mountains, loses his balance

and plummets to the ground. Before computers, such a sequence would probably involve cutting between a close-up of the climber and a wide of mountain footage. Now the audience can follow the character as he flies down, positioned several inches from his face. In doing so the shot creates a new reality, a new visual fiction: imagining what it would be like to fall down with the character, flying just a few inches from his face. The chances of somebody actually having this experience are pretty much the same as seeing a prehistoric dinosaur come to life. Both are visual fictions, achieved through special effects.

DV REALISM

A special effects spectacle has not been the only result of the digital revolution in cinema. Not surprisingly, the over-reliance of big budget filmmaking on lavish effects has led to a reality check. The filmmakers who belong to what I will call the *DV realism* school purposefully avoid special effects and other post-production tricks. Instead, they use multiple, often handheld, inexpensive digital cameras to create films characterized by a documentary style. Examples would be American films such as Mike Figgis' *Timecode* and *The Blair Witch Project*, and the European films made by the Dogma 95 group (*The Celebration*, *Mifune*). Rather than treating live action as a raw material later to be rearranged in post-production, these filmmakers place premier importance on the authenticity of the actors' performances. On the one hand, DV equipment allows a filmmaker to be very close to the actors, literally to be inside the action as it unfolds. In addition to a more intimate filmic approach, a filmmaker can keep shooting for the whole duration of a 60 or 120 minute DV tape as opposed to the standard ten-minute film roll. This increased quantity of (cheaper!) material gives the filmmaker and the actors more freedom to improvise on a theme, rather than being shackled to the tightly scripted short shots of traditional filmmaking. (In fact, the length of *Timecode* exactly corresponds to the length of a standard DV tape.)

DV realism has a predecessor in an international filmmaking movement that began in the late 1950s and unfolded throughout the 1960s. Called "direct" cinema, "candid" cinema, "uncontrolled" cinema, "observational" cinema, or *cinéma vérité* ("cinema truth"), it also involved the use of lighter and more mobile (in comparison to what was available before) equipment. Like today's DV realists, the 1960s "direct" cinema proponents avoided tight staging and scripting, preferring to let events unfold naturally. Both then and now, the filmmakers used new filmmaking technology to revolt against the existing cinema conventions that were perceived as being too artificial. Both then and now, the key word of this revolt was the same: "immediacy."

Interestingly, during the same period in the 1960s, Hollywood also underwent a

special effects revolution: widescreen cinema. In order to compete with the new television medium, filmmakers created lavish widescreen spectacles such as the above-mentioned *Ben-Hur.* In fact, the relationship between television, Hollywood and "direct" cinema looks remarkably like what is happening today. Then, in order to compete with a low-resolution television screen, Hollywood turned to a wide screen format and lavish historical dramas. As a reaction, "direct" cinema filmmakers used new mobile and lightweight equipment to create more "immediacy." Today, the increasing reliance on special effects in Hollywood can be perceived as a reaction to the new competition of the Internet. And this new cycle of special effects filmmaking has found its own reaction: *DV realism.*

DIGITAL SPECIAL EFFECTS AND *DV REALISM* HISTORICIZED

The two ways in which filmmakers use digital technology today to arrive at two opposing aesthetics — the special effects-driven spectacle and the documentary-style realism striving for "immediacy" — can be traced back to the origins of cinema. Film scholars often discuss the history of cinema in terms of two complementary creative impulses. Both originate at the turn of the twentieth century in France. The Lumière brothers established the idea of cinema as reportage. The camera covers events as they occur. The Lumières' first film, *Workers Leaving the Lumière Factory*, is a single shot that records the movements of people outside their photographic factory. Another of the Lumières' early films, the famous *Arrival of a Train at a Station*, shows another simple event: a train pulling into a Paris station.

The second view of cinema equates it with special effects, designed to surprise and even shock the viewer. According to this idea, the goal of cinema is not to record the ordinary but to catch (or construct) the extraordinary. Georges Méliès was a magician in Paris who owned his own film theater. After seeing the Lumières' film presentation in 1895, Méliès started to produce his own films. His hundreds of short films established the idea of cinema as special effects. Devils burst from clouds of smoke, pretty women vanish, a space ships flies to the moon, a woman transforms into a skeleton (a predecessor to *Hollow Man*?). Méliès used stop motion, special sets, miniatures and other special effects to extend the aesthetics of the magician's performance into a longer narrative form.

The ways in which filmmakers today use digital technology fit quite well with the two basic ideas of what cinema is, which began more than a century ago. The Lumières' idea of film as a record of reality, as a witness to events as they unfold, survives with *DV realism*. It also animates currently popular "reality TV" shows (*Cops, Survivor, Big Brother*) where omnipresent cameras report on events as they unfold. Méliès' idea of

cinema as a sequence of magician's tricks arranged as a narrative receives a new realization in Hollywood's digital special effects spectacles, from *The Abyss* to *Star Wars: Episode 1*.

Therefore, it would be incorrect to think that the two aesthetics of computer-driven special effects and *DV realism* are somehow results of digital technology. Rather, they are the new realizations of two basic creative impulses that have accompanied cinema from the beginning.

Such an analysis makes for a neat and simple scheme — in fact, too simple to be true. Things are actually more complicated. More recently, film scholars such as Thomas Elsaesser revised their take on the Lumières.[3] They realized that even their first films were far from simple documentaries. The Lumières planned and scripted the events and staged actions both in space in time. For instance, one of the films shown at the Lumières' first public screening in 1895, *The Waterer Watered*, was a staged comedy: a boy stepping on a hose causes a gardener to squirt himself. And even such a supposedly pure example of "reality filmmaking" as *Arrival of a Train at a Station* turned out to be "tainted" with advanced planning. Rather than being a direct recording of reality, *Arrival of a Train* was carefully put together, with the Lumières choosing and positioning passers-by seen in the shot.

Arrival of a Train can even be thought of as a quintessential special effects film. After all, it supposedly shocked the audiences so much they ran out of the café where the screening was taking place. Indeed, they had never before seen a moving train presented with photographic fidelity — just as contemporary viewers have never before seen a man gradually being stripped of skin and then skeleton until he vanishes into the air (*The Hollow Man*), or thousands of robot soldiers engaged in battle (*Star Wars: Episode 1*).

If the Lumières were not the first documentarists but rather the directors of *visual fictions*, what about their descendants — the directors of *DV realism* films and "reality TV" shows? They do not simply record reality either. According to the statement found on the official *Big Brother* website, "*Big Brother* is not scripted, but a result of the participants' reactions to their environments and interactions with each other on a day-to-day basis." Yet even the fact that we are not watching a continuous 24-hour-a-day recording but short episodes, each episode having a definite end (elimination of one of the house guests from the shows) testifies to the fact that the show is not just a window into life as it happens. Instead, it follows well-established conventions of film and television fictions: a narrative that unfolds within a specified period of time, resulting in a well-defined conclusion.

In the case of *DV realism* films, a number of them follow a distinct, narrative style. Let us compare it with a traditional film narrative. A traditional narrative usually takes

3 This section relies on the analysis of the Lumières by Thomas Elsaesser in his *Cain, Abel or Cable* (Amsterdam and Ann Arbor: Amsterdam University Press / Michigan University Press, 1998).

place over months, years or even decades (for instance, *Sunshine*). We take it for granted that the filmmaker chooses to show us the key events selected from this period, thus compressing many months, years, or even decades, into a film which runs for 90 or 120 minutes. In contrast, *DV realism* films often take place in close to real time (in the case of *Timecode*, exactly in real time). Consequently, filmmakers construct special narratives where many dramatic events happen within a short period of time. It is as though they are trying to compensate for the real time of a narrative.

So the time that we see is the real time, rather than the artificially compressed time of traditional film narrative. However, the narrative that unfolds during this time period is highly artificial, both by the standards of traditional film and TV narrative, and our normal lives. In both *The Celebration* and *Timecode*, for instance, we witness people betraying each other, falling in love, having sex, breaking up, revealing incest, making important deals, shooting at each other, and dying — all in the course of two hours.

THE ART OF SURVEILLANCE

The real time aspect of what can be called *reality filmmaking* (film and television narratives that take place in real time or close to it, including "reality TV") has in itself an important historical precedent. Although television as a mass medium became established only in the middle of the twentieth century, television research began as early as in the 1870s. During the first decades of this research, television was thought to be the technology that would allow people to see remotely what was happening in a distant place — thus its name, television (literally, "distance seeing"). The television experiments were part of a whole set of other inventions, which all were done in the nineteenth century with the goal of *telecommunication*: real time transmission of information over a distance. The telegraph was to transmit text over a distance; the telephone was to transmit speech over a distance; and television was to transmit images over a distance. It was not until the 1920s that television was redefined as a *broadcasting* medium, that is, a technology for transmitting specially prepared pro-grams to a number of people at the same time. In other words, television became a means to *distribute content* (very much as the Internet is today, as opposed to the Internet before the mid-1990s) rather than a technology of *telecommunication*.

The original idea of television has survived, however. It came to define one of the key uses of video technology in modern society: video surveillance. Today, for every TV monitor receiving content, one can find a video camera that transmits surveillance images from parking lots, banks, elevators, street corners, supermarkets and office buildings. In addition to its realization in video surveillance, usually limited to industry; television in its original conception as distance-vision in real time was also realized in

computer culture in webcams, accessible to everybody. Like normal video surveillance cameras that track us everywhere, webcams rarely show anything of interest. They simply show what is there: the waves on the beach, somebody staring at a computer terminal, an empty office or street. Webcams are the opposite of special effects films: they feed us the banality of the ordinary rather than the excitement of the extraordinary.

Today's *reality media* — films that take place in real time (such as *Timecode*), "reality TV" and webcams — return us to television's origins in the nineteenth century. Yet while history repeats itself, it never does it in the same way. The new omnipresence and availability of cheap telecommunication technologies, from webcams to on-line chat programs to cell phones holds the promise of a new aesthetic that does not have any precursors: the aesthetic that will combine fiction and telecommunication. How can telecommunication and fictional narrative go together? Is it possible to make art from video surveillance, from a real time — rather than pre-scripted — signal?

Timecode can be seen as an experiment in this direction. In *Timecode* the screen is broken into four frames, each frame corresponding to a separate camera. All four cameras track the events that are happening in different parts of the same location (a production studio on Sunset Boulevard in Hollywood). This is a typical video surveillance setup. It is to the credit of Mike Figgis that he was able to take such a setup and turn it into a new way to present a fictional narrative. Here, telecommunication becomes a narrative art. Television in its original sense of seeing over distance in real time becomes the means of presenting human experience in a new way.

Of course, as I already noted, *Timecode* is not exactly bare-bones telecommunication. It is not just a real time recording of whatever happens to be in front of the cameras. The film is tightly scripted. We may think of it as an edited surveillance video: the parts where nothing happens have been taken out; the parts with action in them have been preserved. But it is more accurate to think of *Timecode* as a conventional film that adopts visual and spatial strategies of video surveillance (multiple cameras tracking one location) while following traditional dramatic conventions of narrative construction. In other words, the film uses a telecommunication-type interface with a traditional narrative. It does not yet deal with the deeper implications of computer-based surveillance. (We can also use other terms that have less negative connotations: "monitoring," "recording.")

THE COMPUTER AS A UNIVERSAL RECORDING MACHINE[4]

What would it mean for cinema, and the narrative arts in general, to address these implications? One of the most basic principles of narrative arts is what in computer culture is called "compression." A drama, a novel, a film, a narrative painting or a photograph

4 My term "Universal Recording Machine" is meant to refer to the original model of a digital computer described in 1936 by Allen Turing. In his honor, it came to be called the Universal Turing Machine.

compresses weeks, years, decades and even centuries of human existence into a number of essential scenes (or, in the case of narrative images, even a single scene). The non-essential is stripped away; the essential is recorded. Why? The narrative arts have always been limited by the capacities of the receiver (i.e., a human being) and of storage media. Throughout history the first capacity remained more or less the same: today the time we devote to the reception of a single narrative may range from 15 seconds (a TV commercial) to two hours (a feature film) to a number of short segments distributed over a large period of time (a TV series or the time taken to read a novel). But the capacity of storage media recently changed dramatically. Instead of ten minutes that fit on a standard film reel or two hours that fit on a DV tape, a digital server can hold a practically unlimited amount of audio-visual recordings. The same applies to audio only or text.

This revolution in the scale of available storage has been accompanied by new ideas about how such media recording may function. Working within the paradigms of Computer Augmented Reality, Ubiquitous Computing, and Software Agents at places such as MIT Media Lab and Xerox Park, computer scientists advanced the notion of a computer as an unobtrusive but omnipresent device that automatically records and indexes all interpersonal communications and other users' activities. A typical early scenario envisioned in the early 1990s involved microphones and video cameras situated in an office, recording everything that happens, keyed to indexing software that makes possible a quick search through years of recordings. More recently the paradigm has expanded to include capturing and indexing the varied experiences of many people. For instance, a DARPA(Defense Advanced Research Projects Agency)-sponsored research project at Carnegie Mellon University called Experience-on-Demand, which began in 1997, aims to "develop tools, techniques and systems that allow users to capture complete records of personal experience and to share them in collaborative settings."[5] A 2000 report on the project summarizes the new ideas being pursued as follows:

The capture and abstraction of personal experience in audio and video as a form of personal memory
Collaboration through shared composite views and information spanning location and time
Synthesis of personal experience data across multiple sources
Video and audio abstraction at variable information densities
Information visualizations from temporal and spatial perspectives
Visual and audio information filtering, "understanding," and event alerting[6]

5 http://www.informedia.cs.cmu.edu/. For more information on the project, see Howard D. Wactlar et al., "Experience-on-Demand: Capturing, Integrating, and Communicating Experiences Across People, Time, and Space" (http://www.informedia.cs.cmu.edu/eod/); also Howard D. Wactlar et al., "Informedia Video Information Summarization and Demonstration Testbed Project Description" (http://www.informedia.cs.cmu.edu/arda-vace/). Both of these research projects were conducted at Carnegie Mellon University; dozens of simiar projects are going on at universities and industry research labs around the world.

6 http://www.informedia.cs.cmu.edu/eod/ EODforWeb/eodquad00d.pdf

(Given that a regular e-mail program automatically keeps a copy of all sent and received messages, and allows one to sort and search through them, and given that a typical mailing list archive website similarly allows one to search through years of dialogs between many people, we can see that in the course of text communication this paradigm has already been realized). The difficulty of segmenting and indexing audio and visual media is what delays realization of these ideas. However, recording en masse can already be easily achieved: all it takes is an inexpensive webcam and a large capacity hard drive.

What is important in this paradigm — and this applies to computer media in general — is that storage media become active. That is, the operations of searching, sorting, filtering, indexing and classifying, which before were the strict domain of human intelligence, become automated. A human viewer no longer needs to view hundreds of hours of video surveillance to locate the part where something happens. A software program can do this automatically and much more quickly. Similarly, a human listener no longer needs to go through years of audio recordings to locate an important conversation with a particular person; software can do this quickly. It can also locate all other conversations with the same person or other conversations where his name was mentioned.

For me, the new aesthetic possibilities offered by computer recording are immense and unprecedented, in contrast to the aesthetics of special effects and *DV realism*, which, as I have suggested, are not new to cinematic history. What may be truly unique about new media's capacity to represent reality is the new scale of reality maps it makes possible. Instead of compressing reality to what the author considers the essential moments, very large chunks of everyday life can be recorded and then controlled by software. I imagine, for instance, a "novel" that consists of the complete e-mail archives of thousand of characters, plus a special interface that the reader will use to interact with this information. Another possibility is a narrative "film" in which a computer program assembles a story shot-by-shot in real time, pulling from the huge archive of surveillance video, old digitized films, webcam transmissions and other media sources. (From this perspective, Godard's *History of Cinema* represents an important step toward *database cinema*. Godard treats the whole history of cinema as his source material, traversing this database, as though he were a virtual camera flying over a landscape made from old media.)

In conclusion, let me once again evoke *Timecode*. Its very name reveals its allegiance to the logic of old video media: a linear recording of reality on a very limited scale. The film is over when the time code on the videotape reaches two hours. Although it adopts some of the visual conventions of computer culture, it does not yet deal with the underlying logic of computer code.

Contemporary creators of digital *visual fictions* need to find new ways to reflect the particular reality of our own time that go beyond digital special effects or digital "immediacy." As I have suggested, the computer's new capacities for automatically indexing massive scale recordings offer a new direction beyond what cinema has already explored. Rather than seeing reality in new ways, perhaps we simply need to pour all of it onto a hard drive and then figure out what kind of interface the user needs. In short, a filmmaker needs to become an interface designer. Only then will *cinema* truly become *new media*.

STEVEN DIXON

JUST FOR YOUR INFORMATION
COMMUNICATION AND THE REAL TIME
ART PIECE

What is real time art? The question would seem to be straightforward. If we know what real time is, and, naturally, what art is, the question could be answered in the combination of ideas. However, we can see that herein lies the problem. A common definition of real time is, to quote, "of or relating to systems that update information at the same rate as they receive data, enabling them to direct control of a process, or the time it takes for a process to occur." In order to understand what occurs in the process of art, we have to look at two functions of the art piece. The first is the art object itself. The second is the interpretation of the art piece by the viewers themselves. Or, to state this in other terms, we must examine how the piece generates information and how the viewer determines what the art piece is "saying."

THE ART PIECE

The assumption (whether the art piece is developing or changing over a fixed time, as a *process piece* does, or whether it seems to stay *invariable* in its "internal relationships," as in a painting) is that the material of which the art piece is composed is merely the physical medium, by which communication occurs. The material, though important to the art piece, is not what the art piece is. The medium of art is not to be solely reduced to the material, but is also to be seen as the communication between the art piece and the viewer. The medium is understood as both the material and (more

interestingly) as what the art piece is trying to say. In other words, the art piece is not to be reduced completely to the physicality of the object, but is to be understood as the bearer of a set of concepts, ideas or even a story. The conveyor of meaning can hinder or help in this communication, but to understand the art piece as only this "thing" is to miss the point. The information, which is being communicated, is what is prioritized in the exchange and is where the art piece is to be localized. Here, the the art piece is extended and placed into the flow of information.

THE VIEWER

The viewer, on the other end of this communication, is processing the information borne by the art object and localized in the flow of information between him/herself and the art piece (material and process). From this information the viewer selects what is relevant and bypasses or discards data that seem irrelevant. Within the information is a structure that explains what the art work now "means." This is not a strict form of the art–viewer interchange, but is a back-and-forth process by which the viewer collates information; "checks back" with the art piece to confirm or deny the interpretation; and then modifies his/her ideas accordingly. The art piece is now being formed.

PRESENCE

The art piece, then, can never be definitively formed. Though some work may seem to be *fixed* when it is completed by the artist (painting and sculpture belong to this category) the communication matrix that is formed in the exchange between viewer and art piece will always vary depending on space and time, culture and history. The art piece will be open-ended with regard to locating, definitely, the meaning of the work. The communication will never be complete. The presence of an art piece can only occur when the viewer does not communicate with the art piece, as when the one "meaning" of the piece is decided and any further communication is seen as redundant. However, we can then see that presence is never possible for the viewer or the piece of art. There can be no "transcendental" position in the activity of communication.

INFORMATION

We can look to Claude Shannon's work on information theory to better understand what is at stake in this paradigm of art and how such a theory helps us to comprehend our interpretations of the model of art.

For Shannon the model of information exchange has five components: sender,

code, channel, decode and receiver. The sender is the speaker or, as in the case of art, the art object. The code is the relationship among the parts of the art object and how it forms a matrix. The channel is the space between the sender and the receiver. Decoding is a restructuring or reconstruction of the signal, which has been sent to the receiver. And lastly, the receiver interprets the structure to interpret the information being sent.

Here is the formula for the exchange of information in any communication:

SENDER	CODE	CHANNEL	DECODE	RECEIVER
(ART OBJECT)	(ELEMENTS)	(SIGNAL)	(CONSTRUCTION)	(INTERPRETATION)

For the receiver, the interpretation is the correct structure of the information and its meaning. That is the thing that is being said. The signal has a form or order that, when recompiled or reconstructed (or constructed, as we called it in the diagram above), will give us the possibility of extracting from this structure the meaning of the information. Information on the receiving end of the exchange is a reduction of all the possible formulations of information to give definitive form and meaning to the signal.

The exact definition of information is formulated as a process that removes or reduces uncertainty, where uncertainty consist of a given number of possibilities. When we are constructing the information at the receiving end, we then look at all the possible things the signal could mean. From these possible meanings we select one or some, that seem to be more probable. Information, at the receiving end, will be the process that removes possibilities or alternatives to yield a single, probable meaning.

Shannon, however, sees the signal in the channel as not being defined by single possibilities but formed in multiple meanings, which collide, form, degrade and deform. There are two reasons for this. One is that this information, as a signal in the channel, is not unique. There might be, and usually is, more than one single signal. If we want to say this plainly, it means that even one person wants to say more than one thing at any one time. Also, the context in which the signal finds itself will impart a signal as well. That is where and when a person (or art piece) sends out a signal (says something) and the type of context, place, phrases or words that are included. So if we reduce the model to only two signals sending information, we would probably expect that we would be getting twice as much information in the signal. Two signals double the information. But this is not strictly true. Two pieces of information in the channel do not give only two outcomes, but more. As Shannon states it, a signal which has A and B in the channel with signals 1, 2 and 3 does not give only A, B, 1, 2, 3, but must be combined to give A1, A2, A3, B1, B2, B3. The function of the signal is to give information in the channel not merely an arithmetic conclusion, but something more along the lines of an algorithmic function.

Secondly, there will be a degradation of the information caused by the degradation or disordering of the signal in the channel. This degradation can have two sources. One will be from the natural decay of the signal in the channel. This is entropy, which occurs not only in the natural world, but also in communication itself. Entropy is the disorganization or decay of the order of the signal in the channel and is one of the ways in which all information in the channel operates. The second type of degradation occurs in the channel due to noise operating in tandem with the signal or operating directly on the signal. Noise might be a consequence of the medium of the signal itself within the channel or may be caused by an unordered, secondary source impinging on the signal.

We can see a curious distinction within this model about what information is. On one hand, information for the receiver (or to put it another way, the receiver's interpretation of the communication) is defined by the reduction of uncertainty or by elimination of possibilities from the total amount of information transmitted in the channel. When the receiver has found or located the most "likely" interpretation of the decoded signal, then the receiver can say she has received the information. If all the possible interpretations of the decoded signal are equally likely for the receiver, there will be less information for the receiver than if few or one are likely. In other words, knowing the one thing that the signal (probabilistically) "means" to say is the extraction of the information from the signal. Information for the receiver is the reduction of all the possible interpretations of the signal to one probable meaning.

The signal in the channel, on the other hand, is dependent on the total number of possibilities for the quota of information. Within the channel, which holds and transmits the information as a signal, we are to understand how much information there is by the number of signals and as a result, learn how much information is there. The amount of information is based on the sheer number and proliferation of possibilities found in the channel. The reduction to a single signal with no noise would be a reduction in the quantity of data. The less we know about the signal in the channel, and all the possibilities the signals entail, the more information the channel has.

This would appear to be the double bind of information theory. On one hand, information is determined by the elimination of all but one possibility when looking at the receiver. On the other hand, the amount of information is determined by the abundance, possibilities and indeterminacy of the information when looking at the channel.

CHANNEL AND CODE

How does the receiver determine what information (from all of the signals that are present and likely) is to be singled out as being more probable? How is the selection of what the information is "saying," i.e., its specific meaning, to be accomplished? The

receiver must operate upon the signal to reconstruct or decode the transmission in the channel by imparting order to the signal. Because noise along with other signals is operating to disrupt the "clarity" of the communication, the receiver must pull out "extraneous" signals from the channel and ignore or discard them as not part of, or incorrectly transmitted in, the channel. With the remaining elements an order will be created. This is the decoding of the signal. Shannon called this "negative entropy." Decay, degradation and disorder are countered in the decoding of the signal when the receiver gives back orders to the (dis)structure of communication that seems to come from the signal. This negative entropy will be applied to the "apparent" structure the signal seems to have and will seem to arrange the structure of the signal received through the channel. This feedback into the system, that is, where the receiver decodes the signal, will be based on, among other factors (and founded upon previous probabilities) education, place, gender, age, etc. What you are expecting to hear (see, feel) from the sender will be one level of the interpretation and can also be thought of as a signal in the channel though based in the receiver. This interpretation will be a type of hyperinterpretation and is founded on the expectations of the receiver. In a very real way it will determine a form of the reconstruction of the signal at a decoding level. This will depend on factors that are not specified by Shannon; in the work of later information theorists it is defined more extensively by other fields, as psychology, sociology, that go beyond the parameters of a theory of information. Yet this is where a large part of the information is to be formed. If the signal degrades, as well as having numerous possible alternatives, the restructuring of the information, or the negative entropy applied by the receiver (to use terms from information theory), will be as much formed by the inclinations of the receiver as the intentions of the sender. Even if we assume that the code formed by the sender is "totally clear and correct," the assumptions of the receiver will, to a large extent, determine the "meaning of the message." It will be as much formed by the signal as it will be by education, culture, reading habits, etc., and will be applied at two levels: decoding and interpretation.

 This model is constrained by its two poles of interchange, the sender and the receiver. If we add a second receiver, or as many as we like, a situation of information exchange could happen like this: Sender transmits a signal to Receiver-1 and Receiver-2. R-1 and R-2 decode and send signals to one another and to Sender. They agree it meant Meaning-A. Sender says no, it meant Meaning-B. R-1 and R-2 agree it meant Meaning-A and that Sender is wrong. They send back signals explaining why it is Meaning-A. In this case the correct interpreter of the information is indeterminate. We cannot say what the correct interpretation of the signal is. Sender would seem to be at an advantage. She would appear to be the one who "knows" what the signal meant before entropy and noise operated on it. Yet R-1 and R-2 think otherwise and can send

information back to show why their contention is correct. Who, then, is the final assessor of the correct interpretation of the signal? Sender or receiver?

SIGNAL

The signal must also be examined. We would normally think that the total amount of information (and here we mean in the signal transmitted through the channel) is our goal. The more information, the better. Information is a good thing. Noise we think of as interfering with the information. (If we are talking to people in the street, we may find the traffic noise disruptive. For a moment we can barely hear what they are saying.) Yet if we want maximum information in a signal, noise is a way to get further information into a signal. If the noise doesn't obliterate the signal and is added on top of a signal, it will function in the channel as an additional signal and is therefore adding information. (Remember, information is not additive in the normal sense as I described above.) It would seem that the more we want to know and the added possibilities we wish to get from a signal are dependent on the amount of interference we receive. There would seem to be an intuitive balance between getting something from a sender and getting something from the noise, but what seems surprising is that noise and decay of the signal would be things to desire.

Before we discuss how this will apply to art and to real time art itself, we must look at one more thing, that will clarify the interchange in the information cycle: cybernetics.

If we use the information model as Shannon described it, we would expect not only that the sender will send out a signal and the receiver interpret it, but that after the interpretation occurs, the receiver will become a sender to either respond to the information or to clarify it (to see if she was right about what she interpreted the signal to contain). There will be, for lack of a better phrase, an information feedback loop. This is the basis of cybernetics. Sender will become receiver and receiver will become sender. This will occur for an unspecified length of time and will (in the most utopian world) bring the two into closer accord about the information being exchanged. However, this will happen with error and approximation.

According to cybernetic theory, when we send a signal we want to know how effective our transmission was. If we send information that commands a certain physical response from the receiver (like "look at that painting"), we will judge our effectiveness based on the activity of the receiver. We will then try again, ("no, this painting") until it seems we have communicated the information with clarity. Error in this model is what is important in getting the communication to operate correctly. The errors are fed back into the system of information and the next transmission will account for the preceding errors. The information errors, or ambiguities, are the indicators of possible

directions for clarifying the information. Possible information retrieval in the interchange of signals is then more error-based than information-based and, with it, the feedback loop for localizing the "correct" interpretation focuses on response to what are seen as errors. When enough errors have been compensated for or eliminated from the interchange, the communicating participants will be satisfied they have communicated. This will never eliminate all of the errors, but approximations will settle into certainty. The interchange or feedback cycle is where the information is then formed. Error circles around defining the interpretation until the boundaries of error define the model and mapping seems sufficient. Information in the channel is based more on the continual reversal of flow; the concurrent definition of what is being signaled through the channel is based on the continual passage of signals.

Within "normative" fields of study, as Thomas Kuhn notes in his *The Structure of Scientific Revolutions*, information is imparted through the use of textbooks and the problems, which must be worked through at the end of each section of textbooks. "Going to school" in this model is working the problems through and discussing them until only minor linguistic variance occurs between the students, the textbook and the teacher. In the cybernetics model, this is to say that one side of the exchange is privileged and will determine the possible responses of the receiver. Error is seen on only one of the poles of the information exchange and this will occur primarily on the "student" side of the information flow. This will be worked through until the receiver (that is, the student) sends information through the channel, which is coded approximately for the textbook answer and according to the correct signal. Once the receiver is seen as having worked through the feedback loop of errors correctly and therefore is sending the correct coded signal, the student will be able to become a sender in turn. Yet error will never be completely eliminated. Not every sentence or circumstance will be available for the teacher to see if the student response is free of errors, nor will the transmission from the student ever be free from noise or completely freely chosen. Some answers might be incorrectly interpreted as being correct!

What happens, though, in the interchange of signals between sender and receiver and the concurrent feedback loop? As each signal is coded, channeled, decoded, sent back, and so on, what occurs is a change of the state of the system. For the student, this means he or she will "learn," but in non-normative cases, if there are only two people communicating, the change of state will occur in both sender and receiver. In the apparent narrowing of the signal through feedback, the system itself is changing its state continually. This also means that the state of each participant in the exchange is altering as he or she is a part of the interchange. The idea, the concept and the communication are consequences of the flow of the signal and are determined by that exchange.

REAL TIME ART

Now that we have looked at how signals are sent and received, we can begin to explore what this will mean for our definition of *real time art*.

If we look at painting, sculpture etc. as *invariable art*, we can see that the work itself is transmitting a signal, which the viewer is interpreting. The viewer (or receiver) will then take this interpretation and again look at the signal. The interpretation will be a new map, which will be compared to the original signal from the art piece. Errors may be seen and a new interpretation will occur. This may come in the form of, "Oh, I didn't notice that before" or even "I can follow this way of thinking even further now." In this way, the art that we have been calling *invariable* shares in one aspect of *real time*: it will change within a certain and specifiable "duration." The art piece as communication (or its meaning) is formed in the interaction and feedback cycle of error to eventually reach "understanding," and will unfold during the time in which the receiver is assessing the information from the art piece and comparing previous impressions. The *invariable* type of art also shares in other aspects of *process art*. *Invariable art* will cause a change in the state of the receiver. The processes, which occur in the receiver or viewer, will spur a reassessment of information structures that will then be further processed to find information, which will feel probable given the relation of elements in the art piece. This will occur until a state is reached which seems probable given the signal of information from the elements of the art piece. Yet one factor is different between the *invariable art* piece and the *process art* piece. This is the channel.

The channel for the *invariable art piece* is determined by three factors. Firstly (and we will use this only as a methodology to detail the interactions), if we start with the art piece itself, the organization of the elements seem to remain in stasis regardless of the interpretation of the viewer. Yet we can readily see that in the interpretative phase (and this includes the hyperinterpretative and the interpretive in equal measure), the elements operating within the artwork can be related in different ways. Some of these elements will be structured in a hierarchical way to generate the meaning of the piece, with some of the elements being seen as extraneous or unimportant to the interpretation and so omitted from the interpretative reading. This structuring will be formed by the viewer's meanings or based on the information. The viewer will then take the model she has formed in the interchange and map it back onto the art object — that is, the art viewer will send a signal into the channel. The map and the art piece will be compared, and errors checked. The art piece will not respond in the normal mode of sender and receiver, but the new information that the viewer now has, will be mapped back into the system of exchange as another signal in the channel. With the new information of the map of the art object (that is, the signal sent out by the viewer) and the art object itself (that is, its signal in the channel) the viewer will be able to reassess the art object is

"meaning" in a new way. This new information, though, is added by the viewer himself or herself and not generated by the art object itself (even if we cannot reach a conclusion about what is "real" in the art object, given the nature of the cybernetic exchanges and the current unfolding of cybernetic states). Error checking is determined by the reinsertion of the signal by the viewer, who becomes asymmetrical in the relationship now. The viewers insert information into the signal of the channel and then operate on the consequent information. However, even in this asymmetrical relationship, the state of the art object is altering, just as the receiver is. The state of the art object is determined by what it "means," but shifts in the constant flux of the information–interpretation feedback cycle.

PROCESS AND INTERACTION

For the real time art piece, the effects are different. Two systems are operating that act as senders and receivers in the cybernetic sense. A signal is sent, received and then sent back to check or to compensate for the information received. The sender will in turn become receiver and will compensate for the information and retransmission. The map, which is resent, will alter the subsequent state of the information structure in the receiver, who will then retransmit a signal. If the piece is what is (for lack of a better word) called an "*interactive art piece*," the model we noted above will be part of the signal. The viewer will receive and decode (structure) the information. Then a model will be formed and remapped onto the art piece. This means for the *interactive art piece* a type of action by the viewer. The map will entail both a determinate information structure in the viewer and the action to see if the model of meaning is correct. In reality, the action is a signal in the channel and will be decoded by the art piece and alter the state of information in the art object. This new state of information will then be sent back through the channel. The exchange will continue.

If the *real time* piece is a *process* piece, the systems of sender and receiver will not be just the viewer of the art object. Sender and receiver will be two systems internal to the art piece itself, which will interact with each other to alter the state of each other. Two (or more) systems in the art piece itself will send information "within itself"; they will be decoded, modeled and then resent as a signal to be reassessed by the first system and then resent as signal. (Imagine a candle that is burning. The flame and the wax exchange information that alters the state of the candle. Alternations and a change of state come from the flow of information internal to the two systems, wax and flame). The cybernetic interchange will occur within the art object. The art piece will alter according to the interchange within this system. There will be no exact information flow between these two (or more) systems but the viewer will interpret the piece. The viewer

will see a specific state, and depending on how long she stays and "looks", will be sent a "slice" of the information generated by the art piece. The model formed by the decoding of the signal from the art piece will never be possible to determine, as the state of the information in the signal will never coincide with the possible model to be mapped by the viewer onto the art object. The viewer will attempt a complete mapping of the model generated in the "slice of time" in which she views and interprets the art piece, but the incompleteness of the model will be accented by both the internal operation of the system of the art piece and the circumscribed event of the viewing. Openness of the interpretative sequence and the arbitrary section of time in which the art piece is operated in the interpretative feedback cycle will highlight the diffuse nature of the viewer's state. The creation of the communication information of the *process* piece is found both in the "duration" or "timeframe" in which the viewer engages the piece of art and the meanings (process) the piece of art generates outside of the viewer when she is not viewing the art piece and communication has halted. New indeterminacies are generated by the conceptual model of the entire communication process of the art piece (all internal process), their consequences and the indeterminacy caused by gaps in regard to this, and in opposition to, the communication cycles of "duration" and viewing experience of the viewer based on signaling and interpretation. To put it simply, the viewer will have an interpretation of the system, but will know that the internal system of the real time art piece will continue to unfold according to its own internal signaling and responses even after the viewer has disengaged from the communication.

DIFFERENCES THAT MAKE A DIFFERENCE (SOMETIMES)

In many ways the invariable art object and the real time art piece have many things in common. The invariable art piece will be in flux as the continual rechecking of the viewers' model will always be altered by the injection of information that the viewers themselves send back into the channel between them and the art piece. There is no privileged position in the interchange between the art object and the viewer; also, proliferations of noise and additional information impinge on the signal. Unlike the textbook example, which we talked about above, that demands a correct mirroring of the signal to be seen as having the "right" answer, the art object has ambiguous probabilities. The model formed by the viewer, or receiver, has multiple variations from which to choose as "correct." Many of the models are privileged due to cultural and social requirements, but for the art object no one model has primacy. Also, the contextual element of the art viewing experience is elevated by the very mechanisms of the art world, i.e., institutions. The painting seen in a home becomes different then the painting seen in a museum. Whether we want to call this "noise" or not, this type of further

STEVEN DIXON JUST FOR YOUR INFORMATION

information is often accounted for in the viewing of the art piece (and which differs from, say, the mathematician's claims of "pi" being the same in the university lecture hall and at a dinner conversation). This ambiguity, or the indefinable art object's probable "meanings," is often highlighted in the paradigm of the art world and is distinguishable from that of other disciplines. For the real time art piece, this very indeterminacy is grounded in the operations of the piece and its operations, but can be read as one channel of information among other things. The real time art piece may have other content in the information flow (that is, it may have a point or a "statement" about something, such as money, gender, family life) while also offering this aspect of meaning constructions, multiplicity and indeterminacy. This hypertext of meaning constructions and information flow, and the very determination of the state of the person as being constructed in the error feedback cycle, will always be present in the real time art piece.

The real time art piece, though sharing the improbability of determination with the invariable art piece, wishes, and cannot help in its functioning to underline the indeterminacy of signal and development, through the never-ending process of the communitive loop and a denial of a settled steady state. This is due both to the highlighting of error in interpretation of the signal and the proliferation of probabilities of possible correct models to be created from the signal. The structuring of the signal in decoding and interpretation by the viewer will always be "out of synch" with the state of the art piece. The viewer's state will be constantly changing as will the state of the piece. Error, in the cybernetic sense, will be reinvested as the overall creation of differing interpretations, which will call out to multiple positions of response. The emphasis of the multiple states, which the viewer can embrace, will be fed back into the system creating a diffuse and continual deportment of the art object and a shifting state of the viewer.

REFERENCES
Kuhn, Thomas. *The Structure of Scientific Revolutions,* The University of Chicago Press, 1956.
Rosenblueth, Arturo, Norbert Wiener, Julian Bigelow. *Behavior, Purpose and Teleology,* Philosophy of Science 10, The University of Chicago Press, 1943.
Shannon, Claude. *A Mathematical Theory of Communication,* The Bell Systems Technical Journal, October 1948.

STEVEN DIXON JUST FOR YOUR INFORMATION

ALL GINGERBREAD WOMEN MUST DIE.
2003.
Performance with prints, video, and baking
of real cookie (2 meters, taking 4 hours).
Performance was the actual eating of the
cookie by invited guests within their own
working space (so they had seen the baking,
and smelled it all throughout the day).

DAY	DATE	TIME	MASHED	HEALED	NEW	BALANCE
MON	0513	2023	3003	2801	0	-202
TUE	0514	2235	3119	2938		
WEN	0515	1914	3245	3041		
THUR	0516	0730	3254	3056		
THUR	0516	1500	3300	3111		
FRI	0517	0100	3332	3155		
FRI	0517	0700	3336	3161		
FRI	0517	1400	3356	3200		
FRI	0517	2045	3356	3202		
SAT	0518	2030	3366	3218		
SUN	0519	0815	3366	3221		
MON	0520	0830	3369	3226	791	-143
MON	0520	1200	3405	3263		
MON	0520	2030	3408	3269		
TUE	0521	0748	3455	3305		
TUE	0521	2240	3508	3457		
WEN	0522	1100	3540	3491		
WEN	0522	2050	3565	3579		
THUR	0523	0745	3599	3630		
THUR	0523	2030	3629	3711		
FRI	0524	0730	3659	3772		
FRI	0524	2100	3761	4004		
SAT	0525	0900	3793	4062		
SAT	0525	1900	3846	4156		
SUN	0526	0050	3925	4245		
SUN	0526	0820	3940	4258		
SUN	0526	1600	4058	4382		
SUN	0526	2100	4064	4388		
MON	0527	0705	4065	4388	2649	+323
MON	0527	1100	4121	4459		
MON	0527	2307	4160	4489		
TUE	0528	0700	4172	4496		
TUE	0528	2100	4282	4592		
WEN	0529	0720	4283	4593		
WEN	0529	1140	4340	4657		
WEN	0529	1520	4352	4663		
THUR	0530	0840	4403	4722		
THUR	0530	1040	4419	4730		
THUR	0530	1624	4447	4760		
FRI	0531	0911	4545	4873		
FRI	0531	1825	4611	4960		
SAT	0601	0815	4617	4964		
SUN	0602	0730	4620	4966		
SUN	0602	1400	4623	4969		
SUN	0602	2139	4626	4973		
MON	0603	0740	4633	4975	3804	+342
MON	0603	1621	4663	5001		
MON	0603	2030	4668	5006		
TUE	0604	0740	4705	5040		
TUE	0604	2000	5073	5483		
WEN	0605	0800	5111	5525		
WEN	0605	2150	5447	5920		
THUR	0606	0720	5448	5921		
THUR	0606	2050	5506	6003		
FRI	0607	0558	5516	6035		
SAT	0608	1045	5666	6106		
SAT	0608	1743	5673	6111		
SAT	0608	2209	5697	6116		
SUN	0609	0735	5703	6122		
SUN	0609	1315	5706	6123		
SUN	0609	2400	5724	6136	6056	+412

Hit: 5607 Healed: 6084

LETMECOUNTTHEWAYS. 2002.
Internet site where for a 3-week period after
September 11th one could vote to destroy
or mend a gingerbread. Image was broken
or mended and one could see the tally of
both actions.

STEVEN DIXON

JUST FOR YOUR INFORMATION

SOME ASSEMBLY REQUIRED, THREE SECTIONS: RHETORIC, SHOOT, AND SIGN. 2004.
Live video performance using images of President George Bush, the war, and the idea of terror, downloaded from the Internet. Performed live in front of an audience and streamed back onto the web.

MOGENS JACOBSEN

TROUBLE IN THE TIMELINE

The debate on digital art has focused mainly on interactivity and narrative multimedia. Lately, this debate has died out, and software-art or code-art has become the focus of attention. Perhaps this relative failure of responsive narrative media is partly due to models embedded in the authoring tools used to produce interactive media and digital art? One central problem is the underlying assumption of cinematic linear time often inherent in commercial tools. As an alternative, I want to propose low-level programming as an artistic strategy for investigating the nature of time and dynamics in digital media.

5.39 X 10–44 SECONDS

Quantum physics states that energy is not continuous but exists in small packages. You cannot turn energy up or down smoothly, but have to do it in small increments — by quanta. Quantum physicists define time thus: One second is the amount of time it takes for the photon particle with the energy of one packet to oscillate once. To make the math simpler, Max Planck suggested a new natural unit of time in 1899. This unit is called Planck's Time and is approximately equal to 5.39 x 10-44 seconds. Theoretically, this is the smallest measurable amount of time. Shorter time intervals may exist, but we will never be able to observe or measure them. As you might expect, this leads to the idea that time itself comes in small steps or packets. The hypothetical quantum or particle of time is called the chronon.

In contemporary cultural theory, we learn that technology is accelerating the pace of public life and reducing the frictions of the "real" or "natural" world. We read about a compression of time and space that removes the past and present, keeping us focused on a flickering "now." In the French philosopher Paul Virilio's study of speed (dromology), technology condenses time and makes events unrepresentable, replacing the old linear perspective with a hyperperspective.

Information technologies aim at making action and response simultaneous, to compress the time it takes to acquire and process information, to diminish the latency and make things happen in "real time."

My own experience is with computers and other forms of digital technology. Speed and processing time are important selling points, central commercial concerns in information technology. I'm writing these words on a 4-year-old portable computer. The central processor runs at 400 MHz. This means the smallest possible timing interval will be one 0.0000000025 of a second. On my desk stands another computer, just a few months old. It runs much faster at 2.8 GHz (the price was a fraction of the old one), and the smallest interval has now become 0.00000000036 seconds long.

In 1965, Intel founder G. E. Moore stated that technological progress and the density of computer chips doubles every 18 months. The timing interval of my computers has been getting smaller and smaller following the famous "Moore's Law."

The issue of time and timing in computing machinery is vital, and lately it has become one of my interests. Not that I need a faster computer, but questions of time are fundamental in the general theory of computability, e.g., in the Halting Problem:

Given a description of an algorithm and its initial input, determine whether the algorithm, when executed on this input, ever halts (the alternative is that it runs forever without halting). Alan Turing proved in 1936 that a general algorithm to solve the halting problem for all possible inputs cannot exist.

(ON-LINE TEXT: HTTP://EN.WIKIPEDIA.ORG/WIKI/HALTING_PROBLEM)

In my day-to-day life as a digital artist, I struggle with much simpler "halting problems." Will my works — my "black boxes" — have collected data and finished computing before I lose my patience? Before my audience has lost interest? How long will you wait for the content of a web page to load? Most people will accept only a 3 second or less delay.

I wish to stay down-to-earth for the rest of this paper, and share some of my ideas, personal experiences and practices regarding time and timing in digital media. Perhaps it might not quite address "real time" as in zero latency, but I hope it will prompt a broader exploration of the "chronon" inherited by digital media.

MULTIMEDIA
INTERACTIVITY
BLAH
BLAH
BLAH

It seems like everybody is getting tired of discussing interactivity. That is fine by me; I have almost stopped using the "I"-word. When I talk with students, I try to avoid it. I found the word became too broad and meaningless years ago. It became almost as intimidating as the word "multimedia."

A lot of what is labelled interactive media is in reality hypermedia. By that I mean navigational media, where the spectator/user can jump between or recombine existing media fragments.

Generally, the navigational possibilities have been very restricted. The postulated "free" interaction was narrowed down to a predefined branching structure. You could select path A or B. Turn the switch on or off. Press the button. Click the mouse. (FIG. 1. P. 054)

I'm not really interested in navigational media anymore. I used to be, in particular when net.art took off. And I still think there are enormous possibilities to explore in the difficult field of the navigational narrative. Personally I agree with Lev Manovich, who pinpoints data indexing and the database as the key form of cultural expression of contemporary society: the database opposes the narrative.

As a cultural form, a database represents the world as a list of items and it refuses to order this list. In contrast, a narrative creates a cause-and-effect trajectory of seemingly unordered items (events). Therefore, database and narrative are natural enemies.
(LEV MANOVICH 2001: 225)

I still have some confidence in the recombinant abilities of navigational media. Great works have been done using montage or cut-ups of existing media. And the renewed interest in the works of the French literary group OULIPO indicates a brighter future for recombinant media (OUvroir de LIttérature POtentielle — the Workshop of Potential Literature — has a website at http://www.oulipo.net.)

The click'n'choose branching structure might be a problem within the binary nature of digital media. But other problems arise within the existing authoring software. In many of these tools we find a timeline playing a major role in the interface. This is the case with the extremely trendy and well-known Flash software. This prioritization encourages you to think of digital media in cinematic time: frame by frame in a forward linear manner. (FIG. 2. P. 054)

Computer-based media do not have to be trapped by linear time, nor does it have to be a playback of existing files. They can be responsive at a low level by computing and constructing media on the fly. For me this capability of feedback or direct response is an important quality. It is like a medium performing for you and in collaboration with you. To become truly engaging, this feedback loop often has to be tight. The performing medium has to react almost instantaneously — it has to perform in real time.

GAMING
Modern computer games might offer a different and freer approach to responsive media. But my experiences in computer games are virtually nonexistent. And I have no children to show me how to use them.

ALGORITHM CONSUMPTION
Computers are excellent at executing simple commands at high speed. In fact, they will do very little themselves without orders to follow (aside from crashing). You instruct your computer by giving it a step-by-step procedure to follow, an algorithm. When you are using applications like Photoshop, Flash or Word, you are choosing among predefined algorithms nicely packaged in a friendly graphical user interface (a GUI). (FIG. 3. P. 054)

When Alan Kay developed the first graphical mouse-controlled computer environment at Xerox PARC in the 1970s, the separation between "usage" and "programming" was implemented for the first time as separation of media. "Usage" became graphical, "programming" textual… The result was an ungrammatical, Swiftian operating system that gave birth to the "user," with the message: You are supposed to read, not to write.

(FLORIAN CRAMER 2003: 100)

The algorithms in Photoshop, Flash or Word are industrial strength. They are robust, efficient and geared towards very specific tasks. Nobody does spell checking in Photoshop or writing his letter in Flash (but I have seen hackers doing image processing in an Excel spreadsheet).

As an artist working in electronic art, I spend a lot of time trying to learn different software environments and I spend a lot of mental energy thinking about tools I ought to learn. I try to stick to a few and to restrict my urge to explore new ones.

Lately I have developed a kind of GUI-diabetes and feature-fatigue. I'm getting very tired of the eye candy of contemporary operating systems like the generation "X"

of operating systems from Microsoft or Apple. Multicolored icons jumping up in my (inter)face. And I'm getting exhausted by having to choose among the countless icons in Microsoft Word. I want to get behind the façade — to leave the role of reader/user — and become a writer and a creator. (FIG. 4. P. 054)

SCARY STUFF

Why do most of us remain content with expensive commercial software and choose to remain in the role of the naive and baffled user/consumer/reader? Why do we retreat from programming? In his short essay "Fear of programming," artist Zach Lieberman gives four plausible reasons:

1. STEREOTYPE OF PROGRAMMERS AS GEEKY GUYS
2. WALLS OF INTIMIDATINGLY THICK BOOKS AT BOOKSTORES
3. FEAR OF MATHEMATICS
4. FEAR OF HIEROGLYPHICS

You can examine the full content of Lieberman's encouraging text at http://thesyte-mis.com/dbn/fear.html. But I would also like to help you to conquer these phobias.

I know a lot of people who think artists are geeks, so I will not comment on the part about programmers being "geeky." The "guy" part is a little harder to ignore, but I have noticed a lot of women getting involved in software, so I will leave it to the female artist or programmer to erase this prejudice. However, I will address the thick-book-syndrome. I have spent substantial amounts of hard-earned money in bookstores and on ama-zon.com buying computer books. Now most of them gather dust on my shelves, especially the "learn X in 24 hours /learn Y in 21 days"-type of books. The only kind of computer book I still use is the inexpensive reference-book, the utterly plain and boring book with lists of commands. These books typically cost nothing more than 20 euros. They work as a sort of catalog of ideas for me; skimming through them and finding an exotic command might help me conceptualize a new piece. When I'm actually working with code, I rarely make use of books, as most of them deal solely with entirely utili-tarian programming. When I get stuck, I seek help from people on-line. The majority of programmers love to share their knowledge. The hieroglyphic issue and the math-phobia will be dealt with in subsequent sections.

HELLO WORLD

Don't be fooled: Programming languages won't liberate you. They still run as applica-

tions on your computer and somebody else has defined the rules of the game. But by moving from sealed prepackaged applications to a programming language, you will be taken to a more basic and open level. You will be transformed from a user to a maker — from a reader to a writer.

(A lot of people) ... seemed to think that hacking and painting were very different kinds of work — that hacking was cold, precise and methodical, and that painting was the frenzied expression of some primal urge. Both of these images are wrong. Hacking and painting have a lot in common. In fact of all the different types of people I've known, hackers and painters are among the most alike. What hackers and painters have in common is that they're both makers.

(PAUL GRAHAM 2003: ON-LINE TEXT)

Not all programming languages are created equal. Some are easy to learn, some are very domain specific (and will only do a few things for you), some are fast running and some are hard to learn. Many are freely available but some are awfully hard on your credit card.

Most programming languages are very much alike once you get under the surface. And a lot of code resembles simple English sentences — not at all like hieroglyphs. Learn one and you will be able to comprehend many others.

According to computer science tradition, the first program you write in any language will output the sentence "Hello World" on your screen. On the webpage www2.latech.edu/~acm/HelloWorld.shtml you can explore an impressive collection of "Hello World" programs written in many different languages. Most of them look like identical twins and the code will resemble the following snippet:

print "Hello World"

Some eccentric languages are structurally just as simple, but intentionally made awfully hard to understand — like the notorious languages Brainfuck (http://www.hardtware.de) or Malbolge. This is the "Hello World" program written in Malbolge:

(=<`:9876Z4321UT.-Q+*)M'&%$H"!~}|Bzy?=|{z]KwZY44Eq0/{mlk**
hKs_dG5[m_BA{?-Y;;Vb'rR5431M}/.zHGwEDCBA@98\6543W10/.R,+O<

SOFTWARE SKETCHING
I prefer the easy languages. In fact I would always choose an uncomplicated language

to start a project, even if it means sacrificing speed and performance. Perhaps professional certified programmers have an overall structure planned when they approach their keyboards. But I do not have a planned structure — and nor do any of the programming artists that I know of. None of us are superior programmers — we are pigeon-programmers. Artistic programming is hacking, sketching in code.

… a programming language should, above all, be malleable... It should be a pencil, not a pen. Static typing would be a fine idea if people actually did write programs the way they taught me to in college. But that's not how any of the hackers I know write programs. We need a language that lets us scribble and smudge and smear, not a language where you have to sit with a teacup of types balanced on your knee and make polite conversation with a strict old aunt of a compiler.

(PAUL GRAHAM 2003: ON-LINE TEXT)

I need a simple and tolerant software environment for writing my code. My programs might not work at first. That's not the primary objective. Getting my hands dirty in code is a vital creative process and I try to stay open and responsive to ideas that evolve within the code. I let the process foster new ideas. I am willing to wander off track, working by subtly tweaking and combining snippets of code.

Let me share the most brilliant creative feature of any programming language: The possibility of making part of the code inactive by adding comment-tags to it. Simply by adding "//" in front of a line of code, you switch it off. That line won't execute. This is a superb way to explore mutations or variations of a program.

MATH

Perhaps I'm not the one to tell you mathematics is easy. Twenty-five years ago I spent a year studying math at university, but I dropped out and have forgotten everything about it.

Now I sometimes have to use math in my programming. But most of the math necessary is very straightforward. I think the most advanced math I have used in the past ten years was trying to find a point on a circle. That's really kid stuff. If you remember the words "sine" or "cosine," you have almost made it. The rest you will find easily on Google.

Most multimedia or drawing programs have a button that lets you create perfect circles. But by describing the circle in a formula, you can begin twisting the circle, freeing your work from prepackaged perfect circles.

SCANMOVIES

In 2003, I became interested in exploring cinematic time, and I wanted to do something neither interactive nor responsive, something quite old-fashioned — like video.

In the 1970s I borrowed the book "Expanded Cinema" by Gene Youngblood from the public library. I renewed this book again and again, but finally returned it. Sadly, I never bought the book, but thanks to the Vasulka Archive I can now download the book as a pdf file (http://vasulka.org/Kitchen/PDF_ExpandedCinema/ExpandedCinema.html). The images from the book made a great impression on me in the 70s and I have always wanted to experiment with something like them. I was first struck by the early films of the Australian Len Lye and Canadian Norman McLaren. In particular, McLaren's short animations "Lines Horizontal" and "Lines Vertical" (1961/62) fascinated me. Both Lye and McLaren made films by drawing directly upon the film with pen and ink. By doing so they escaped the boundaries of the single frame and thereby the discontinued time of stop-frame animation. They escaped the embedded "chronon" of movies. (FIG. 5. P. 055)

I didn't want to draw on film, paper, or on DV tape, but I still wanted to experiment with the idea of making images by expanding several frames on the video. I began sketching ideas in software.

HACKING THE IMAGE

As you would expect I have some standard software installed on my computer; Microsoft Office, Adobe Photoshop, Mozilla Firefox browser and stuff like that. Some of these very common programs have hidden scripting or programming features, ideal for nerdish exploration.

Photoshop has a relatively unknown feature called "Filter Factory." It is basically a very small and simple programming language, which allows you to write image-processing filters. It is not installed by default, but you will find it on your Photoshop CD (hidden in the "Goodies" folder).

I started experimenting in Adobe Photoshop and soon became mesmerized by images with extreme low resolution in the vertical dimension, while leaving the horizontal resolution of the original image unchanged, making scenarios of columns of repeated pixels. In the spirit of open source programming and Creative Commons, I will show you the fundamental code written in the Filter Factory scripting language:

```
y<ctl(0)?src(x,ctl(0),z):c
```

If you have never done any programming before and have an all-pervasive fear of programming, let me translate the code to plain human language. Its relatively straight-forward and is centered in a conditional statement "y<ctl(0)?." Conditional statements are very basic concepts in any type of programming and this one asks if the current vertical position of the pixel is lower than the value of an on-screen slider. Determined by the state of the condition, the software will do one of two things. If the condition is true (the current vertical position is lower than your slider) then the action "src(x,ctl(0),z)" is performed. This piece of code gives the pixel the same color as a source-pixel at the vertical position determined by the same slider. If the condition is false, the simple action "c" leaves the color of the pixel unchanged. The colon before the "c" separates two possible actions. (FIG. 6. P. 055)

TRUTH 25 OR 29.97 TIMES A SECOND

Computers are excellent at repeating themselves. If you put the following short line of JavaScript code in a web page, it will render the famous quote by Jean Luc Godard 10.000 times in your browser:

```
for(i=0; i<10000; i++) { document.write("Cinema is truth at 24 frames per second"); }
```

Working with video requires 25 images per second (29.97 if you are in the USA or Japan and watching NTSC). I don't mind spending a long time working on an artwork, but I did not want to engage in the tedious process of loading, manipulating and saving 1,500 Photoshop images per minute of playing time. I had to move on to a program-ming environment that allowed more iterative procedures and a faster workflow.

I chose Macromedia Director. It is standard software for authoring multimedia that you will find installed on the computers of many interaction designers. It has been around since 1988 and you can get a lot of help from a large community of very dedi-cated users on-line. Director is desecrated by the infamous timeline, but blessed by an accompanying programming language called "Lingo." Ignore the timeline and you will have an entry-level coding tool.

My idea was to use one very large image as the background image. This would emulate the celluloid canvas of Lye and McLaren. Instead of drawing onto this image, I used a collage of photos. You can see a small section of this collage through a narrow horizontal gap in the screen. The rest of the screen is filled with two single lines — the top and bottom of the gap repeated. The gap runs down the large image, exposing only parts of it at a time. (FIG. 7. P. 055)

As I always try to keep my math simple, the gap would be moving at a speed of one pixel per shown frame. Therefore the total duration would be dictated by the height of the collage. A collage 1,500 pixels high would result in an animation lasting for 1,500 frames, which equals 1 minute of playback time. By altering the size of parts in the collage, I could change their timing and duration. It no longer made any sense to distinguish between temporal and finite objects, but it gave me a relationship that unified the image space and time: pixeltime or the chronon-pixel. I have made several short videos using variations of this program. (FIG. 8. P. 055)

OBJECTS IN MOTION

Having worked with short video originating from a single image, I became interested in using motion footage as the input for my videos. And I was beginning to think of video as a 3D object in space.

Film as a 3D space/time object has been creatively explored by the German group *Art+Com* in their project "Invisible Shape of Things Past" (1995-2001). They collected short documentary films about Berlin, and the films were then digitized and positioned inside a VR model of the city of Berlin.

Since a time as well as a place exist for the occurrence of each film sequence, we modelled a virtual representation of the place for each object, thus enabling the user to navigate through time. Taking the city of Berlin as an example, we modelled all the urban situations since 1900, and positioned the film objects according to their place and the time of shooting.

(SAUTER & LÜSEBRINK 2003:466)

The individual frames were lined up along the path of the camera. The movements of the (real) recording camera created a framework of virtual 3D shapes. A camera moving along a pavement created a simple elongated box. More compound motions created more complex shapes.

My plan was much simpler. I imagined video as a 3D object. The individual 2D frames constitute the vertical and horizontal axis, the series of successive images being the third axis. With time substituting for depth, a video sequence becomes a tunnel of images. When watching the sequence you are moving through movie space at a speed of 25 frames/second from one end of the tunnel to the other. (FIG. 9. P. 055)

I began to hack some code in "Lingo." I had no intention of making the fastest or "smartest" program, but needed something I could experiment with. It had to take all

the single images in a video sequence — 1,500 per minute — and construct a virtual volume filled with pixels (or "voxels" as volumetric pixels are called).

As most programming languages are so similar, programmers often use a kind of pseudocode to describe ideas or algorithms. You can then translate the pseudo-code into your preferred programming language. The pseudocode of my program could be something as simple as this:

```
y=image_height/2;
for (frame = startframe; frame<endframe; frame=frame+1)
{
loadimage(frame);
for (x=0; x<image_width; x=x+1)
{
voxel(x,y,frame) = read_pixel (x,y);
store(voxel,x,y,frame);
}
}
```

Once I had the code running and the volume stored, the idea was to explore the dynamics in the video by moving through the object along a different route. The simplest variation would be rotating the axis, passing through the video from top to bottom. (FIG. 10. P. 055)

However, these volumes are huge, so I was heading for trouble. The full resolution of a DVD or DV video is 720 x 576 (PAL format). Each minute of video would require manipulating 720x576x(25x60) voxels; that's more than 620 million voxels to keep track of at any one time. If I were to store them in full color, one minute would fill the content of 3 CDs. At the moment I have no chance of juggling this kind of information space in responsive real time. Instead I store lots of still images of the movement through the video object. It is almost like the good old days of computer-based art. I conceptualize an algorithm, write the code, press "run" and go to bed. The next morning I explore the resulting images on my hard drive. The two images on page 056 show different sequences in the film "Playtime" by Jacques Tati (1967). Each sequence is 750 images or 30 seconds long. Sharp horizontal shifts in the image indicate a cut in the movie; everything in the scene changes. The rectangular red area in the first image originates from a scene where Monsieur Hulot (Jacques Tati) switches on a red lamp and a couple of seconds later switches it off again. The more organic swirling shapes — resembling forms from the works of Umberto Boccioni or Giacomo Balla — are actors moving around. (FIG. 11. P. 056 + PP. 198-199)

Perhaps when I learn a faster programming language, when I become a better programmer, when computers get faster, it will become an intuitive and responsive real time experience to examine these time/space volumes of video. But at the moment, I have the great pleasure of exploring something at a slow pace in this time-compressed technological world.

FIG. 1 BRANCHING STRUCTURE FIG. 2 THE TIMELINE IN MACROMEDIA FLASH FIG. 3: THE FRIENDLY INTERFACE

FIG. 4: MS WORD INTERFACE FULLY EXPANDED.

MOGENS JACOBSEN TROUBLE IN THE TIMELINE

FIG. 5: "TAL FARLOW" BY LEN LYE

FIG. 6: EXAMPLE OF THE SIMPLE PHOTOSHOP CODE

FIG. 8: FRAME FROM "BRIDGE, SCANMOVIE #7" (2003)

FIG. 7: SCANMOVIE PRINCIPLE

FIG. 9: VIEWING A VIDEO THE TRADITIONAL WAY

FIG. 10: MOVING FROM TOP TO BOTTOM THROUGH A VIDEO

REFERENCES
Manovich, Lev. *Language of New Media*, MIT Press, Cambridge, MA, 2001.
Cramer, Florian. *Exe.cut[up]able statements: The Insistence of Code*, CODE / Ars Electronica, Gutenberg-Werbering, 2003.
Graham, Paul. *Hackers and Painters*, 2003. Http://www.paulgraham.com/hp.html.
Sauter, Joachim & Dirk Lüsebrink. *Future Cinema*, edited by Jeffrey Shaw and Peter Weibel, MIT Press, Cambridge, MA, 2002.

FIG. 11: DYNAMICS IN 30 SECONDS OF "PLAYTIME" BY JAQUES TATI

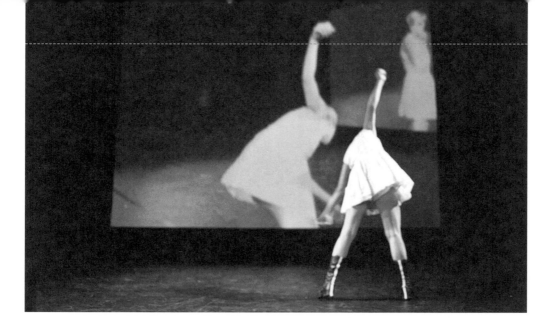

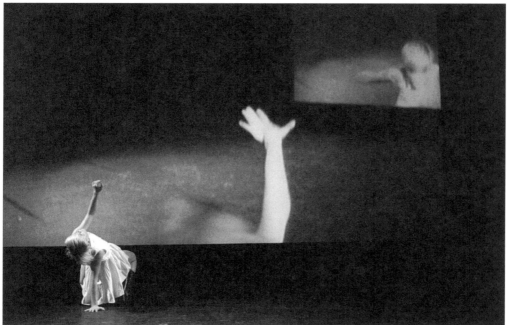

SYNK

H.C. GILJE

WITHIN THE SPACE OF AN INSTANT

Video is a medium of time. Real time video allows the artist direct access to the videostream, which can be transformed and molded on the fly using customizable software and hardware.

Real time processing of video enables the artist to work more intuitively and immediately than before, and accessible programming environments give the artist full control over structure and content. More specifically real time processing allows him to create a situation within which events unfold. The live experience is created in the meeting between structure and chaos.

My work focuses on the perception and conception of reality through exploration of the physical experience of the moment, which involves both spatial and temporal aspects. I seek to create suspended moments of time in a space, by creating fictional spaces within the video frame, and by transforming or creating a physical environment using video projections.

My departure point was the three-pronged project VideoNervous, iniated in 1999, which set out to explore video as a live medium through three collaborations within more established live art genres: music, dance and theater. This later lead to my improvisatory works in 242.pilots and BLIND, my involvement with the dance company Kreutzerkompani and installations like *Shadowgrounds*, *Split*, *Storm* and *Sleepers*.

VIDEONERVOUS

The project was a collaboration with performers within live art fields, and it produced three very different works: one jam session with a musician exploring the musicality and immediacy of live video; one dance performance creating dynamic spaces by projecting video onto the dancers; and a hybrid installation/performance setup exploring video as both a narrative and spatial element.

The main foci of the project were to make use of the immediacy that digital technology offers and develop video as an instrument; to create fluid spaces through projections; and to explore the ability of video to function as both a set design and narrative element.

The project was based on recent technological changes, which have given video many of the same possibillities as digital audio, including sampling, software and hardware control of the videostream. Technology has also produced cheaper and brighter projectors.

The analog videotape has both a physical and a time-based limit; because it has a beginning and an end, it takes time to access a specific videoclip on the tape. Digital video transcends this limitation: the video holds a stream of information, which can be accessed and transformed instantaneously on a computer. The directional time aspect inherent in the tape medium dissolves into Random Access Video, where each frame of the video can be fetched with a keystroke. From being a mechanical tape-based playback system, video has evolved into a reactive organic medium, an extension of the performer's actions.

VideoNervous focused on the performer and the computer as part of the same system. The instrument, a combination of software and hardware in relation to the visual material, was intended as an extension of the human's actions, e.g., Heidegger's ideas of the "zeug". The human senses were the system's perception of the environment.

VideoNervous was conceptualized as an extended central nervous system in which many of the processes parallel our daily processing of reality: sampling from reality, transforming the samples. The hard drive could then be seen as a memory bank, the video samples as pieces of a reality: memories, dreams and thoughts triggered by impressions from the outside world.

242.PILOTS

242.pilots was born out of a necessity to define and refine a new genre: live video improvisation; to focus on live video as something more than visual eyecandy for laptop concerts and club nights. The name refers partly to the software initially used to create our own video applications, and also to the way we work: We create programmed

structures through which we navigate during a performance. Each pilot has his distinct way of processing the images before they blend together.

We established 242.pilots as a visual band with Kurt Ralske, Lukasz Lysakowski and I as members, and invited different musicians to collaborate with us, instead of the other way around. We specifically chose to perform in art-related venues such as galleries, cinemas and theaters to tie our links to early avant-garde cinema of the '20s and experimental cinema of the '60s, more than to the VJ club scene.

Being completely improvised, each performance is unique, and is of course also influenced by our different audio collaborators. As our sound collaborator on the 242.pilots DVD, Justin Bennett, explains: "It's like improvising a soundtrack to a film, but the film also responds to what I do. [the pilots] are also listening, obviously. So it's very much a two-way process."

242.pilots have been compared to free-jazz groups, operating on the outer fringes of experimental cinema. Using our individual video instruments, the three of us respond to and interact with each other's images in a subtle and intuitive way. The images are layered, contrasted, merged and transformed in real time and combined with the improvised soundtrack into an audiovisual experience.

Our first performance was in Rotterdam in 2001, and we later played at numerous festivals and venues, including Transmediale, Ultima and Mutek, The Montreal Museum of Contemporary Art, The American Museum of the Moving Image and Guggenheim Bilbao. In 2002 we released a DVD on the New York label Carpark Records, based on a performance recorded in Brussels. 242.pilots received the Image Award at Transmediale in 2003, for mastering "the multifarious aspects of image production under the conditions of digital, interactive and network-based media."

INSTRUMENT BUILDING

Software has become a very important tool for artistic creation with digital images. In the video field, advances have been made since the mid-nineties in terms of the real time manipulation of images and their adaptation to sound and other digitally-based data flows.

My first experience in a live context with real time video software was with x<>pose, one of the first video-triggering programs: by connecting a MIDI keyboard to my Mac, I triggered different Quicktime loops with different keys, and could also apply simple effects and vary the playback rates of the movies. This is still the basic structure of a typical VJ program today: a bank of clips and effects, which can be triggered manually or synched, to the music.

In 1998 I was introduced to Image/ine, created by Tom Demeyer in dialog with

Steina Vasulka at STEIM in Amsterdam. Image/ine was a much more powerful tool for manipulating and layering images, combining live videostreams and prerecorded loops. Its most interesting feature was the way it made it possible to sample video into a buffer with direct user-control of the buffer contents. Image/ine was designed for performance purposes, and used a clever combination of keypresses, mouse movement, midi controllers, audio and lfos (low frequency oscillators) to create a very responsive visual instrument in a live context. Image/ine and x<>pose were my main tools in the VideoNervous project.

Image/ine was great in many ways for live purposes, but lacked the potential to make the more advanced programmable control structures necessary for installation setups. As an experiment I used the graphical programming environment Max on one computer to control the behavior of Image/ine on another, which I used in the 1999 installation *Node*. This is an interactive computer/video installation in the form of a metal well that provides a meeting place in space and time by collecting faces and reflecting them back to the viewer. Sensors connected to the computer running Max sensed when people were above the well and triggered different states in Image/ine running on the other computer: record a new image, play back a video sequence, play the buffer of previous faces or show the livestream from the camera.

Max is a program for making programs. You build your own programs in a very visual way by working with boxes that represent objects with different functions. These boxes have inlets and outlets which allow them to receive and send information to and from other objects. They are connected with patchcords, reminiscent of analog synths.

A program made in Max, often referred to as a patch, can be compared to building a circuit board. You control the flow of information using the various connected

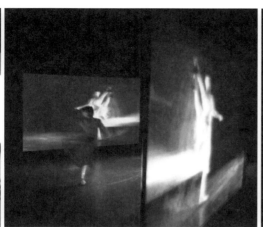
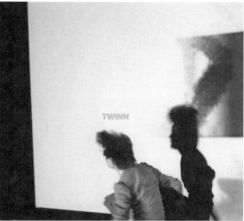

objects, yielding a very visual representation of what the patch actually does. The program structure and the GUI (graphical user interface) as presented to the user are identical.

Originally Max was a visual programming language developed at IRCAM in Paris, based on the MIDI protocol that enabled the computer to talk to synthesizers and external controllers like faders, knobs and sensors. Later Max was expanded to include audio processing, and in 1999 the first version of the real time video objects *nato+055* was released by Netochka Nezvanova, opening up tremendous possibillities for working with real time video. Over the years nato's capabilities expanded and several other sets of video objects surfaced: mainly *Jitter*, *SoftVNS* and *Auvi*. So now we have a wide array of flexible tools for recording, playing, combining, creating, analyzing and manipulating video, graphics and sound in real time. The best thing about this environment is the amount of objects made by the users of Max, vastly expanding the capabilities of the original application.

Artists can now design their own video programs without the knowledge of a programming language like C.

Some of the decisions being made during a live performance are: selecting an appropriate video source file; combining multiple images (in additive or subtractive ways); applying effects to images (e.g., blurring, warping, distortion, etc.); dynamically varying the parameters of effects (e.g., depth or speed of effect) or applying effects only on parts of images; dynamically modifying the playback speed of videoclips; composition of multiple images in the frame; and time-based effects (buffering, feedback, etc.).

These and many other processes offer a huge range of options for expressive, real time control of the image. Some of these processes are random, some of the para-

meters might be controlled by lfos (sinewaves, squarewaves, etc.). Other parameters are mapped to on-screen controllers or external faders or knobs, creating a multitude of choices to be made and seemingly endless combinations. Therefore the structure of the setup is a key factor in how the actual visual output emerges.

THE EXTENDED NOW

I have found many similarities between my approach to video and the way musicians work, especially within the noise and impro scene: The idea of video as a flow, an energy, something that can be molded and transformed like a substance, the focus on texture and the moment instead of on creating a musical structure. A live setting implies an attempt to have some control over a chaotic energy, or to create a dialog between performer, structure and chaos.

In music, the whole idea of improvising deals with the immediate presence, the notion of nonlinear time instead of sequential time, where time *is*, where presence is more important than position. The notion of vertical time is the extended now. This is where the physical experience takes place; it is the presence of your body in the present, mediating between inner mental space and outer physical environment. It's the ultimate mode of sensibility, and it has for me also become a method of working.

Vertical time is closely related to the process of dreaming, of being there as an experience unfolds, where the images and sounds are a chain of associations, often not intended by the creator, but made in the live meeting between performer/ environment and audience/visitor. There is not a big difference for me between improvising in a performance and filming with my camera: intuition, immediacy and responsiveness are in focus. Grasping the moment is the most important thing. The video camera is an instrument of perception, the videopatch an instrument of conception. What is produced is a chain of associations in the meeting between my mind and the world.

STRUCTURE

Improvisation needs to be structured, and there are several strategies for doing so. One strategy is to think of structure as a way of limiting the options. In principle, my instrument can do anything, so I need to set limits to avoid total anarchy and chaos. Interesting results often occur in the tension between structure and chaos. The limits are determined by the situation, who I play with, what kind of space, what type of project, technical setup, etc.

I build a new instrument for each new project, ranging from one-time collaborations with audio artists and other impro events, but mainly from associations with a regular

group of people for specific projects. These are mainly Jazzkammer, Kelly Davis, composers Yannis Kyriakides and Maja Ratkje, and choreographer Eva-Cecilie Richardsen.

These collaborations have gone in very different directions. My collaboration with noise duo Jazzkammer already started in 2000 with a series of concerts, followed by a tour to Japan in 2002, which later resulted in the commissioned audiovisual composition *Night for Day* in 2004. We have also collaborated on a Kreutzerkompani performance in 2004, *Twinn*, and for the *Voice* performance with Maja Ratkje at Ars Electronica in 2003. My collaboration with Kelly Davis in BLIND is in many ways a continuation of my work with 242.pilots (an example of this is included in the REAL TIME + ART + DVD), but by being a fixed audiovisual unit we can develop ideas over time and produce subtler work. We released a DVD of live recordings on German label Audioframes in 2004.

Yannis Kyriakides is a composer and improviser whom I have worked with on three projects. Our most extensive collaboration so far, *Labfly Dreams*, was made for a 40-piece orchestra and premiered at Queen Elisabeth Hall in London in November 2003. Four composers and four video artists were each invited to create a composition, and the orchestra and video artists performed the four works live. Kyriakides and I created our piece based on speculations that fruit flies might dream during their short lifespan; we wondered what they would dream about. This was a new challenge as the music was composed and rehearsed, because I wanted to keep the video as open and flexible as possible. I created different states for the different parts of the music making it possible to have quite a tight structure, while allowing for improvisation within each part.

Another way of structuring improvised material is by giving it a form after the performance, by recording the performance and importing the footage into an edit application. For instance, in my BLIND collaborations I usually record the performances and use the material as source material for other work. *Shiva* is completely constructed from fragments from several live performances. The audiovisual composition *Night for Day* made in collaboration with Jazzkammer was a constant negotiation between the live raw energy derived from improvisations, and the subtler composed/edited parts, resulting in deconstructed footage from Tokyo that was transformed into 13 dreamlike scenes.

I sometimes use real time video processing for the sole purpose of creating source material, not in a jamming situation, but as a way of exploiting the responsiveness of the instrument to manifest the energy of the moment. An example is the video *Sunblind*.

In working with installations I attempt to create a system that breathes on its own. This means setting up certain rules by which the installation system makes decisions, sometimes in dialog with the visitor, as in the work for the Get Real exhibition. This adds another level of structure.

I think of many of my video installations (such as *Sakrofag*, *Storm*, *Shadowgrounds*) as dreamweavers, using a stream of consciousness analogy as the structuring element, where the main questions are which videostreams to play, and when. Of course, there is a limited amount of video sources available, so there will be repetitions of content, but not in the same sequence. This creates an everchanging stream of images. Since there is no beginning or end to these works, they also create a sense of timelessness or suspended time. Locations are pulled out of linear time and into nonlinear time, creating mythical spaces.

SPACE

I look for the point where impression and expression blur. According to newer cognitive science, it is probable that the same parts of the brain dealing with perception and motion are also used to conceptualize, so that perceiving and conceiving a reality are strongly connected, mediated through the body. The mind is in the body, meaning that all our mental facilities and concepts are grounded in physical experiences. The way the human body is made up determines how we categorize, and thus filtered, the information we receive. This in turn strongly influences how we think and relate to the world. Our relation to the world is mediated through our brain structures, our bodies and our interaction with the environment.

Since the mind is part of the body, then the way we relate to the physical environment has emotional consequences. Moving in space and organizing in space is a way of thinking, dreaming and remembering. Modern dance is relevant to this premise: dancers have a body knowledge, and choreography is about organizing movements in relation to space.

The connection between the mind and physical space is not new. The ancient Greeks used temples as a way of remembering speeches: By linking different parts of the speech to physical places in the temple, the speech could be reconstructed by mentally moving through the temple. Landscape paintings often reflect mental states; American films often reflect mental state/reactions to physical elements.

Working with computers often means relating to virtual worlds; the interaction between man and computer takes place on the premises of the computer. I want to move away from the abstract, slick virtual space and move the meeting place of man and computer to the physical space; to make a immersive reality that a person can walk around physically and relate to the projections of the computer, instead of being dragged into a virtual reality. The architecture of the space structures your experience. You don't have to relate to mouse/keyboard/monitor/goggles/helmet. I create dynamic audiovisual spaces, which the audience relates to physically, and thus emotionally. This

is also an opportunity for several people to experience the installation at the same time. This is often not possible in most interactive installations, where only one person at a time gets a chance to relate to the work, while the others are waiting in line.

TIME

The body is the measuring rod for our experience of time. We cannot observe time in itself; we can only observe events and compare them. Time is defined through regularly repeated motion, like the ticking of a clock, the motion of the sun, or the neural firings in the brain that occur forty times a second.

We all encode our experience of time at different rates. A single moment from several months ago may consume our thoughts, yet a whole summer ten years ago may have completely vanished from our memory. We stretch and compress time until it suits our needs.

Most of our understanding of time is a metaphorical version of our understanding of motion in space. There is an area in our brain dedicated to the detection of motion, not time, so this could explain why time is often conceptualized through motion.

Concepts of time often relate to space: metaphoric time as locations in space (the future is ahead of us, the past behind us and the present is here).

In musical terms, extremely slow time can be experienced as static space, so space could be seen as a degree of time.

Timebandit is a continually developing series of computer video algorithms/installations/performances based on live input, dealing with different ways of presenting and transforming space over time, and time into space. It is a way of restructuring reality by breaking down time, by recombining spaces into new realities.

The first use of the *Timebandit* structure as an installation in a public space was in the Norwegian Autumn Exhibition (2000), as part of the group installation segment. A live feed from the camera pointed at the door of the space was captured, chopped up, transformed and projected onto a screen meeting the visitors. The next development in this project was for the Sommerfest 2001 exhibition at Podewil in Berlin, where the concept of capturing and transforming the live input was refined by working on different ways of combining the buffered material with the live feed. This stage of the project emphasized motion in the space of one mode, and in another focused on the static quality of the space where people moving in it became mere shadows. The final major installation was at Kunstnernes Hus, Oslo, in 2002, again as part of the Norwegian Autumn Exhibition. This version tried to incorporate the previous realizations into one work.

During work on a live performance with the 242.pilots at STEIM, Amsterdam in Fall

2001, I developed an algorithm that spatializes time by layering random parts of incoming video feed on top of the existing image, creating a continually changing collage that reflects different layers of time. I have also developed this concept for my live performances (one document of that is the video *Crossings*) and the installation *Storm*.

LIVE

One problem with the use of recorded footage in live video improvisation is that the audience loses part of the live nature of the performance. Many think the video is just playback, as there is no obvious link to the person sitting with the laptop and the output on the screen. It has never been the intention to direct too much attention onto myself as a performer on stage with 242.pilots or in solo work, because the focus should be on the audiovisual experience.

For me, the liveness exists in the situation itself: if you weren't there, you missed it, and subsequent documentation is merely a substitute. I like the idea of unstable media, meaning that a work only exists within a short time–space and among the people who are present. This gives the work a sort of fragility. Also, considering that the average attention span is getting shorter, live art has a clear advantage over the gallery. Here, the audience actually choose (and sometimes pay) to watch what you are making, so while you are performing, you have their attention. This is a privileged situation!

I brought my experience from live improvisation and the *Timebandit* project into my work with the dance company Kreutzerkompani, which I established with choreographer Richardsen in 2000. Eventually I found my work with dancers to be perfect times to use live action as raw material. No need for prerecorded footage. In previous Kreutzer productions, it was always a problem to balance the use of video in relation to the dancers. When using the dancers as live source material, focus shifts from the dancers and video as distinct elements to the idea of motion itself. The video is abstracting the movements of the dancers; it is not as important which element takes focus at any point, because our main interest is motion in space.

The great benefit of the Max environment (with its video objects) is that it treats video as a stream of information: There is no difference between working with recorded footage or with a live feed from a camera. They are both streams of images. This means I can do the same type of transformations in the live video as I would in my improvisation in general.

Our first experiment with live video was *Synk*, which premiered at the Ultima festival in Oslo 2002. It involved one dancer, Justin Bennett on sound and me on video.

The idea of *Synk* was that no prerecorded video or audio would be used; only material sampled during the performance was allowed.

We wanted to investigate live sources as raw material, to impose a structure on a live situation that allowed for unpredictable results. My setup allows me to sample the dancer's movements and create loops that then recombine with what the dancer is doing on stage. I also use several delay buffers, feedback systems and blend a stream of consecutive images into ghostlike images. The interplay between my program, the variations of the dancer and the action picked up by the camera creates a unique performance everytime, mainly influenced by the shape and look of the spaces in which we perform. These include everything from white gallery spaces to small blackboxes and big stages.

Real time expands the possibilities for responsive environments and responsive instruments, allowing for tighter bonds between intention and action, between mental space and physical space. Real time extends video as a medium of time, making video a medium of the extended now.

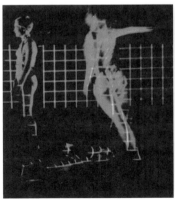 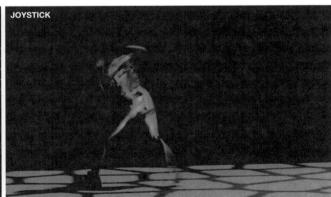

JOYSTICK

GET REAL SEMINAR. KIASMA. NOV 2004.

MORTEN SØNDERGAARD

A COMMANDO RAID INTO SOCIETY
MEDIA ART PRACTICE RECONSIDERED

A transdisciplinary mapping of competencies is taking place in the fields of art. The extension of art history´s field of work to include ... culture studies is... extended even further to encompass fields of work that had previously been reserved for areas of scholarship far removed from art — ranging from sociology to ecology [...] The redistribution of competence ... is precisely the progressive status of the contemporary avant-garde: [...] its protagonists attempt to undertake new comparisons and redistributions of competence, and to make the transition from the formal level to the level of practice [...] Extension of competence is the latest phase in the expansion of the concept of art. Art expands from the object to the practice and its practice expands from its field of work into new domains...[1]

Real time is a transdisciplinary issue. It is media art practice; it has a transaesthetic profile; it uses the temporal and duration as aesthetic material; and it is hybrid, performative and highly contingent.

This article is about real time as media art practice and its transaesthetic platforms. Founded in the connection of virtual and real spaces, the transaesthetic platform of real time constitutes a kind of kaleidoscope of new practices, through which the combination of art and (new) media may be studied and analyzed. To echo Peter Weibel: Real time as a transdisciplinary issue points towards new domains of art.

However, the transaesthetic platform of real time also has a history. It begins with

1 Peter Weibel, "New Protaginists and Alliances in 21st Century Art." In *Timeshift — The World in 25 Years*, ed. Gerfried Stocker & Christine Schöpf. Linz: Ars Electronica / Hatje Kantz, 2004.

Walter Benjamin, who has shown, in his essay about art in the age of technological reproduction, that new technology is an amplifier that intensifies and upscales the possibility of the way art uses time and space,[2] up to and including the current (post-McLuhan) debate, where real time is a new media issue specific to the computer and Internet technologies, as Lev Manovich points out:

[…] Thinking about new media … foregrounds the use of computers for fast algorithm execution, but ignores two other essential uses: Real time network communication and real time control. The abilities to interact with or control remotely located data in real time, to communicate with other human beings in real time, and control various technologies (sensors, motors, other computers) in real time constitute the very foundation of our information society […] real time networking and control seem to constitute qualitatively new phenomena.[3]

The concept of real time first enters our language because of the possibilities given to us by the (new) media — electronic communication and control. It is, on the first level, a concept created by new media and by the use of new media. Real time is the term for a conceptual framework created by the new possibilities that technology creates. Furthermore, through media consummation it becomes a phenomenon that we live by and understand in relation to our everyday life. On a second level, real time is a social praxis and has become an integral part of our conceptual understanding of society and community: You are on-line if you are part of something, off-line if you are not.

But there are even more levels: Real time as conceptual framework and as social praxis has entered the unconscious of human culture and expression, and from there it is changing the way we perceive and understand our world and ourselves in it:

The most fruitful thinking … came from artists who, far from giving up on their critical consciousness, worked on the basis of possibilities offered by new tools, but without representing them as techniques … we can say that art creates an awareness about production methods and human relationships produced by the technologies of its day, and that by shifting these, it makes them more visible, enabling us to see them right down to the consequences they have on day-to-day life.[4]

Before I continue with the discussion of real time as media art practice, I will take a brief look at the position of reality in western thinking, as exemplified by philosophers and artists.

2 Walter Benjamin, *Das Kunstwerk im Zeitalter seiner technischen Reproduzierbarkeit: drei Studien zur Kunstsoziologie* Frankfurt: Suhrkamp, 1962. pp. 56-58. For a discussion of this: Noël Carroll. *A Philosophy of Mass Art*. Oxford: Oxford University Press, 1998. pp. 114-171.
3 Lev Manovitch, "New Media from Borges to HTML." In *The New Media Reader*, ed. Noah Wardrip-Fruin and Nick Montfort. Cambridge, MA; London: The MIT Press, 2003.

4 Nicolas Bourriaud, *Relational Aesthetics*. Paris: Le presses du réel, 1998. p. 71.

A REAL RETURN

The discussion of "reality" opens up a philosophical debate as enduring as the history of western philosophy. To indicate the vast complexities involved, contemplate the following: Reality has been either favored as the door to all knowledge — even the knowledge we may never know (Aristotle) — or rejected completely (as shadows) in favor of pure ideas (Plato). It has been connected to God (Hume) or to Man (Locke/Descartes); to the intuition of the senses (the Empiricists) or to connected ideas (rationalists); to prior knowledge (Kant) or to history (Hegel, Nietzsche) (which might or might not bring progress to human culture); to existence (Kierkegaard) or to Faneroskopi (Peirce); to materialism (Marx) or to pure phenomena (Husserl); to structure (Jacobsen, Levi-Strauss) or episteme/power (Foucault); to cognition (Wittgenstein, Serres) or to difference (Derrida, Deleuze). Finally, the real(ity) has been seen as something entirely reproduced or mediated — an alternative to materialism creating new possibilities for human culture (McLuhan) — or as something disappearing into a virtual surface of signs (the thinkers of the late 20th century continental post-modernism (Lyotard, Baudrillard) or post-modern critical theory (Jameson)). And these are just a few of the existing positions on the status of "the real" and the human condition. There may be others and they may also be organized differently.

A POST-MODERN CONDITION?

Of course, much contemporary debate has already evaluated the issue of media art and real time as a post-modern condition. In "The Perspective of Real Time", Paul Virilio sees it as a case of the virtual space of real time (the media) taking over from what he calls "real space" or simply: The real. This — the "real" — Virilio envisions will be a hidden dimension in the future, polluted by the "reduction" that the media and the mediated bring:

… [T]here exists a hidden dimension to the communications revolution, one that affects duration, the lived time of our society […] A movement that is today intensifying due to remote control and long-distance telepresence technologies that will soon land us in the ultimate state of sedentariness where real time environmental control will take over from the development of the real space of the territory … causing confusion of near and far, of inside and outside, disorders in common perception that will gravely affect the way we think … volume is no longer the reality of things … The real is hidden in the reduction of the images on the screen […] The speed of the new optoelectronic and electroaccoustic milieu becomes the final void … dromospheric pollution is pollution that attacks the liveliness of the subject and the mobility of the object…[5]

5 Paul Virilio, "The Perspective of Real Time."
In: *Open Sky*. London: Verso 1997.

However, according to another post-modern thinker, and follower of "critical theory," Hal Foster, there is a need to invest a new critical/dialectic approach to the discussion of contemporary art. But he finds it difficult to foresee any possibility of a critical platform when it comes to the relation of technology/mass media and art.

With the sacrificed students in Beijing and the racial riots in Los Angeles, the murderous war in the Persian Gulf and the ethnic bloodbath in Bosnia [...] we have become wired to spectacular events. The wiring connects and disconnects us simultaneously, renders us both psychotechnologically immediate to events and geopolitically remote from them [...] A thrill of techno-mastery [...] but also a thrill of an imaginary dispersal of my own body, my own subjecthood.[6]

Foster uses the technological discussion as a means to show that there are limits to what we may accept, within a critical theoretical approach, as art. He juggles Walter Benjamin's dialectic of auratic/reproduced art and Marshal McLuhan's theory that technology creates an entirely new society where what is real is always networked and mediated. The post-modern condition, he says, is both the critique of the old seen through the lenses of the new, as well as the loss of distance between subject and object in what he calls a "wired" world. Foster wants to find a new platform for critical theory that may account for contemporary art and, by the same token, establish a safe distance from "techno-mastery." The goal is not to understand the practice of art that uses technologies, but to be able to "make value judgments that... are not only re-active but active..."[7] Foster wants to put history back in the driver's seat and take a look at post-modernism from below and beyond the mediated — from the perspective of something he calls "the real" (which perhaps — perhaps not — is the same "real" as Paul Virilio's).

6 Hal Foster, *The Return of the Real*. Cambridge, MA; London, England: The MIT Press, 1995. pp. 221-222.
7 Ibid., pp. 218-226.

The positions of Foster and Virilio are common today. They are important critical approaches and remind us that the use of (new) media/real time in culture and art is neither simple nor straightforward.

But I also find their approach too narrow — too deductive — with no real understanding of what media art practice is about. I find that the voices of artistic practitioners and thinkers that try to grasp the possibilities and consequences of real time are more rewarding. Contrary to Foster and Virilio, I would say that the speed of media and the confusion — the signs of hybridity and a transaesthetic field of art — are very interesting, maybe even promising, positions for art to be in. (New) media art practice is dramatically supplanting the "old" ideas of aesthetics and positioning art as something "inside" the circulation of everyday life.

This was already visible with Charles Baudelaire in the mid-nineteenth century, and many so-called modern or avant-garde artists in the twentieth century have battled with the hybridity of an increasingly technological field of art. The results have varied from a total productive pessimism (a good example is T.S. Eliot) on behalf of "modernity" to very important attempts to grasp reality as an endless complexity of simultaneous events and perspectives.

Paul Cézanne and, a little later, the Cubist experimenters found that you could never grasp reality-as-such since it would always be connected to other perspectives as real as the first, and a temporality that constantly changed the perspective of the perspective. So the truly modern artists were on the job! They tried to grasp the reality of the real, the complexity and temporality of "the existing."

TIMING TIME

Introducing time into the equation makes it even more complicated. Only the concept of time has arguably developed more dramatically in the industrial age. As Stephen Kern has shown, by the turn of the century the human concepts of time and space change dramatically in psychoanalysis, physics, philosophy and art.[8]

Real time is, from the very beginning, a mediated concept that develops within psychoanalysis, physics and art simultaneously. Thus, new ideas of time — subjective, subconscious, unconscious, relative, stalled, multiplicity — enter the concept of the real and in turn change it on several levels. Therefore, what is real is also timed and in time — in motion, processual, simultaneous and modern. Seen in this perspective, it is perhaps not surprising that the first real time experiences are sonic, sound-based, noises carried across the prairie in the USA by telegraph and later by "wireless" radio.

Artists have used sound and other "new" media expressions since the Futurists and the Dada-ists at the beginning of the twentieth century. And here temporality and

8 Stephen Kern, *The Culture of Time and Space, 1880-1918*. Cambridge, MA: Harvard University Press, 1983. pp.1-2.

simultaneity become integral parts of art. The complex and interconnected concept of reality, as well as the modern city as landscape of noises and coincidental meetings, becomes a context rather than a representation, as witnessed by Luigi Russolo:

… Let us cross a great modern capital with our ears more alert than our eyes, and we will get enjoyment from distinguishing the eddying of water, air and gas in metal pipes, the grumbling of noises that breathe and pulse with indisputable animality, the palpitation of valves, the coming and going of pistons, the howl of mechanical saws, the jolting of a tram on its rails, the cracking of whips, the flapping of curtains and flags. We enjoy creating mental orchestrations of the crashing down of metal shop blinds, slamming doors, the hubbub and shuffling of crowds, the variety of din, from stations, railways, iron foundries, spinning wheels, printing works, electric power stations and underground railways.[9]

Through "new" media, the concept of simultaneous reality events and complex, relative time experience becomes the "material" of art. At this point, and to point out that the ideas of a real time media-practice is not new, the vision of *The Electronic Revolution* by William Burroughs, first published in 1968, seems appropriate:

Imagine a pop festival… Festival area comprised of car park and camping area, a rock auditorium, a village with booths and cinema, a large wooded area. A number of tape recorders planted in the woods and the village. As many as possible so as to lay down a grid of sound over the whole festival. Recorders have tapes of prerecorded material, music, news, broadcasts, recordings from other festivals, etc. At all times some of the recorders are playing back and some are recording. The recorders recording the crowd and the other tape recorders that are playing back at varying distances. This cuts into the crowd who will be hearing their own voices back. Play back, wind back and record could be electronically controlled with varying intervals... We can carry it further with projection screens and video cameras. Some of the material is preprepared … and this material is cut in with live TV broadcasts and shots of the crowd. Of course, the rock festival will be cut in on the screens, thousands of fans' portable recorders recording, and playing back, the singer could direct play back und record. Set up an area for travelling performers, jugglers, animal acts, snake charmers, singers, musicians, and cut these acts in…[10]

The real time of artistic practice, and its transaesthetic platforms, is far removed from the dialectic and critical "action" that Hal Foster is looking for. But then again Foster is looking from within the tradition of reception theory — deducing relations from inter-

MORTEN SØNDERGAARD A COMMANDO RAID INTO SOCIETY

9 Luigi Russolo, *Manifest 1913: The art of noises.* Translated from the Italian with an introduction by Barclay Brown. New York: Pendragon Press, 1986. First published in Luigi Russolo, *Intonarumori.* Milano: Mailand, 1916.
10 William Burroughs, "Electronic Revolution", 1970-71. Quoted from *Word Virus — the William s. Burroughs Reader*, ed. James Grauerholz and Ira Silverberg. New York: Grove Press, 1998. p.299.

pretations of finished works of art. Instead, it is time to take a look at what the artists are doing; they are performing important "research" into the very nature of (new) media and real time *by practice*. Through practice, media art is creating its own new domains, platforms like the one Burroughs is imagining, operating in backstage reality spaces through real time and stored media action. Domains for new relations between art and its audience — the festival being a good metaphor for the intersubjective platform of both the reception and production of art:

As part of a "relationist" theory of art, intersubjectivity does not only represent the social setting for the reception of art, which is its "environment," its "field" (Bourdieu), but also becomes the quintessence of artistic practice.[11]

BACKSTAGE/ON STAGE/IN REAL TIME

Real time art practice belongs to both the virtual space (the abstract situ of social and human relations) and the real space (the concrete situ of the social and human relations). Any media art practice that produces hybrid art forms in real time always relate to both of these classic opposites, the virtual and the real, abstract and concrete, at the same time diminishing and accentuating the differences between them.

In this article I am investigating the strategies of media art practice and the new domains and transaesthetic platforms this practice creates, often by combining images, words, and sounds with (new) mass media technology. Contemporary media art practioners invade and/or investigate many different kinds of spaces — public, social, private, virtual, and conceptual. These practices signify something important within the framework of transaesthetics and are not just expressions of random choices made by the artists. They signify an urge to operate both on stage as well as with our *backstage reality spaces*.[12]

In fact, the hybrid art forms using real time all work in the backstage reality spaces of everyday life — constantly probing behind the norms of conventional aesthetic judgment. Since Kant founded the modern term of "aesthetic judgment" (which in Kant's terminology had nothing to do with art; art was beyond all that, beautiful at best), art has drifted further into the very field of "Urteilskraft,"[13] into the everyday cognitive practices of life. All through the twentieth century, art has tried to understand the changes in culture, knowledge and consciousness before these changes were conscious or even felt by the audience. The political and existential urges of art in the last century, even those of counterpolitical and counterexistential/post-modern art, are all expressions of one fundamental urge: to investigate, and understand, the cognitive framework of a fast-changing world. Early in the twentieth century, the Futurists were looking

11 Nicolas Bourriaud, op.cit, p.22.
12 Gilles Fauconnier, *Mental spaces: aspects of meaning constructions in natural language*. Cambridge, MA; London, England: The MIT Press, 1985.
13 Immanuel Kant, *Critique of Judgment*. Indianapolis: Hackett Publishing Company, 1987 [1790]. pp.141-144.

for ways to express these changes, and one of the things they found was "noise." This pointed towards a function of art that has not been dealt with adequately in music history, art history, or literary history: That media art practice transcends the categories and genres of art: It is transaesthetic.

However, the transaesthetic profile does not just serve as an excuse to cross or destroy categories and genres. It also emphasizes a new awareness among artists of producing works based on the media and materials at hand — or rather emphasizes making sense, making a difference in a culture where meaning and language are based more than ever on electronic media and international networks. Hence, media art practice is also transdisciplinary.

Richard Kreische perceives the transaesthetic profile of the art of new media — including sound art — as containing more than just another "formal" change of expression and media. As he sees it, our language about art is revised and our role as beholders and critics of art has changed. Widening the discussion of categories and conceptions includes the possibility of revising man's status as "a being of knowledge." We become aware of the fact that our language, the limits of our knowledge and ourselves are entities of change:

... A discussion of the "new media," i.e., the "electronic media," will have to include a discussion of the language of art and thus of our self-consciousness as well.[14]

The play with categories calls for a fundamental discussion of art's impact on human thinking and action in different political, social and cultural contexts:

Sound overwhelms its own limits, refracting across social space — it seeps through the cracks and disturbs another's sleep, violates demographic borders, spills over. In other words, sound interferes... In this way, sound is never a private affair; rather, it invades public space, occurs within a multiplicity, as a multiplicity.[15]

The changes of (new) media and its widening impact are not just limited to the arts, but also include the emerging structures of language and culture beyond the direct control of the artists. In this exposed position, what the artist is really looking for is a set of rules, emerging from the possibilities at hand, from which something can be created. This is not unlike field research or playing a new game:

All I did was what interested me: a kind of research or perhaps more of a game than research... I work a lot with chance and actually chance deserves the applause.[16]

MORTEN SØNDERGAARD A COMMANDO RAID INTO SOCIETY

14 Richard Kreische, "Artificial Intelligence in the Arts", 1985. In: *Media Art Interaction — The 1980s and 1990s in Germany*, ed. Rudolf Frieling and Dieter Daniels. Wien; New York: Springer Verlag, 2000. p. 200.
15 Brandon LaBelle, "Private Call — Public Speech: The site of language — the language of site". In: *Writing Aloud — The Sonics of Language*, ed. Brandon LaBelle and Christof Migone. New York: Errant Bodies Press & Ground Fault Recordings, 2001.

16 Daniel Pflumm, "In One eye and Out the Other." In: *Media Art Interaction — The 1980s and 1990s in Germany*, ed. Rudolf Frieling and Dieter Daniels. Wien; New York: Springer Verlag, 2000. p. 137.

Sound in particular seems to be the phenomenon expressing this transaesthetic exploration of the foundation of language and cultural consciousness in constant change. An exploration taking place in real time.

This can be seen as a part of a large-scale artistic project, where technology is being used as a means of exploring what is *between* the world and the human mind:

Projects embarked upon by today's artists have the same ambivalence as the techniques from which they are indirectly inspired. As writing in and with real and cinematic works, they do not claim to be reality, notwithstanding [...] The influence of technology on the art that is its contemporary is wielded within limits circumscribed by this latter between the real and the imaginary.[17]

This practice also points towards the total transformation of aesthetics which, as Frederic Jameson once saw it, is strongly connected to a social space — or, as he termed it, the space where *the political unconscious* becomes a platform for a new aesthetics:

In ... a society, saturated with messages and with "aesthetic" experiences of all kinds, the issues of an older philosophical aesthetics themselves need to be radically historicized, and can be expected to be transformed beyond recognition in the process.[18]

Furthermore, the transmission of sound and image, and the introduction of the immediacy of real time, is part of a major change in the relation between art and the world:

... The transmission of sound and image across spatial and — with the storage media — also across temporal distance appears to make possible that immediacy of relationship between event and recipient that was lost with the use of speech and writing. The sounds that emerges from the telephone sounds authentic thanks to its materiality [...] at least that is how it appears. In fact, however, they are too the product of mediation; they too undergo a typical, media-specific metamorphosis.[19]

REAL TIME PRACTICE

The Danish media artist Michael Kirkegaard is using this critical middle position of media art practice to open up the central issues of real time communication and control in a radical way. He uses three levels of technological real time in his installation *Observing the world in the rear mirror makes your head spin*. First, he has recorded himself reading, in real time, words and phrases taken from CNN and BBC news dur-

17 Nicolas Bourriaud, op.cit. p. 22
18 Frederic Jameson, *The Political Unconscious*. London: Routledge, 1983. p. 5.
19 Volker Straebel, "Between Musique Concrète and Intermedial Experience." In: *Hans Peter Kuhn — Klang aus Licht*. Heidelberg: Kehrer Verlag, 2000. p.10.

REESTABLISH
CLEAR
ROUTES
BOOBY
TRAPS

MICHAEL KIRKEGAARD
**OBSERVING THE WORLD IN THE REAR
MIRROR MAKES YOUR HEAD SPIN**

GET REAL. KIASMA. NOV 2004.

VALUE
CRITICAL
REAL
ACTION

MORTEN SØNDERGAARD A COMMANDO RAID INTO SOCIETY

ing the first Gulf War until his voice is worn down, becoming almost unbearably hoarse. Eventually, it is unable to perform any longer. Second, this recorded reading is played as it was recorded, in real time in front of an audience, which has to go through the same process of sound-decay with Michael. Third, live radio from the BBC News in real time is played simultaneously with the recorded reading. On a fourth and fifth level, then, there is a virtual as well as a social real time space that the audience experiences: The news from the first Gulf War is mixing with the news of today; these news items, when looked at through the rear mirror and compared, are relevant for the audience on a politically unconscious level. Conceptually, *Observing the world in the rear mirror…* is a backstage reality space put on stage in front of the audience. It targets the audience between their ears, activating their consciousness of the world and, perhaps, their critical position.

Another example of using sound as a real time tool to enter backstage reality-spaces is the work of Jacob Kirkegaard, who is participating with Thor Magnusson in Get Real. In one of Jacob Kirkegaard's earlier works, *Pause* from 2000, we pass from the everyday sounds of a coffee machine (and the conceptual space of kitchen/morning or stressed out working situation where coffee really is the only chance to revive your brain cells) to a new reality space where you get the impression of snorkelling though the electrons of an inner "secret" circuit of life. What is going on lies far beyond the function (coffeemaking) of the coffee machine, far beyond the intuitive understanding of any coffee, at least that I have ever tasted. Kirkegaard refurnishes our everyday conception of a coffee machine by using well-known sounds (and their repetition) as models. These models are repeated (sampled and looped) in such a way — using a rhythmic pattern — that they are mapped onto the listeners. The minimal is mapped onto the universal, the "machine" onto "life," "digits" on java (the real java, not the software). A connection between the conscious and the subconscious, between the functional and the mystical, is created. In this sense, the work by Kirkegaard stages a new domain — a construction — that undermines our everyday dualisms.

A COMMANDO RAID INTO NOTHINGNESS AND OUT INTO SOCIETY

To sum up, real time could be described as an interface of practices, a connection between the virtual and the real world. As media art practice, it is reinvestigating the relation between everyday languages and reality, and between the political unconscious and the backstage reality spaces.

The real time artists are the practitioners of this relation. What we need now, it seems to me, is critical thinking about the practice of media art. At the end of this article, I would like to refer to the Danish poet and media artist Per Højholt (1928-2004).[20]

20 Per Højholt has published two very important "theoretical" books about his own media art practice: *Cézannes metode (The Method of Cézanne)* 1967 and *Intethedens grimasser (The Grimaces of Nothingness)* 1972. Both have only been published in Danish. English titles, like all quotations in this article, are my translations.

After 1967 his artistic production and his poetic work are media art practice founded in a search for new domains of art after the dissolution of genres:

The road towards hybrid art forms does not move through unselfish and optimistic collaborations, but finds that which art has always put up as a condition for a work of art: The striving for a temperament. The work of art is a result of some kind of dominance... But even with this as a precondition, no hybrid artwork could become valid communication as long as it relates to the norms that the criteria of a genre create... The creation of hybrid art forms preconditions the dissolution of genres.[21]

In the media art practice "awareness of media/a media sensibility is essential,"[22] and one of the things that hybrid art production creates is the possibility of a new artistic language and a break with old aesthetic "norms":

Being an artist is characterized by ... the ability to create the conditions for a use of language, utilizing these conditions and destroying them with and by his/her work of art. Art is practice, suddenly something can be done, and when everything is done, then art is abolished... Because practice will not then be possible and the norms will not be accessible anymore. Then the hour of truth has come and we all die difference-less.[23]

He warns, that:

The danger with ... any aesthetics, including the one I am trying to explain here, is that it can never be used in a "pure" form; that aesthetics as a method involves its user and is colored by him/her and by the society from which it has emerged, as well as by the experience of the society that the user of the aesthetics has, consciously or unconsciously. Therefore, the user has to explore the validity of the method in the same process as it is used, criticizing it and by trying to break it down, even though it may seem to be the most adequate solution at the time.[24]

One important criterion of any media art practice, then, is that it targets a public:

[The purpose is] to draw the public into a production of meaning from premises that it has not chosen, therefore giving the public the possibility to ... experience existence as a poised, problematic, responsible and continuous production of meaning.[25]

21 Per Højholt, *The method of Cézanne* (*Cézannes metode*. Schønberg, 1967). p. 76.
22 Per Højholt, *The Grimaces of Nothingness* (*Intethedens grimasser*. Schønberg, 1972). p. 91.
23 Ibid., p. 91.
24 Ibid., p. 135.
25 Ibid., p. 140.

PER HØJHOLT
STOCKCAR
(STILL FROM TV FILM, 1973)

He discusses art practice as something being part of an aesthetic strategy, which should neutralize the prejudices of the public:

Aesthetics is strategy, a practice that if used on something is developed in concordance with practice and not decided from the prejudices and wishes of the receiver...[26]

But it is not enough to have a strategy of aesthetics; according to Højholt, you have to have a *strategy of aesthetic strategies*, which means that media art is actively exploring the relation between art and reality instead of representing it:

When a strategy of strategies can be maintained ... then it is because the relation between language and reality has changed [...]: Whereas language was utilized to describe reality, it is now used in an exploration of reality.[27]

What is being produced is the ability of exploring real time relations. Time and timing form the matrix of Per Højholt's exploration of reality. It is an emptying of the conventional ideas of aesthetics, of any referential function of art to reality. Per Højholt called it a commando raid into nothingness or out into society:

Instead of making the text into a mask of nothingness, it could be made into a grimace; which means that you follow the mask with words, so to speak. One could accomplish that, instead of making texts that empty themselves into nothingness ... you follow this emptying with words. A kind of commando raid into nothingness, or out — into society, as some would choose to call it.[28]

26 Ibid., p. 123.
27 Ibid., p. 138.
28 Ibid., p. 133.

Real time art practice is both a commando raid into nothingness and society. It is a transdisciplinary platform being established with new norms and formalisms coming into being. But it is also a new way of grasping the "role" of art in society as something creating and investigating real human relations rather than representing them.

SOCIETY /
NOTHINGNESS /

STEINA VASULKA

MY LOVE AFFAIR WITH ART

VIDEO AND INSTALLATION WORK

My love affair with art was all-consuming from the time I was eight or nine years old un-til my late teens. I lived by it. I went to every concert, play, opera and exhibition I could. Nothing else in life made any sense to me. I never chose to be an artist. I just knew I would not work in a bank or wait on tables. I loved playing my violin, but when faced with the prospect of being a professional musician, I realized I had made a dreadful mistake. I found myself in New York in the mid-1960s going from gig to gig, wondering if there was not more to life than a black dress and meager fees.

DISCOVERING VIDEO

I met Woody Vasulka in the early 1960s in Prague where I was studying music, and by the mid-1960s we had moved to New York. Woody was a filmmaker, and through his film contacts he came across video in 1969. Both of our lives were changed forever.

Woody introduced me to his new discovery — and what a rush! It was like falling in love; I never looked back. As soon as I had a video camera in my hand, as soon as I had that majestic flow of time in my control I knew I had found my medium.

We already owned a two-track audiotape recorder, which allowed delays and speed changes. We immediately proceeded to process and manipulate videotape us-ing the same principles we had applied to audiotape. During the same period we were

taking portable video equipment to New York's cultural playgrounds: the WBAI Free Music Store, Judson Church, La Mama, Automation House, the Village Vanguard, Fillmore East, Blue Dom, Kansas City Steakhouse, etc.

After those outings, everyone would gather in our loft to look at the instant playback, something that most people at that time had never experienced before. Even the word "video" was a brand-new addition to the vocabulary. By 1971, there was so much traffic in our loft that, when a friend told us he had found a large space in an abandoned kitchen in the old Broadway Central Hotel, we were ready. The space was intended to serve the artists, not the audience. We named it *The Kitchen* — LATL (Live Audience Test Laboratory).

ENVIRONMENTS

In the early days of video, everything was an installation or an "environment," as we used to call it. In the first generation of 1/2-inch reel-to-reel video, there was no provision for editing. The solution was to cut and glue, as was done with audiotape. Our environments, therefore, consisted of either "live" camera or "live" ABSTRACT switching of tapes. Woody and I preferred to use multiple screens — typically, a stack of monitors and several players.

One of our first installations involved the horizontal drifting of images from one monitor to the next. After we started *The Kitchen*, we had plenty of opportunities to create environments and live video performances. Later, when electronic editing became technically feasible, everyone became infatuated with editing. Installation work disappeared for a while, to be reinvented later by the art world.

In the 1970s, I did a series of environments entitled *Machine Vision*, the first variation of which was called *Allvision*. (FIG. 1)

In the first variation, two video cameras on a motorized turntable were combined with two mirrored half-spheres and two monitors, emphasizing a camera view that moves beyond the restrictions of the human all-seeing eye, all-encompassing vision.

For *Allvision*, I put a bar across a turntable and mounted two video cameras back to back at the center, pointing out at two small mirrored half-spheres placed at each end of the bar. Each camera viewed 180° of the space and displayed the results on four pairs of monitors placed in the corners of the room. As the table slowly turned, the cameras captured the entire room, including viewers, monitors and the turning machinery itself. In a later version, I put a large sphere in the middle of the turntable with the cameras at each end pointing in. Another *Machine Vision* variation made use of a motorized moving mirror placed in front of a camera. Depending on the horizontal or vertical positioning of the mirror, the video monitor would display a continuous back-

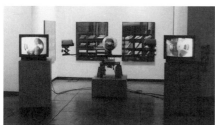

FIG. 1: **MACHINE VISION**
Series of video installations, 1976.
PHOTO: Kevin Noble

and-forth pan or up-and-down tilt of the room. A third variation implemented a continuous rotation of the image via a turning prism, while still another involved a zoom lens in constant motion, zooming in and out. These automatic movements simulated all possible camera movements without making the camera and its operator the center of the universe. Time and motion became the universe, with endless repetitive cycles and orbits.

I was a latecomer to this infatuation with machines, but I vividly remember, after moving to New York, going to Canal Street and looking at gears and motors as kinds of miracles that resembled life itself — mechanistic replications of the biological mystery. I love gizmos such as the ones I find in surplus yards that can be refitted to serve my purposes. If I had a lot of money I would spend it on optical gadgets, mechanical toys and state-of-the-art electronics. I would make gigantic environments, such as monitors embedded in the floor from wall to wall, all showing imagery moving in either the same or a contrapuntal direction. Or I would build a four-sided corridor in which viewers could look down a long lane of images that keep moving toward and past them. In reality, though, I am very flexible about the size of the display, since to me, the size of an installation is not determined by the number of monitors, but rather by the complexity of the composition. I therefore often improvise on how to configure an installation based on what is available at an exhibition site. For example, for my favorite installation of *Geomania* (1986), I stacked the monitors into a pyramid. (FIG. 2)

I always intend these environments to be experienced in a quiet, dark place. A museum is potentially a good exhibition venue, but museum staff always seem interested in placing video installations in a location that maximizes visibility. They tell me triumphantly, "We are going to give you the lobby." It is always assumed that video ought to be loud and public, but I want it to be quiet and private: a thousand monitors and one viewer, not the other way around. I want the viewers to be so absorbed by the work that they experience another level of consciousness. I expect them to share the kind of feelings I have for the material and, to my amazement, they sometimes do. An old man who had watched *Tokyo Four* (1991) (FIG. 3) over and over explained to me that this installation was all about death. At that moment I knew that he had really seen it, even though it is not all about death.

Borealis (1993) (FIG. 4) uses two video projectors that transmit through a split beam mirror onto four translucent screens. ("Translucent" means that the image appears with equal intensity on both sides of the screen.) Upon entering the room, the viewer can watch the work from a distance and see all four screens at once, or walk directly up to and around one screen, a much more intense experience. The images are mostly of rivers, oceans, steam and sprays.

SUBJECTS

The aspect of the creation process I like most is the initial recording. Sleet or snow or howling rain, I love that part, especially if I am alone out in nature. In New Mexico where I live, my images are rivers, mountains and arroyos, but when I found myself in the metropolis of Tokyo, the people became my material. The Japanese have a social protocol that, for them, is a daily routine, but to a Westerner looks like fabulous theater — the way they bow, the way they make certain signals. For example, when the Japanese want to cut through a crowd in a hurry, they put their hands forward in a chopping gesture and a magical corridor appears in the ocean of humanity. They have hand signals for "yes" and "maybe" (although "maybe" usually means the unutterable "no"). They seem to wear invisible armor, a "no-man's land" around their bodies. Elevator girls in a perpetual state of performance, train conductors, taxi drivers in their white gloves and Shinto priests ritualistically pruning their arenas are all elements of *Tokyo Four*.

Between taping and editing, there is usually an intermediary step during which I alter and mix the images, change color or run things upside down or backwards. This is where the particular uniqueness of working with the electronic image comes into play. It is somewhat akin to photographic darkroom techniques, but it actually reminds me of playing an instrument. I change style, timber, dynamics and key in an improvisational and spontaneous way.

FIG. 2: **GEOMANIA**

FIG. 3: **TOKYO FOUR**

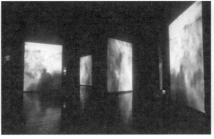

FIG. 4: **BOREALIS**

MUSICAL TECHNIQUES

In my multichannel video compositions, I often make a master image of a certain dura-tion, which I duplicate as tape #2, tape #3, etc. I then drop different but complementary images onto the copies, and a phenomenon similar to musical composition occurs. Starting with a melody or theme, I add harmonic lines and discover that the melody is far less interesting than the counterpoint. Sometimes there is an emergent melodic structure that weaves through the instruments or (in my case) the video screens.

Late twentieth-century art is fast — too fast for me. But I realize that I am out of sync with the mainstream, which wants things fast. Multichannel compositions liberate me from this concern with speed, since they rely on different time principles and are more like music.

TEACHING

I do not like teaching, just as I did not like going to school. It is an absurd theater, the teacher supposedly all-knowing and the students posing as eager minds waiting for illumination. So when I do teach, I go through the theory and the techniques — video is rather complex technically — and explain frequencies, voltages and the timing structure of the signal. I discuss history, show a lot of tapes — mine and those of colleagues — and discuss them with the students. Then I ask them if they believe in UFOs (unidentified flying objects), at which point the whole class gets very uneasy. Half of them say they do, half say they do not.

The class sessions that the students seem to appreciate most are the ones in which I present "the world according to Steina." We discuss the way the galleries monopolize the art scene and make the artists kiss ass. I always tell them that they do not have to kiss ass, and they seem greatly relieved, almost as though they did not know this. I remember once overhearing a student say, "But we have to do this kind of conceptual/intellectual work because this is that kind of school." I turned around and said, "NO YOU DON'T." And the whole class laughed because they realized that they really don't. I tell them that it is every artist's duty to be disobedient. We discuss what it means to be mainstream and have a comfortable life, and how deciding to be an artist basically means deciding to live a materially unstable, but more rewarding, life. They discuss this for a while — not that they have not already thought about it a lot, but they get lonely and confused. So I reassure them that there is no grander life than the creative, artistic life. It is the unknown, the exploration, and the fact of being your own person on your own time.

After I ask my students about UFOs (and some of them say they do believe and others say they do not), I tell them we are not going to talk about UFOs anyway but about how we must stick to our beliefs. I tell them that if they believe in UFOs, they should raise their hands whether the other half of the class sneers or not. The discussion turns to intimidation and lying about one's beliefs just to get along. It is emotionally stressful to admit to having an independent mind. One does not have to be an artist to experience this dilemma, but I believe it is the artist's duty to stay on the fringe.

CREATIVITY AND COMMUNICATION

The creative process, for me, is a tremendous pleasure even when it is painful, such as when I feel inadequate to the task. People perceive this pleasure in my work and often object, "But you are just playing!" This comment gives me tremendous pleasure!

The motivation to make art seems to come from a deep desire to communicate; for some artists, it comes from a desire to communicate on a massive scale — something

that does not particularly interest me. I see no qualitative difference in more people versus one person if I am communicating. Our whole existence seems to be about communication. It cuts through cultures, languages and continents. It also cuts through time. We spend so much time with people we have never met, often with people who are long dead. But the primary motivation for all art is the desire to communicate with oneself. This is a spiritual idea. It has been the sad lot of many artists to communicate only to future audiences, but, through lucky coincidences, artists and their audiences have sometimes found each other in the same place at the same time. Paris in the 1920s was like that. New York in the late 1960s was like that for us. It was a luxury.

REFERENCES

Boyle, Deirdre: *Video Classics: A Guide to Video Art and Documentary Tapes* (Phoenix, AZ: Oryx Press, 1986).

Cathcart, Linda, ed. Vasulka, Steina: *Machine Vision Woody: Descriptions* (Buffalo, NY. Albright-Knox Gallery, 1978).

Clancy, Patrick, ed.: *Video as Attitude* (Albuquerque, NM: Univ. Art Museum, 1983).

Dietrich, Frank: "The Computer: A Tool for Thought-Experiments," in *Leonardo* 20, No. 4 (1987).

Furlong, Lucinda: "Notes toward a History of Image Processed Video," in *Artjournal* (Fall 1985).

Gill, Johanna: *Video: State of the Art* (New York: Rockefeller Foundation, 1976) .

Huffman, Kathy Rae, ed.: *Video: A Retrospective* (Long Beach, CA: Long Beach Museum of Art, 1984).

Pritikin, Renny: *Video Installed* (San Francisco: New Langton Arts, 1986).

Schneider, Ira; and Korot, Beryl, eds., *Video Art: An Anthology* (New York: Harcourt Brace Jovanovich, 1976).

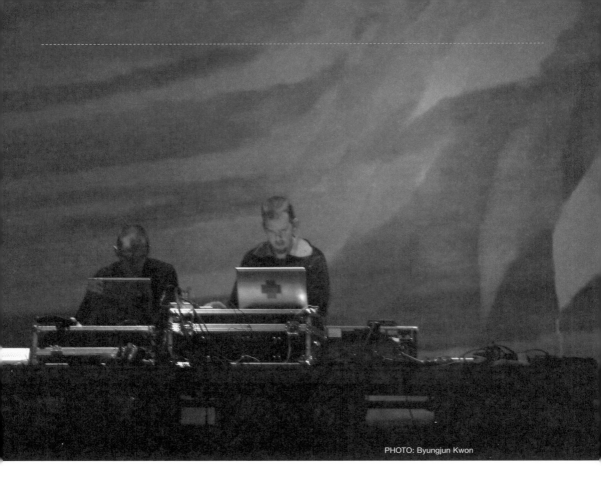

PHOTO: Byungjun Kwon

PINK TWINS

UNSTABLE RHYTHM

Pink Twins started in 1997 with a series of recording experiments. We recorded various examples of sound and then treated and processed them. We thought of a plan or a concept and executed it.

The employment of real time techniques was an important step. We listened to the sounds, reacted to them and used sound processing tools as they happened — basically live playing and improvisation. What made the difference was thinking of music as a series of active events taking place and developing in time instead of planned, pre-fixed, preprogrammed sequences.

This change in viewpoint naturally led to doing live performances. When playing live, we exit the controlled studio surroundings and go into a situation where the nature of the event, size and acoustics of the space, the sound system and the audience directly influence the performance. Often the influence and our reaction is something unexpected. When we play in a concert hall, an art museum, a rock club or outdoors, clashes with the audience's expectations are inevitable and fruitful.

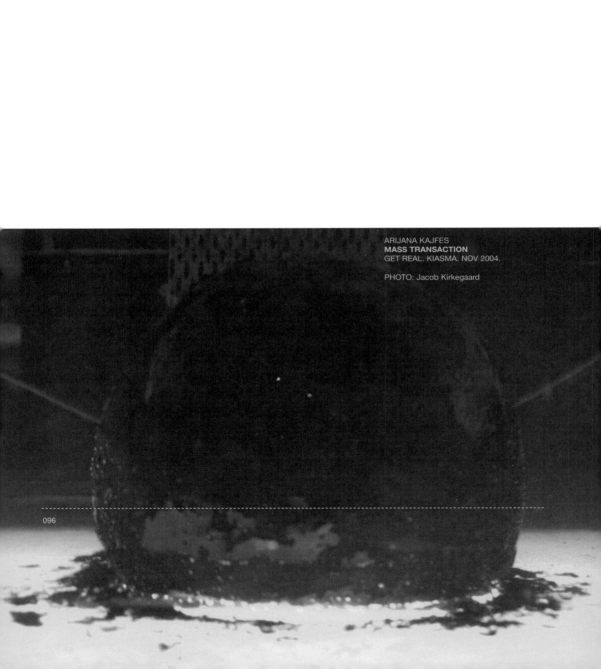

ARIJANA KAJFES
MASS TRANSACTION
GET REAL. KIASMA. NOV 2004.

PHOTO: Jacob Kirkegaard

ARIJANA KAJFES

MASS TRANSACTION

In 1988 I took one thousand Swedish kroner (SEK) out of circulation and melted them back to their base materials, copper and nickel. This was the exact amount of capital I received from a cultural foundation to support my creation of a piece of art. Therefore, this was a direct translation of capital into art.

WHAT IS THE RELATIONSHIP BETWEEN CAPITAL AND ART?
CAN ONE TRANSFORM CAPITAL INTO ART AND VICE VERSA?
WHAT IS LOST AND WHAT IS GAINED IN THE TRANSFORMATION?
WHAT IS VALUE?
WHAT IS THE POWER OF EXCHANGE?
WHAT IS MATERIALITY?
WHAT IS DEATH?

In 1993 I completed a reconstruction project about the one thousand SEK, called *To All Kings Adrift*. It consisted of one thousand gold boxes containing documentation of the significance of capital; one uncirculated SEK was placed in each box. Each box was valued to one thousand SEK or their equivalent in goods.

In 1998 I put the lump of metal back into circulation through electrolysis, releasing the copper and nickel particles from the lump. This took place in an exhibition at the World Trade Center in Stockholm during a five-day period. This action was repeated at the Kiasma Museum in Finland in 2004 during a three-month period and will be repeated until the lump is gone.

1. BEEOFF. **ATARASHI YUME.** 2002.
2. 1-3: BEEOFF. **ATARASHI YUME.** 2002.
2. 4: BEEOFF. **PSEUDOPHOBIA 1.1 & 1.2.** 2001.
3. 1: NORDIC DUMPLINGS. **FACE MANDALA.** 2004.
3. 2: PALLE TORSSON. **TEXT VOYEUR.** 2002.
3. 3: ELIN WIKSTRÖM. **WHAT DOES THE NUMBER SAY?** 2001.
4. 4: HELENA LOPAC + MAGNUS BUNNSKOG. **KITCHEN.** 2000.

5. 1: UNKNOWN PIECE BROADCASTED 2000.
5. 2: HELENA LOPAC AND MARTIN THULIN. **SPIEL.** 2002.
5. 3: LOVE NORDBERG. **THE MTV.** 2002.
5. 4: BEEOFF. **PSEUDOPHOBIA 2.** 2002
6. 1-3: BEEOFF. **INFLICT.** 2004.
6. 4: JACOB KIRKEGAARD + ELLEN RÖED. **YES/NO.** 2003.

BJÖRN NORBERG

IT'S REAL AND IT'S ALIVE

In my work as curator at nonTVTVstation*, I often have to explain and defend the focus on real time. In the years since we started nonTVTVstation, this exposed position has compelled me to consult history for arguments and to involve myself in contemporary discussions. I also felt obliged to look for theories to support my arguments. What was natural and obvious in the beginning, and a gut feeling of mine about methodology, has revealed itself as a complex discourse, which is rooted in an important, and never-ending, discussion about the connection between art and reality.

This construction of theories has often started far away from the art scene. Science, for example, offers theoretical discussions that could be transformed into art theory. I like the complexity of subatomics, where it seems necessary to take a whole system into consideration to get as close as possible to an answer. A more reductionist form of thought might get an easier and quicker answer, but then a number of para-meters would have to be cut away. This, of course, affects the interpretation of the experiment. I prefer the fragility of the complex system where conditions and inter-pretations are always changing. As I see it, there is an important similarity between the relationship of the piece and the spectator, and that of the scientist/subatomic physi-cist and the particles s/he wants to observe. This is also important for my reflections on real time.

It is not a very radical opinion that the meaning of the piece of art changes as a result of the context; that it changes from time to time, from site to site and from spec-

* nonTVTVstation is part of the Internet gallery Splintermind, located in Stockholm, Sweden.

tator to spectator. The situation and the moment together seem to form the experience, the interpretation of the work of art. Everything can be questioned and everything seems to be relative and dynamic.

In many ways the subatomic physicist is a spectator. In subatomic physics there are no small static bricks that build up the material. The particles are dynamic, always moving, and it is hard to observe them since they cannot really be pinpointed. Rather, they tend to appear at certain positions at a certain time.

Together, the particles build up a dynamic ever-changing web of enormous complexity — what we experience as mass. If a scientist would like to observe the particles, s/he can use an accelerator to isolate one. The trouble is that now the particle is transferred to a new context and the circumstances of the experiment affect the particle. The equipment used and even the presence of the scientist affect the behavior of the particle. This is exactly the problem with (and also the strength of) art — the meaning and the experience of art seem to change from context to context, from spectator to spectator. For the scientist, it is more complicated.

My interpretation and understanding of art, and real time art, very much depend on these thoughts. The relationship between context, work of art, spectator and artist forms a dynamic web of meaning. They are all particles in a web. A change in one of the parameters affects all the others in a very complex way. Here, real time appears to be helping art. Where everything else seems to be relative, real time offers a truth. It is part nature, and reality is used as an input, an integrated part of the art, and there is no need for reductionalism. It is understandable but still very complex and it teases you. Real time art exists for the moment and at the moment and then disappears. It reminds me of the dynamic particle. It exists, but it is impossible to grasp.

Of course, this way of confronting art also plays an important part in my role as curator at Splintermind and nonTVTVstation. In this essay, I will use a number of pieces produced for nonTVTVstation to point out different ways of working with real time. At the same time, I will try to discuss what the use of real time can mean to works of art.

All artists who have participated in projects at nonTVTVstation have been given the same working frame: they are asked to produce a piece of art, which is meant for/conceptualized for a real time video stream. They are asked to produce the stream in real time for real time distribution 24 hours a day for a period of one month. The piece of art reaches its audience while it is being produced. From the very beginning this condition seemed to be hard for the artist to cope with, and the working frame was often misunderstood. In the end the frame always turned out to be a strength.

A couple of years ago it was still hard for me to describe our work in a historical context. It has taken us some years, but now we are much more aware of the tradition in which we are working. In the beginning of nonTVTVstation we always mentioned

Nam June Paik, and Andy Warhol — his *Sleep* and *Eat* are important influences. But we did not know how much we were in line with their "tradition." Again, it was more of a gut feeling than real knowledge. What from the beginning seemed to be a question of time, process and non-objecthood has evolved into questions of what truth is and what is real. We are still in the middle of a period of research into a historical and theoretical understanding of the form we have created.

Recently, I noticed that people have stopped asking us what we mean by the term "real time." There is no need to defend the focus on real time anymore. Instead, we are asked what our perspective on real time is. The term is also more widely known today. For example, in 2003 a Swedish telecom company marketed their new video mobile telephones on big screens, saying they worked with real time video over the phone. And the other day I saw a music journalist using it in reportage from a live concert by a pop group. In art, too, the term is used now and then, but a year ago no one spoke of it. Another example is the exhibition *Zone de Confluences* at the festival La Numerique at La Villette in Paris in autumn 2004. Here real time was often used in the catalog describing the pieces.[1]

It seems that we at nonTVTVstation have become a part of a collective consensus concerning the meaning of real time and the meaning of a new form of art. For me, it is interesting to try to find out where the attraction in working with real time lies.

Art gives an opportunity and a way to both create and describe reality. Throughout history, artists have developed different methods to describe reality. Sometimes, they depicted nature like a human camera; sometimes they looked for an inner reality and focused on subjective expression while seeking truth. All of them confronted the major problem with the visual image: no matter how "realistic" a picture is, it is always an abstraction on some level. Some artists perceived the consequences of this truth and started to create *l'art pour l'art*.[2]

Now, this might be a very modernistic description, but a useful one. Real time is an increasingly widely used concept, and real time has become part of our daily lives. Big companies have sensors giving them real time reports on production inside the company; these replace monthly and weekly reports. In hospitals you can have real time reports about your body's condition; sensors send out real time reports of vibration, temperature, motion etc. These sensors can, for example, be attached to buildings to give exact reports on the conditions and need for restoration.

One explanation of this interest in real time on the part of society is the development of new technology that offers new possibilities. But technology doesn't emerge alone. Theory and philosophy are often part of changes in technology. The development of ideas and technology seem to go hand-in-hand. I believe that the use of real time involves both an idea of control and a need for control. The post-modern era has

1 In the catalog, real time is used to describe several of the works within the Zone de Confluences exhibition, for example *Carnivore* by the Radical Software Group, QQQ by Tom Betts, *Four Stories With a Twist* by Maviej Wisniewski and *Trauma 2.0 (version 2.0)* by Paul Johnson. This is just a recent example; there are numbers of works that can be described as being real time.

2 Here a number of modernistic masters could be mentioned, from Malevitj to Donald Judd. There are also obvious steps against "l'art pour l'art" in earlier painting, as in van Gogh's paintings, where the paint is given a certain integrity and intrinsic value seperate from nature and reality.

brought us insecurity. Every situation gives us new possibilities; there are no definite truths and even time has become relative. The only truth left is the now, the present. This new interest in truth may also be seen in the sudden interest in documentary films. In Germany, a studio is producing a cop show for television; it is fiction but played, recorded and distributed in real time, just to "get a certain nerve in it."[3]

For art, this signifies something really important. A new dimension is brought to art. Film and video gave us time, but performance and video feedbacks give us real time. Art gave us a sense of reality and a sort of life. Art started to live, to become a living thing, and took on different layers of unpredictability. Art became a process, and when real time was taken away from it, by taping it or stopping the process in some way, it died.

One good example is the piece *What if I was a rat?* by Ilona Huss Walin. When Huss Walin and I started to discuss the piece, long before the actual production, she didn't know what her project was going to look like. The working frame at nonTVTVstation — a one-month period of real time — seemed very hard for her to work with. We had a long correspondence about it. She took it very seriously, and she really wanted to understand the format. I guess this is due to her background as a conceptual performance artist. She really enjoyed investigating the concept and wanted to make something specific out of it. Then she came up with the idea of working with rats, and she started to build a model of a human apartment where the rat was supposed to live for the entire month.

The model itself was magnificently detailed, containing everything that you would find in a "human" apartment. Huss Walin scanned her own bookshelf down to rat scale and included every title. She even installed a real, micro-sized television set and a kitchen sink with running water! Eight security cameras were placed inside the model and captured every movement that the rats made throughout the month. It was all broadcast in real time on nonTVTVstation.

But something else happened when the cameras started their registration. The sense of scale became diffuse. The model in its perfection looked like a full-scale apartment (in IKEA-style) and the rats looked 2 metres tall! The result was surreal. For some people it was a nightmare and for others a fantastic fantasy. The model was placed in the Splintermind studio and my colleague Olle Huge picked the rats up now and then to give them some exercise and a change of scene.

A few months after Huss Walin's real time project was finished, the National Museum in Stockholm wanted to exhibit documentation of *What if I was a rat?* In the context of art works depicting animals. I went to the exhibition, which contained rows of oil paintings of dogs, cats, lions and horses and also Huss Walin's piece. Here I experienced something very special. The original nerve was missing since the real time

3 Interwiew, Dagens Nyheter, Stockholm, 26 October 2004.

element was gone; in my opinion, it was as dead as the paintings. It was still a very fine piece, but what I felt was essential to the piece was gone. This was a very important experience.

Huss Walin's piece mixes reality and dream. The "nature" of the animal is contrasted with the "human" lodging. There are similarities here to several other works shown on nonTVTVstation. One example is *Simulated Social Model no 2* by Peter Hagdahl. In a number of works, he connects virtual and analog reality. The spectators trigger digital images in different ways when walking in the gallery space. In *Simulated Social Model no 2* Hagdahl uses Internet transmissions, which intensifies the theoretical approach. A camera was hidden somewhere in central Stockholm to register traffic motion and people passing by. The information was sent to a computer showing a 3D-animation, which in the beginning was static. As the computer received the transmission, the animations started to move. The act of people driving or passing by was mirrored by the animation. As the title indicates, Hagdahl sees this piece as a model for how technology works in society.

Every day we create loads of digital data. In the supermarket, for instance, a computer registers everything you buy, and if you use your credit card a data transaction is made at your bank. This happens without us even noticing it. A virtual profile of your everyday activities is created. Hagdahl describes it as similar to a Freudian situation, where the virtual profile practically functions as your unconscious self. Since people in the streets do not know that they are being observed or are taking part in a work of art, this piece gains a certain twist. All individuals seem to act like particles in a web. They avoid each other when walking so they will not bump into each other. They build up relations to each other and Hagdahl's piece creates an image of that dynamic web. This sharpens the idea of how art functions as a model for our concept of reality. Art uses reality to depict reality.

In this way, working with real time also implies working with documentation. One example is *Text Voyeur* by Palle Torsson. He uses a function in the search engine of the filesharing program Lime Wire where the key words were screened in real time. *Text Voyeur* is comparable to a ready made program. The key words running over the computer screen are shown while it is logged in on Lime Wire. It depicts what people are looking for on the Internet at the moment. For Palle Torsson, Text Voyeur describes human desires. It functions as a real time poem with wishes created by a great dynamic between elitist culture and pornography. Also, the content changes according to seasonal events in society. For instance, when *Spiderman* premiered in Swedish cinemas, the number of words connected to the film increased visibly. It created a temporal profile of the whole society.

As already mentioned, the long period of production and sending time — one

month — is perhaps the hardest task for the artist. This is especially the case when the artist puts him/herself in front of the camera for the entire month. Two Swedish artists have been working with long duration performances on the nonTVTVstation: Elin Wikström in her piece *What does the number say?* and Nils Edvardsson in *Sperm Phase Detector*. Here time becomes very visible and puts inhuman demands on the artist. Elin Wikström counted money for almost two months in her apartment in Gothenburg as a part of the exhibition *Money* at the cultural center in Stockholm. She counted the money, 100 Swedish kroner bills, on a tight schedule. She left small notes when she rested, ate or slept to indicate how far along she was with the counting.

Edvardsson built a machine that detects the motions of spermatozoa in liquid and transforms these motions into a thin fuzzy buzz. After about two days, the spermatozoa died and so did the sound; Edvardsson replaced them. This interval required his presence in the studio every other day. The monotony and repeated action became an important tool for both artists. They shared an almost obsessive focus on time and duration.

What I find interesting in the case of both Wikström and Edvardsson is that their pieces so obviously belong in the performance tradition. This, I think, is the beauty of the use of the concept of real time as an art term: It combines both new and old media. It is the content and not the technique that creates the discussion and the content. Generally, I think that all the real time works of art belong to the performance tradition.[4]

However, there is a great difference in the working methods of Wikström and Edvardsson. Wikström is active all the time the piece is on. She is always at the center of the process, driving it and acting it. Edvardsson initiated the process every other day, and then he left to let it live (and die) on its own. I am sure that Edvardsson himself would disagree since he saw himself as being very visible throughout the whole piece. Asked if he needed a stand-in, he quickly replied, "No, no. I need to have control over my piece throughout the whole process. I just can't use any other sperm than my own."

The real time works of art produced at nonTVTVstation have lives of their own. The artists plan the plot, build the scene and then leave the rest to the real time media situation. Some artists try to lose control over their piece by letting the audience create part of the work by interacting, implicit or not. Some used an external source like television or the wind to develop and run the process of the work. The piece of art has a life of its own; it is almost a living organism for one month.[5]

Another working method is to use digital and electronic devices only. Pink Twins, the Finnish brothers Juha and Vesa Vehviläinen, work with their own software *Framestein* that allows them to reduce an image to pixels that they put together again, in real time, in sparkling new combinations. Pictures of everyday surroundings are torn

4 I choose to see performance as a tradition of the spoken word, dance, storytelling and theater, a tradition as old as the human being. In this way performance is the opposite of a painting that belongs to a written tradition.

5 I have been careful not to mention too many influential artists. Of course the ideas of John Cage are key to understanding the method of giving up control (obviously Edvardsson disagrees here) over creation to an external source. But the influence of Cage on real time art is so great that it could fill an essay, and more.

apart to create flickering digital sensations reminiscent of a big, abstract colorful painting in the style of Gerhard Richter. The images are completed with scratches, weird rhythms and noises, and the combination of sound and images produces a very physical experience. The piece by Pink Twins should be experienced not only with your eyes and ears but with your entire body.

I have noticed that working as Pink Twins do, using their own software, helps one to create unique methods when compared to artists using standard VJ software, for example. But at the same time, if the artist learns a technique too well, then the technological issues tend to dominate and the art seems to lack content as it concentrates on the beauty of the technological solution. It becomes more about programming than a wish to correspond with the spectator. The art becomes cold. However, this is definitively not the case with Pink Twins; their programming helps them to create powerful images and sound that have a profound impact on the spectator through a language that is very much the artists' own.

Also the art group Beeoff, which consists of Michael Scherdin, Tomas Linell and Olle Huge has developed their own software, a different solution to the problem of advanced streaming communication via the Internet. Artistically, much of their work has been based on intellectual and theoretical research into new ways of connecting different sites with an absolute focus on real time. They developed software, for example, that allows them to turn changes in light into sound. When connecting the program to a camera, it transfers what the camera captures into music, in real time.

Significantly, the Beeoff pieces often combine analog and digital technology. Their collaboration started with video cameras and monitors exploring video feedbacks. One example is *Head* from 1996-97. Like many artists before them, they investigated video technology and found that the real time result on the monitor was interesting. This experience made them think of the Internet as a form of art distribution; on the Internet, art could be distributed in real time over a distance.[6]

Art is an illusion, an abstraction of reality. Artists have throughout time been looking for the most truthful method to depict reality. In the beginning I mentioned that real time offers a kind of truth, something very reliable in the most complex communicative system between artist and spectator. It is then interesting to see that the methods I have described above used nature as an external source to create a piece of art or to transfer reality to art. Other artists use the technology in itself as a tool to initiate a process that starts to live and become a reality on its own. More and more artists are interested in real time, both theoretically and as a method to achieve a very special "nerve" in their art. It offers a method to hook the reality directly onto the piece; maybe as a whole, real time art can be seen as a very realistic movement. Maybe it is even a backlash against post-modernism and the kind of complex system I described. When

6 Video feedback as an artistic method is as old as the technology itself. Steina Vasulka is a pioneer of video, and her early work included feedbacks and other types of real time video installations. At the time, in the middle of the 1960s, video technology was expensive. Artists borrowed equipment from collective workshops and media centers. Even taping their work was expensive. Few early real time video pieces are documented. I suspect that they felt the same as anyone who discovers the beautiful effects you can achieve with the feedbacks, that the beauty was created at the moment and very much for the moment. Their video seemed to generate a virtual living process.

everything seems to become uncertain and complicated, real time art is something that is very reliable.

Real time cannot be questioned. Even if you cannot grab hold of it, the moment exists. It doesn't offer a static situation or something you can observe like a frozen image, but it is always there. This is the kind of truth I believe all artists want to achieve.

1. PINK TWINS. **LET IT BEEP**. 2003.
2. JUHA HUUSKONEN. **THE MOMENT OF LONG NOW.** 2002.
3. NILS EDVARDSSON. **SPERM PHASE DETECTOR.** 2003.
4. ILONA HUSS WALIN. **WHAT IF I WAS A RAT?** 2002.
5. PETER HAGDAHL. **SIMULATED SOCIAL MODEL NO 2** (SENSORIC TRANSFORMATION). 2002.

E1 VS. E2
(VS. E3)

ELIN WIKSTRÖM

E1: You often spend weeks at a time repeating a determined action. Could you elaborate on this process in your work?

E2: This aspect of my work constitutes a substantial difference from performance art, while of course owing it a debt. Repetitive action is a way of raising issues that have to do with our expectations of art, work and worth. My projects satisfy and also confound the most traditional of demands of the work of art, that it should somehow attest to the application of labor and commitment. However, I nullify the desire to equate labor with product or output, insisting instead that we focus on the systems and structures that surround us and engender such assumptions.

E1: Repetitive action also enables your process to coincide as closely as possible with what might be described as a "real situation."

E2: More important to me is the opportunity for participation that it gives. In my way of treating the audience, the person who experiences the work is there both as a speaking and acting subject. Subjectivity is formed through both discourse and inter-subjective exchange; the very act of participating in these exchanges makes us better able to engage in discursive encounters and decision-making processes in general.

E1: What does this kind of contact produce?

E2: Whether the audience member ignores

or gets caught up in the situation, the process is an experience and a test in itself: What defines the situation? How do you relate to it? How do I want to listen, speak, act and judge? How do I want to express my attitudes, desires and needs? The dialogic response could be to stay and have a longer conversation. But "non-encounters" in the form of quick responses might be to shake one's head, shoot a glance or make a face. However, these are also kinds of encounter.

E1: When you organize your scenarios, how do you anticipate whether the communicative experience will work out?

E2: I want to get people to react to or discuss something visible in a social situation.

E1: Isn't it common for a work of art to provoke dialog among viewers?

E2: Yes, but in my projects conversation becomes an integral part of the work itself.

E1: Your work involves both verbal and physical interaction. In the piece *What Would Happen If Everyone Did This?* you were doing nothing for three weeks.

E2: Yes, it was in 1993 and I participated in a group show entitled "ICA," which took place in a supermarket in Malmö. My contribution was to place a bed in the shop and mount an electronic display diagonally overhead with the following running message: "One day I woke up feeling sleepy, sluggish and sour. I drew the bedcovers over my head because I didn't want to get up, look around or talk to anyone. Under the covers I said to myself, 'I'll lie like this, completely still, without saying a word, as long as I want. I'm not going to do anything, just close my eyes and let the thoughts come and go. Now, what would happen if everyone did this?'" For three weeks, I lay silent in the bed, without doing anything when the shop was open, on weekdays from 9:30-7:00 and on weekends from 9:30-3:00.

E1: At that time, did you have an extra job as a chambermaid at a hotel?

E2: Yes. As a chambermaid you have to get up very early. Every morning a few of us complained, "Oh, I wish I could have stayed in bed today." I am very interested in the power of dreams and fantasies and their ability to act either as escapism or as disruptive forces against power relations and morals.

E1: Is the text an excerpt from your diary?

E2: No, it's written especially for this piece.

E1: In the piece two movements confronted each other: the activities in the shop and stillness in the bed: the order of the external world, the unlimited and purposeful, which is constantly repeated, and the

disorderly flow of the senses in the state between wakefulness and dream, the un-limited, the flexible, the superfluous and extravagant, where everything is possible. An older woman leaned over the bed and said: "I know how you feel. Jesus saved me, let him help you."

E2: Yes, and then she began to read aloud from the Bible. When I turned over to the other side, she followed me. She chased me from one side to side on the bed.

E1: "Open your eyes! Look at me!" she said.

E2: I pulled the covers over my head, but she stayed and read on. This woman visit-ed me every day. After her sermon she placed a note with a quote from the Bible under my pillow.

E1: Do you remember the old man mutter-ing to his friend, "What in the hell is this? An advertisement for bedclothes?"

E2: Yes. A few days later he turned up again, this time with another friend. The man's friend pinched my toe and asked: "What is this? Is it a real person or a man-nequin?" The old man answered him in a tone of voice that let the friend know that he was a bit backward for not understand-ing my work, and proceeded to give a little lecture on contemporary art taken directly from an article on the exhibition in the newspaper.

E1: And what about the father who asked his son what would happen if the whole of Sweden woke up one morning and didn't want to get out of bed.

E2: "There would be chaos," answered the son. "Right," said the father and went on about his business.

E1: You have continued to place many of your projects within the commercial mi-lieu.

E2: Yes, at the exhibition "Shift" at De Appel in Amsterdam I made a portrait of a poor but smart customer. The title of the project was "Poor Patricia's Complete Receipts." Everyday during the exhibition she cruised the shops of Amsterdam and purchased an entire outfit that she wore for a time, documented and then returned to the shop for a refund.

E1: After the morning's shopping, you went to De Appel, which opened at noon, and put on the day's new outfit, including the shoes, and ate lunch at a place near-by. Back at De Appel, you copied the receipts and put them in a notebook, strolled around the gallery and talked with visitors or went on a bicycle tour.

E2: Everywhere I went people reminded me that I had forgotten to remove the price tags. If, at this juncture, I decided to

tell them about Poor Patricia's provisional lifestyle I had to be prepared for people wanting to know more about Poor Patricia, about me and about my other projects. Sometimes they proposed that we continue our conversation at a café or bar. If I wanted to avoid getting stuck in such situations, I just answered "oh dear," or something like that.

E1: There were only about 20 shops in Amsterdam where you could buy and return clothes and the project went on for 49 days. When did the shop assistants begin to recognize you?

E2: They began to recognize me as soon as I started. A certain amount of cunning was needed to manage to get the refunds. It was exciting to see how long they were willing to tolerate this without appearing to be annoyed. In the last week of the project, one shop assistant covered her own back by not giving me the receipt, but I didn't realize this until it was too late.

E1: Do you know if the — sometimes slightly soiled — garments and shoes were sold after you had returned them?

E2: I don't know.

E1: How did you document the project?

E2: Each day, I asked one visitor at De Appel to take a picture of me with my camera. In the exhibition space, the physi-cal presentation of the project consisted of a table with a pile of clothes, a chair, a notebook with copies of the receipts, a beauty box, a full-length mirror and a constantly growing mountain of shopping bags from different shops. At the end of the project Poor Patricia had bought and returned one hundred and thirty-six items of clothing worth around £4000.

E1: What is it about the commercial milieu that fascinates you?

E2: I have been doing quite a lot of research on its history and development up to the present day. For example, I found out that the department store was one of the first public arenas where a woman could hang out alone or with friends, without being escorted by husbands, fathers or brothers. A more recent example is the way different groups in subservient positions actively use commercial products to rebel against domination.

E1: Typical in the history and ideology of commerce is the ongoing spectacle: What satisfies needs? What tickles desire?

E2: Yes. The milieu produces mixed desires and needs. On the one hand, one feels the need to adhere to a norm, to adapt, to go along, to act without thinking, to be everyone and no one in particular. And on the other hand, there are the needs to deviate from the norm, to remain other, to disagree, to think about what we are doing, to be absolutely unique.

E1: Poor Patricia doesn't fit into the clichés of the consumer.

E2: No, she is neither a manipulated and irrational customer, nor is she guided by will power or calculation. In my latest project RETAiliATOR, at The Showroom in London, the customer acts as selector, communicator, explorer, identity-seeker, hedonist, artist, victim, rebel, activist, empowered citizen and fellow-being.

E1: The consumer is both powerful and powerless. It's strange the way corporate power is sometimes taken for granted in the same way the power of royalty was taken for granted hundreds of years ago.

E2: The logic of big structures and systems is to expose individuals and groups to permanent anxiety and alarm.

E1: There is always either too little, too much or the wrong kind of consumption… This is something for consumers and producers as well as distributors to constantly worry about.

E2: Threats are something that consumer culture both arouses and assuages. I find that process extremely interesting.

E1: Consumer culture always has to do with power but culture is never solely that; it is also communication, aesthetics, ethics, fellowship and pleasure. In the project "Cool or lame?" you worked with how much and what kind of power producers, distributors and consumers have over the use of merchandise. How do retailers develop dominance or resistance in everyday life?

E2: "Cool or lame?" started off with thoughts about the circulation of goods, labor, ideas and information. This led to reflections on individuality and uniformity, risk and reliance, rights and obligations, the individual good and the common good, mass-production and originality. The globalization process has resulted in large changes, many of them at a macro level: in the global market, the state, the industry, service and education sectors. But what does it look like from a micro-level?

E1: How have the roles of the individual, citizen and consumer changed in a world ever more integrated in terms of technology, economy and politics?

E2: The easiest way to construct an identity is to conform by applying a fixed identity from the cultural milieu in which we live. Another possible way to react is to create an identity of resistance, protesting against the fixed identity. Yet a third way could be to find a project identity, based on the will to become something not yet invented.

E1: Your contribution to the exhibition was to create a project identity for yourself. What separates the project identity from other constructions of identity?

E2: A project identity is temporary, a state of different meanings, definitions, interpretations and points of view. It could be used as a tool that helps you prevent your views and lifestyle from becoming commercialized and stereotyped.

E1: Is it a way to expose yourself to something that could change the very foundations of your everyday life?

E2: Yes, that was one of the five regulations I decided on for this project. The others were: to make a statement, to act out an opinion, to do something that I had never done before and to keep doing it for a year.

E1: After lots of thinking and discussing you finally decided on a task. What was it?

E2: The task was: Starting on April 26 2002, I will no longer use the clothes that I already have or buy any new ones, and continuing until April 26 2003, I will only use clothes that I have manufactured myself. The only exceptions were socks and shoes.

E1: If everyone at some point in his or her life did something totally new for a year, would the world be a different place?

E2: Perhaps.

E1: Have you read Naomi Klein's book *No Logo*? The economic value of a product is no longer found in the product itself but in the trademark.

E2: Yes. Above all, what I wanted to react against and discuss is how trademarks control our very existence. Many products are built from basically the same components and therefore need some additional value to distinguish them and attract customers.

E1: Everything is for sale and it's the logotype that costs the most!

E2: Klein also says that the clothing market is an impenetrable, global maze of subcontractors and starvation wages. It motivated me to put the deliberately naïve question to anyone I ran into as well as to the key figures in the fashion and garment industry: Is it possible to create an exploitation-free wardrobe?

E1: You spent seven weeks on location in the exhibition space at Kunstverein in Munich where you had your workplace, with a sewing machine and sewing equipment, a mannequin, an iron and an ironing board. What happened?

E2: When I bought the sewing machine, a sewing course was included in the bargain. However, I didn't make use of it because I wanted to see if I could learn to sew by using the "learning-by-doing" method, totally without prior knowledge or any help from experts. The first, most striking experience was, of course, how

ELIN WIKSTRÖM CONVERSATION BETWEEN E1 AND E2

daily routines can seem to be insignificant but are closely connected to a feeling of security.

E1: The first three weeks were crazy and chaotic.

E2: Yes they were. I had to wash the few outfits I had every day. And all of a sudden the weather got much colder and I really missed warm clothes. Practically and socially, it was difficult. I felt uncomfortable not being able express myself with my wardrobe as I'm used to.

E1: The first thing you made was a dress, wasn't it?

E2: Yes. Trying to make jeans and T-shirts was more tempting than creating imaginative and unique garments. I wanted to find out how long it took to make a T-shirt and a pair of jeans, and how much they would differ from mass-produced stuff. Surprisingly, the most common reaction I got when I told people about the project was, "What? Have you made everything you're wearing yourself?" Few noticed that my clothes were not bought. I think it had to do with the fact that at the time there was a developing trend in fashion which focused on fake mistakes and failure.

E1: What about thread and textiles?

E2: It is possible to buy textiles on the Internet on the basis of fair trade and environmentally friendly production. In my situation it was too time-consuming and a bit too expensive. Most of my clothes were made from fabric from shops. Most companies making clothes now put labels on their garments, like "made in China." It is much more difficult to get information about where the thread and textiles are produced.

E1: You met Katarina at the exhibition in Germany.

E2: Yes. Katarina brought me to her grandmother's place and gave me textiles that had belonged to her grandmother.

E1: Katarina's grandmother, Anne-Marie Lange Seidl, passed away in 1989. She was a linguist and Germany's first female university professor. Anne-Marie found interesting parallels between text and textile.

E2: Her philosophy of life was that theoretical and practical knowledge are equally important. For example, Lange Seidl designed and built her own house and made all her own clothes.

E1: Knowledge is an essential part of our identity. At the same time, knowledge is something that the market and the powers that be desire.

E2: Basically, all knowledge is founded on practice and, Lange Seidl thought, uncertain. Therefore, it must be acquired actively and not passively. It's never fixed and

for that reason it must constantly be examined and put into action.

E1: Another important event in the development of the discourse of the project was your meeting with Carina Carlström in Umeå. She is a journalist who wrote the book *The World in Your Pocket* based on her visits to garment factories in Cambodia.

E2: Yes, she travelled there to investigate whether the Swedish clothes company H&M and others kept their promises about improving working environments and wages. Unfortunately, these changes had largely failed to be implemented. The workers, mostly women, are excellent seamstresses, but at the same time they live in poverty. The wages are so low that it is almost impossible to survive on them. The only hope, Carlström says, is to be found in the growing union movement and in the pressure brought by consumers in the West. At a lecture she held in November, I asked how much of the money I spend on a garment actually goes to the workers. Around 2 SEK (Swedish kroner), she answered. You pay more for advertisements than you do for the manufacturing of the garment.

E1: There is no sewing industry in Sweden today because it is so much cheaper to have the work done in Asia or in Eastern Europe.

E2: That's right. These countries are forced to provide cheap labor, raw materials and therefore cheap products for the Western World.

E1: After your stay in Germany, what garments did you have in your "Do It Yourself" wardrobe?

E2: Three pairs of jeans, a skirt, four T-shirts, two tops, seven pairs of underwear, a jacket, three dresses and a coat.

E1: Reports from the project have also been made in the form of exhibitions at Gallery Hlemmur in Reykjavik in August 2002 and Brändström&Stene Gallery in Stockholm, November 2002.

E2: I offered each visitor a 20-minute visual and verbal presentation of the project as a discursive framework. Through this the various participants — for example, handicraft teachers, young designers, representatives from the antiglobalization movement, risk capitalists — could exchange insights and observations. I'm very fond of the kind of provisional knowledge, meaning and understanding that the "dialogical" part of the projects establishes. None of my projects could have been carried out without the fantastic support of the participants and the involvement of the audience.

E1: To create something that is actually lived... It's different from the way information normally spreads and the way knowledge and meaning production in general set their agenda, isn't it?

E2: One could say that parts of the project function as a proposition or model on the basis of which you can get real.

E1: It's like setting out on a voyage. A process-based project is always fragmentary, partial and unfinished. The outcome is never clear. It's a state of potentiality, a complex interplay between the real and the potential.

--

E1: In Dundee, 2002, you and your assistant at the time, Swedish artist Elin Strand, implemented the project "… the need to be free …" that was sited both in a gallery and in a public context.

E2: Yes, a couple of years ago the city of Dundee in Scotland acquired two new buildings: an art gallery, called Dundee Contemporary Arts, with a bar and a cinema, and a shopping center, called Overgate, with greatly anticipated shops and cafés: GAP, H&M, Starbucks, etc.

E1: The comfort factor at both places is somewhat better than usual.

E2: Yes, but in general they look and function like any other art gallery or shopping center.

E1: Overgate shopping center is located next to a church and spreads out over what used to be the central square in Dundee.

E2: What I found interesting was that the public function of the square had been destroyed by a privately owned building. The square could no longer function, for example, as a venue for the local market or for public demonstrations.

E1: A palace that contains products for everyone, from birth to grave, serves here as good example of how branding has taken the place of religion and ideology. Not only products, the latest clothes, food and trips are bought and sold here, but so are messages and dreams: happiness, strength, status, power, success, integrity and so on.

E2: Companies have gone from the production of goods to the production of symbolic values. It's fascinating how the boundaries between advertising and art, and marketing and culture are being continually erased.

E1: On the trams, TV, the Internet and in magazines and films, the message is scanned into our consciousness. The project you made actually happened to be an indication of how the rules for the consumer in a department store are slightly stricter than they are for citizens in general.

E2: With the help of Katrina Brown from Dundee Contemporary Arts, I applied to the managing director of Overgate for permission to do my project. After a lot of negotiation, I got permission.

E1: Otherwise, your action would have been stopped after ten minutes!?

E2: It took no longer than that to be stopped by a guard. He grabbed my shoulder. I was listening to music and didn't hear what he said. He ripped off my headphones and asked what I was doing.

E1: All you were doing was using the escalator.

E2: Yes. I was riding up and down, up and down, over and over again.

E1: "Why?" asked the guard.

E2: "Because I like it," I answered.

E1: "Are you mad?" he asked.

E2: "No," I said. "It's such a lovely feeling. The building is fantastic and all the people are fantastic! Look at that man down there in the café. What sort of book do you think he is reading? And have you seen that one of the joker dolls up there in the ceiling has lost its head? It looks as if it's passed out or collapsed." By now the guard had also gone up and down a few times so I said, "It's great, you hover, fly! Why pay masses of money to go to some exotic faraway place when you can get kicks for free right here!" Then he began to laugh and said that was exactly why it was forbidden.

E1: "If you're going to hang about here, you have to buy something!" he said.

E2: So I asked my assistant to get me a coffee to buy a little time. "We might as well introduce ourselves," I said. "I am Elin Wikström. My friend and I have permission to use the escalator for two weeks. You are being filmed now; the camera's over there. We're doing a road movie on freedom." By this time, five more guards had arrived. They wanted to see the permit. I didn't have it on paper, so I asked them to call the art gallery.

E1: "I make movies, too," said the guard, pointing to the surveillance cameras. You couldn't help playing the fool and waving at the guard behind the monitor. That was quite a stupid thing to do… You began riding at noon. At five minutes to one, your assistant, Elin Strand, took the videotape out of the camera and put in a new one.

E2: Before she got onto the escalator she gave the tape to me and I took it to the gallery.

E1: The film was shown on a monitor mounted in the stairway between the entrance and the bar. At five minutes to two you were back at Overgate, loaded the camera with more videotape and continued your ride.

E2: Back at Dundee Contemporary Arts, Elin Strand put in the second tape.

E1: How many hours, how many days did you do it?

E2: We went on like this for 6 hours a day for the next two weeks, everyday except Mondays when DCA was closed.

E1: And how many tapes did you fill?

E2: Altogether we filled 84 videotapes.

E1: You also had shopping bags just like the other customers on the escalator, but instead of shop logos, your bags said "… *the need to be free …*"

E2: We had them printed in the graphic workshop at DCA. They had exactly the same design, color and print as DCA's own shopping bags.

E1: What did you have in the bags?

E2: We had the cassette tapes that we were listening to and flyers with a short explanation of the project, which we handed out whenever we needed to. However, it was more exciting to talk to people.

E1: People either asked the employees or they came directly up to you asking: "Are you a model?" "What are you advertising?" "Are you collecting money for something?" "Are you from *Smack the Pony*?" (a comedy program on TV). "Why are you doing it, then?"

E2: "If you want to talk," we said, removing our headphones, "then you have to ride with us."

E1: The guards had a lot of patience with everyone who called them.

E2: One guard told us about someone who came up and said, "Have you seen that girl riding around on the escalator? Is she bonkers or something? She's been there for a half an hour now. Hasn't she anything better to do?"

E1: "You, then," replied the guard. "Have you nothing better to do than stand gaping at her?"

E2: But sometimes the guards got too involved: a big gang of pale, black-clad Goths whom Elin liked talking to were thrown out!!!

E1: What reactions did you get?

E2: People thought it was a good joke, a good political prank. Gave the thumbs up and gave us presents. Or they got annoyed and quarrelled with us. Jabbed at us.

E1: They flirted with you and invited you to lunch.

E2: We got that, too, and we had those who used our camera for advertising and those who took time to ride with us; we had discussions about everything from freedom to holidays, architecture to feminism.

E1: Did those who put on acts in front of your camera come to DCA afterwards to look at the tape?

E2: Yes, and people who had seen the video at DCA came to Overgate to see us "live"!

E1: In practically the last hour of the last day, the escalator broke down. That was weird. So to reach the second floor we had to walk up and to get down we had to use the lift!

E2: I learned from the repairman that if we had gone south instead of in circles, we would have made it to London.

E1: Underneath the monitor at DCA hung the same sort of headphones that you used.

E2: They were connected to a CD player with the Funkadelic song "Free Your Mind and Your Ass Will Follow." From the speakers in the stairway came a 30-minute remix of the song, with sounds of bagpipes and the escalator thrown in.

E1: Who made the soundtrack?

E2: Trio Escort. Fredric Bergström and Jesper Norda.

E1: Like Elin Strand's and your shopping center activity, the song text is about feeling free or being confined.

E2: Yes, what is freedom? What is freedom to me, or to others? Is it to be able to exercise freedom and the concomitant rights expressed in the UN Charter on Human Rights? Is it to be free in one's actions and thoughts, feelings, desires and perceptions? What internal and external factors prevent us from fulfilling our desires and our goals? Economic? Social? Ignorance? Fears? And is there a difference when you are on our own or with others?

E1: And how can we be sure that our desires and goals are authentic?

E2: Or as George Clinton puts it: freedom is to be free of the need to be free, free your mind and your ass will follow.

E1: In the shopping center where people usually run about following their impulses, you voluntarily subordinated yourselves to a structure.

E2: Someone said that if one thinks of an escalator as directed thoughts and desires, you and your friend are like a thought or feeling flowing free.

E1: For you "… the need to be free …" concluded with Elin Strand and you flying from Dundee to London, putting on your headphones and listening to the Funkadelic song.

E2: Since we had told the guards that we were doing a road movie — like *Thelma and Louise*, you know — we wondered if we were going to die in the air like Thelma and Louise? George Clinton shrieked: *Open up your fucking mind and you can*

fly!!! We had listened to that song every day for almost a month. And we laughed and cried and arrived safely in London. That was fun.

E1: As an artist who has adopted a performative, process-based art practice, how do you regard your art works in relation to reality and reality TV?

E2: What do we mean when we talk about reality?

E1: The way I see it, reality is never just one thing. There are always different versions of reality, yours and mine. Reality is in a constant process of being perceived and shaped. It's always plural. It's something we are participating in rather than something we look at from an inside or outside position. It demands attention. There is no emergency exit or escape route…

E2: Reality is perceived differently and that difference is based on our historical, economic, political, ethnic, social and psychological backgrounds.

E1: It's never neutral and always ethical. The making of difference is an activity within a relationship. It's experiential and dialogic.

E2: The point, as John Perry Barlow acknowledges in *The Economy of Ideas* (1992), is that reality is an edit. People are willing to pay for the authority of those editors whose point of view seems to fit best. And again, point of view is an asset that cannot be stolen or duplicated.

E1: I like Barlow's example of the horse.

E2: "If I sell you my horse, I can't ride him after that. If I sell you what I know, we both know it."

E1: Yeah!

E2: He also says that most information is like farm produce. Its quality degrades rapidly over time and distance from the source of production.

E1: Like the art market and institutions, the media strongly decide what will be highlighted. I am interested in the new forms of dissociations of time and space, and coordinations of time and space that the media offer.

E2: It's difficult to distinguish the borders between communication and control in the production and consumption of media.

E1: The use and reception of media depend on different power structures and the power structures always have either direct or indirect influence on the use and reception of media. The production, organization and consumption of media also reflect the commodification and colonization of time and space.

E2: Media users today are both con-

sumers and producers. Even when information has been encapsulated in a static form, for example, a newspaper, the actual decoding process must still be performed by and with a mind. The creation and exchange of meaning is something that happens in the field of interaction between minds or objects or other pieces of information.

E1: What is central is what we *do* with the various types of media, *how* and *for what* do we use them.

E2: When we talk about communication and control, I think that Michel de Certeau's *The Practice of Everyday Life* (1988) presents useful ideas of power. He distinguishes between knowledge production as a strategy and as a tactic. A strategy is territorial, a system of control through geography and architecture. It is connected to a spatial and institutional location. "A tactic insinuates itself into the other's place, fragmentarily, without taking it over in its entirety, without being able to keep it at a distance."... "Because it does not have a place, a tactic depends on time — it is always on the watch for opportunities that must be seized 'on the fly' ..."

E1: ... "Whatever it wins, it does not keep. It must constantly manipulate events in order to turn them into 'opportunities.'" And here he uses the example of the housewife. That's funny!

E2: Yes, in the supermarket, he writes, "the housewife confronts heterogeneous and mobile data — what she has in the refrigerator, the tastes, appetites, and moods of her guests, the best buys and their possible combinations with what she already has on hand at home, etc."

E3 enters the room.

E3: There is someone on the phone for you!

E2: I'll get it!

E1: It's for me!

E2: No, it's not, it's for me!

Söngvar Sólvindanna

Sferics.

Sferics are the impulsive signals emitted by lightning. The frequency range is from a few hertz to millions of hertz.

The part of this range that we can hear (the audio range) has frequencies up to about 15 thousand hertz (15 kHz). The spectrograms of sferics are characterized by vertical lines on the frequency -time graph indicating the simultaneous arrival of all of the audio frequencies. The sound of sferics consists of sharp crackling noises like twigs snapping or sizzling noises like bacon frying. Sferics are caused by lightning strokes within a couple of thousand kilometers of the receiver. The VLF radio signal is ducted to the receiver between the surface of the earth and layers in the ionosphere which reflect radio waves. This path is called the earth-ionosphere waveguide.

country	alaska
local time	10:07
activity	0 no activity - 0
auto movement	off

JACOB KIRKEGAARD + THOR MAGNUSSON

SÖNGVAR SÓLVINDANNA

Söngvar Sólvindanna is a sound installation that presents aurora: a special natural phenomena, which we find around the magnetic poles of the Earth. Aurora borealis and aurora australis — also known as the northern and southern lights — appear when solar winds from the sun land on the ionosphere of the earth and release energy in the form of light. Thus, we see the magnificently beautiful dance of light in the sky above polar countries on clear winter nights.

This installation investigates the northern lights, which can normally be experienced north of the 60-degree latitude when the sky is clear. Electromagnetic activity is constantly present, but to varying degrees. Contrary to common belief, the northern lights are also present in the daytime, but obviously not visible due to the sunlight.

People in the northern countries have given accounts of hearing the sound of the northern lights, while others have denied that this is possible and pointed to research that shows there is no sound coming from them. The fact is that when light originates in the hemisphere, electromagnetic radio waves on a very low frequency (VLF) are created and they can be received with special VLF receivers, down on the ground.

We found the question of the "sounds of the northern lights" very interesting, because the claim of some scientists that there is no sound contradicts people's stories of being able to hear them. More stories can also be found throughout the ages in mythology and folk tales about the northern lights. People usually describe the sounds as "ticks," "sparkles" or a "chorus," and in fact it seems as though they are hearing the

sounds of frozen snow and gentle winds. It was therefore a fantastic experience when we were in Iceland in January 2004 and Lapland a month later to hear in our headphones those very sounds that people have described so accurately. But how do people hear them without the right equipment? The mystery of the sounds of the northern lights is far from solved.

Söngvar Sólvindanna is not concerned with the visual aspects of the northern lights. It concentrates solely on the sounds and on creating a suitable space for listening to them. A computer screen in the room displays a map showing the current state of the northern sky. The installation is real time in the sense that at regular periods, it receives satellite data from on-line sources and calculates the activity around the northern pole at the current time. This information is then drawn onto the map in the form of light-to-dark-green colored areas. The user can navigate over the map with a crosshaired cursor using the buttons in front of the screen and listen to the sounds that fit the electromagnetic energy of a particular location.

AUDIBLE AURORA

Observations have been made on meteors moving through the sky, where delicate sounds, such as crackling, were heard simultaneously with viewing the meteor. In 1719 the astronomer Edmund Halley collected different accounts of sounds experienced in relation to a meteor seen over England. But since this meteor was moving across the sky at around 100 kilometers per hour, and because light travels much faster than sound, he concluded that the sounds could not be directly related to the meteor. His conclusion inhibited research for many years to come.

Today we use the term "electrophonic meteor sounds," which attempts to describe this audible meteor phenomenon. Colin Keay, a physicist at the University of Newcastle in Australia, has discovered that the glowing meteor tails do not only give off light, but also VLF radio waves travelling at the speed of light. This fact should revive the lingering question concerning the audible phenomena related to meteors.

But even though these radio waves reach the earth without delay, how is it possible for us to hear them without the use of special electromagnetic receivers? Keay's theories state that materials such as thin wires, aluminium foil or dry hair could respond to VLF waves by vibrating. Very low frequency waves put things into motion, thereby causing the compression of air, which we hear. Colin Keay proposes, as an example, that a pair of glasses or a person's long hair could be a connecting link for hearing VLF radio waves, since this material may respond to a VLF field. The electromagnetic waves would vibrate eyeglasses resting on the ear and skull, thereby making an audible sound.

The same applies to aurora, as it has been said that some types of electromagnetic waves coming from them could make a person's hair stand on end, in response to these disturbances. Normal FM radio transmissions do not have the same vibrating effect on hair, for instance, because these frequencies exist in a much higher range and oscillate far too fast to cause hair to move. Furthermore, we would not be able to hear such waves, as they oscillate above the range of hearing.

REAL TIME

In the installation, we access on-line data from a satellite travelling about the electromagnetism above the North Pole. This data is updated every six minutes. We interpret this data and draw the result onto the map of the northern hemisphere on the screen of the installation. So every few minutes the installation retrieves new information about the current state of the sky. The user can move a cursor around the map and listen to sounds that are connected with the kind of auroral activity above the chosen location. The sounds are prerecorded, as it would be technically impossible to set up VLF receivers over the whole northern hemisphere and stream that sound into the installation. We therefore chose to go the middle way and use real time data to show the sky at a given moment, but we also use prerecorded sound. The main idea is to represent the beautiful sounds of the northern lights in a way that is engaging, but also aesthetically pleasing.

Söngvar Sólvindanna is an installation that draws from some of the ideas which can be related to generative art. It uses a natural parameter — the electromagnetic sky — as a dynamic variable in a piece of software that plays the sounds of the northern lights. The listener can interact with the software and navigate over a map of the northern hemisphere, although in a very limited way. The main focus is on the very sounds created by the solar winds. Because the installation senses user input, receives new data and calculates constantly, it would not be possible without the Internet or the computer that hosts it.

OUR TOOLS

To record the sounds of aurora in the Icelandic wilderness, we brought with us two different VLF receivers. To build them, we followed diagrams found on the Internet. The receivers consist of basic electronic components similar to those found in ordinary radio technology. These receivers are different, though, since they capture electromagnetic waves in a much lower frequency range. Hence the name VLF. Because of this, no manmade radio transmissions disturb the recording process. On the contrary, one

has to be located far from electric power lines because their noise and hum interfere and obscure the natural electromagnetic waves.

THE RECORDINGS

Our recordings were done mainly at sunset or seconds later, around 8 p.m. The sonic activity was stronger after sunset, similar to the way in which short wave radio transmissions are affected by the absence of the sun. At night we also had the rare opportunity to view the beautiful aurora while listening to the sun storms as shown in the picture below.

A diagram of the BBB-4 VLF receiver.

The Whistler Receiver has a stronger built-in amplifier and therefore better reception. A normal telescopic radio antenna can be used for handheld recordings.

The best antenna we had was an eight-meter wire twisted around a fishing rod mounted on the back of our car. The cable led into the receiver inside the car so we could locate ourselves at various places and listen to the solar winds.

```
                              BBB-4 VLF RCVR        o  +9 Volts
\    | /                                           |
 \   |  /                            |0.1uF |       |_____  \  To Audio
  \  | /             C9  + |         _|_ C10 |      |                  /  amp. 9 v
   \ |/             100uF _|_        _|_     |      |                     rail.
    \/                     |          |      |      \
     |                     |          |      |      /
1 to |                     |          |      |      / 1K
3 mtr.|                    |          |      |      \ R4
whip |                     | / / /  2N3819   |      /
ant. |       R1      C1    |         Q1   D   |_____||____ \  To filter &
     |      1 Meg  0.1 uF  |         G   |____|      ||     /  A.F. AMP.
|---/\/\/\---||---|-----|--------|           |        0.1 uF
     |              |      |                 |        C3
     |      C2     _|_     \         |-----| S |
     |      47pF    _      / R2      /
     |              |      \ 10 Meg. \
     |              |      /          / 220 ohms
     |              |      /          \ R3
     |              |-----|           /
     |   / / /              / / /    _|_
                                     / / /
```

ABOUT THE COLLABORATION WITH INSPIRE
(INTERACTIVE NASA SPACE PHYSICS IONOSPHERE RADIO EXPERIMENTS)

Half of the sound files used in Söngvar Sólvindanna we have kindly borrowed from Shawn Korgan on the INSPIRE team. They were record-ed April 1 and 2, 2001, in northern Colorado USA, using a so-called E-field (dipole) VLF receiver along with two 8' whip VLF antennas.
Having the pleasure of incorporating a variety of VLF recordings from around the world into this installation has been an interesting experi-ence. Learning how these sounds are heard throughout the world — from the volcanic deserts of Iceland to Colorado — always alive and in a constant flow, creates a true feeling of unity across the cosmos.
INSPIRE is a nonprofit, scientific, educational corporation whose objective is to bring the excitement of observing natural and manmade radio waves in the audio region to high school students, amateur astronomers and others. Stimulating students to learn and understand science and technology is key to the fulfillment of their potential in the best interests of our society.

Carrying out ground-based recordings with
the handheld BBB-4 receiver. January 2004.
The aurora is seen in the background.

Söngvar Sólvindanna has been created by Jacob Kirkegaard, Thor Magnusson and Birta Thrastardottir.

For more info on Söngvar Sólvindanna:
http://secretsounds.dk/nada

Websites of the artists:
http://ixi-software.net
http://fonik.dk

We would like to thank the following: Kunst-hochschule für Medien Köln (KHM) for sup-port, komponent.dk and KHM for technical support on receivers, Shawn Korgan from the nonprofit, scientific, educational corpo-ration INSPIRE for additional sound files.

REFERENCES
INSPIRE: http://image.gsfc.nasa.gov/poet-ry/inspire/2004/
http://science.nasa.gov/headlines/y2001/as t26nov_1.htm
http://www.astronomycafe.net/qadir/q1852 .html
http://users.hunterlink.net.au/~ddcsk/auro-ra1.htm
http://www.members.tripod.com/~auroral-sounds/aslist.html

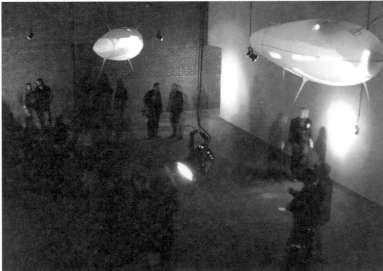

BEEOFF
TENTACLE
INSTALLATION DOCUMENTATION

MIKAEL SCHERDIN / BEEOFF

REAL TIME
A CONCEPT OF THE "HYPERREAL"?

In my earlier texts, "Jungle of Time"[1] and "The Forces of Flow,"[2] I explain some of the thoughts and philosophical statements in my own art. Some of those statements and ideas are also influencing the work and creation of other structures, such as nonTVTVstation, Beeoff — the art group — and Splintermind, as the studio and place for several activities in the contemporary art field. In this text, however, I will discuss the concept of "real time" as a successor to the old concept of what is considered "reality."

In this text I want to suggest that art, created in a real time context, especially created in the context of the nonTVTVstation, can be considered as "passing the point of reality."

Let me start with a few important statements around time and space.

Time is a way of measuring, as weight, light and other things are measured according to the SI system. Time is simply a common tool for society to use, a tool that is the same for all. It is a standardized tool for the whole world, which was not always the case. The perception of time is, however, something completely different in different cultures. In the Western world, we consider time as running from point a to point b, in a (never-ending) linear way.

In many Eastern societies, on the other hand, time is perceived to be "circular."

Independent of the way that time is perceived, it can be said to culminate in one

1 Published at http://www.beeoff.se (May 2001)
2 Published at http://www.beeoff.se (Oct. 2002)

singular point: the exact now. Whether we see the world from a Buddhist perspective or a Christian one, all moments merge in this one very single point called "real time."

The point of "real" exists only now and at this very moment, and will never return. It is absolute. It is no measurement tool, it is no perception of the world depending on religious thought or anything else. It is simply neutral and blank.

It is nothing. It is just a point.

It is an ever changing, exact point, in a perfect "stand-still."

The art piece exists in every single point and reinvents itself in a never-ending process of repeated points of real time. The real time art piece becomes a flow without any concept of time.

An art piece that is generated and shown at exactly the same time as it is produced, becomes in this sense a perfect reality. One perfect reality of an infinite number of realities. But still a perfect and clear reality. A reality on its very own.

If such an art piece is produced and shown in a context, such as the nonTV-TVstation, something else occurs. Something really interesting happens. But in order to show you what I think, I first have to explain the nonTVTVstation in more precise terms.

The nonTVTVstation transmits art that is produced in real time. And in real time only.

The real time art piece is literally connected to the nonTVTVstation. The distribution of the real time art piece starts at the very moment it is connected to the nonTVTV-station.

So, the stand-alone real time art piece is added to the idea and format of the production and distribution of it.

There is a type of "network." It is a network of physical showspots at museums combined with a "virtual" showspot/room on the Internet.

Those two contexts, one physical and one virtual, create a joint virtual and analog context for the actual real time art piece to exist within ... or ... ?

Yes, I have used the word "context" on purpose, since it can have several meanings. In a sense we have created an "art context" for real time art to act within and on its own terms. In itself, it is a perceived context, a perceived space.

So... now... we are moving into the other dimension af the real time art piece.

The first dimension was time, or in the case of the real time art piece, the lack of time — or just a point. The second one is space.

In our modern way of perception, of our reality, the concept of time is often combined as a twin-concept with its sister space to give us time-space.

A real time art piece, produced by a software program, computer or a complex installation that is "constructing" the actual art flow, the flow of sounds and images shown to the spectator, is, by definition, physical and has "extension in a room."

That program can be considered as the machine behind the art piece, but what about the art piece that is created as a flow (from the machine)?

What about the flow of images and sound?

I say a real time art piece exists without time and without space.

A real time art piece has no connections whatsoever to the old traditional concepts of time and/or space.

A real time art piece is its own time and space.

A real time art piece creates its own single and perfect, true interpretation of its own world.

A perfect truth.

It creates, together with its context, in our case the nonTVTVstation, a perfect world.

A world completely on its own. Parallel to that world there exist an infinite number of other real time systems. Art or not art.

I, as the writer of this document, and you as the reader, are according to this way of thinking, in this very particular philosophy, two perfect real time systems existing parallel to an infinite numbers of other real time systems or worlds.

All of us are more real than the old concept of reality or real world.

We are surpassing the concept of reality.

We are hyperreal.

JACK BURNHAM

REAL TIME SYSTEMS

I READ THE NEWS TODAY OH BOY
FOUR THOUSAND HOLES IN BLACKBURN
LANCASHIRE
AND THOUGH THE HOLES WERE RATHER SMALL
THEY HAD TO COUNT THEM ALL
NOW THEY KNOW HOW MANY HOLES IT TAKES
TO FILL THE ALBERT HALL
I'D LOVE TO TURN YOU ON

Presently it will be accepted that art is an archaic information processing system, characteristically Byzantine rather than inefficient. To emphasize this cybernetic analogy, programming the art system involves some of the same features found in human brains and in large computer systems. Its command structure is typically hierarchical.[1] At the basic level artists are similar to programs and subroutines. They prepare new codes and analyze data in making works of art. These activities are supervised by metaprograms, which consist of instructions, descriptions, and the organizational structures of programs. Metaprograms include art movements, significant stylistic trends, and the business, promotional, and archival structures of the art world. At the highest level art contains a self-metaprogram which, on a long-term basis, reorganizes the goals of the art impulse. The self-metaprogram operates as an undetected over-

1 Lilly, John Cunningham, M.D. *Programming and Metaprogramming in the Human Biocomputer: Theory and Experiments* (Baltimore; Communication Research Institute 1967).

seer, establishing strategies on all lower levels in terms of societal needs. Because we have no comprehensive picture of human life, these needs remain rather obscure (*Zeitgeist* is not sufficiently teleologic to express the anticipatory monitoring function of the self-metaprogram).

Aesthetic values emanate from the self-metaprogram. These are now changing, as evidenced by a number of symptomatic conditions: loss of interest in the gallery scene by the informed public, strong support for "street art" by several important critics, the "newsreels" of the underground cinema, anxiety marked by rising prices in bluechip art, the fact that museums of modern art are closing the circuit on modernism, and the response to so politically inept a group as the Art Workers Coalition.

Values, though, are simply the result of long-term information processing structures. This is the business of museums and art historians. The more aggressive commercial galleries have long considered controlling and creating art information vital to selling, while not forgetting that sales are art information. The survival strategy of all social organizations, including the art system, is that of transforming preferred information into values.

In business this is taken for granted. At the management level, information "is data that has been culled, analyzed, interpreted, and presented on a selective basis in a manner useful for understanding and decision making. Its function is to decrease uncertainty."[2] As indicated, every artist produces data by making art. Critics, magazines, galleries, museums, collectors, and historians exist to create information out of unprocessed art data. History is uncertainty about art minimized.

A major illusion of the art system is that art resides in specific objects. Such artifacts are the material basis for the concept of the "work of art." But in essence, all institutions which process art data, thus making information, are components of the work of art. Without the support system, the object ceases to have definition; but without the object, the support system can still sustain the notion of art. So we can see why the art experience attaches itself less and less to canonical or given forms but embraces every conceivable experiential mode, including living in everyday environments. Thus art, according to John McHale, becomes "temporal immersion in a continuous contextual flow of communicated experiences."[3]

Examine the function of information in art: communication theory states that information is obtained when a signal reduces uncertainty within a system. Information is need requited; hence information for a system has high entropy-reducing potential (negentropy). Negentropy is the ability of information to increase the structure and potential energy within a system. Such information is only obtained by expending the energy of systems outside the one receiving information. Thus the art system has maintained its vitality by constantly reaching outside of itself for data. In the past this

2 Heyel, Carl. *Computers, Office Machines, and the New Information Technology* (New York: The Macmillan Company 1969), p. 178.
3 McHale, John. *The Future of the Future* (New York: George Braziller Inc. 1969), p. 300.

has taken the form of new subject matter, materials, and techniques. But art now challenges the entire art information processing structure, not merely its content.

Encoding information always involves some physical process. In high-speed processing this takes the form of digital computer "hardware." The procedures or programs for processing data are called "software." In all previous art, distinctions between software and hardware were not recognized, so that encoding took the form of other art media and materials, where some information was lost, and perhaps some gained. Graphic reproductions of original works of art were a form of advertising. We now look upon them as works of art in their own right. Electronics have taught us that we often confuse software with its physical transducer. In other words, if we extend the meaning of software to cover the entire art information processing cycle, then art books, catalogs, interviews, reviews, advertisements, sales, and contracts are all software extensions of art, and as such legitimately embody the work of art. The art object is, in effect, an information "trigger" for mobilizing the information cycle. Making, promoting, and buying art are *real time* activities, That is to say, they happen within the day-to-day flow of normal experience. Only Art Appreciation happens in ideal, non-existential time.

Ideal time and "experimental idealism"[4] are both outgrowths of the classical frame of reference. They stem from the intuition that location and proportion transcend the illusion of time. Classical scientific methodology, as Spengler pointed out, is so premised. In both classical artistic and scientific experimentation the strictest control is exacted over isolated formal relationships. Only under such conditions may variables be compared. Reduction, isolation, and manipulation are the foundations of the Classic inventive structure — in art or technology. The problem of form and antiform represents polarities of this structure, not an alternative. Paralleling experiments in Classic science, works of art are simplified models of complex, unmanageable situations. To insist upon the "reality" or "anti-illusionism" of such art, no matter how informal or diffuse its limits, is to deal in tautologies. All models also exist in real time. To sum it up, "style" is the artist's choice of invariants — used to excess.

Experimental idealism rests upon the intellectual and physical isolation of the aesthetic experience. Its tools are picture frames, bases, spotlights, guards, galleries, hypostatic objects, and the concept of "high art" itself. It suggests that sensually the world is impossible as experience and must be broken down into palatable sanctuaries. Herbert Marcuse indicates that aesthetics originally pertained to the study of the senses. By the end of the eighteenth century, aesthetics had a different meaning: it referred to the study of beauty and specifically beauty related to art.[5] All of which is reminiscent of the words of one young lady: "I don't mind New York City, I just shut off my senses and visit the Met on weekends."

4 Sackman, Harold. *Computers, System Science, and Evolving Society* (New York: John Wiley & Sons, Inc. 1967), pp. 516-550.
5 Marcuse, Herbert. *Eros and Civilization: A Philosophical Inquiry into Freud* (Boston: The Beacon Press 1955.) Paperback edition (NewYork: Vintage Books, 1967), pp. 157-169.

To interpret pragmatism either as a rejection of illusionism and its attendant idealities, or as an appreciation of contextual differences, or as a kind of tough-minded precisionism rooted in literal description, is to underestimate the intentions of one of its founders. As a psychologist, William James realized the scientific value of ordinary, unprepared events; he also understood that such events represent infinite amounts of raw data, which defy scientific scrutiny. His alternative was to return to freer and more existential investigation, fully recognizing the limitations of scientific "law." "Concreteness," "adequacy," "facts," "action," and "power" are words used by James to describe the methods of pragmatism; however, the essence of pragmatic conduct is an ability to remain open and flexible despite conflicting experiences. As a result, correlating experience into a coherent picture of reality is the pragmatist's only objective.

Since the beginning of archeological research into art, theories of art have sought a lateral and vertical synthesis of cultural values, promoting the idea that these theories all represent disparate aspects of the "art impulse." But I agree with Alan Watts that, "What our museums now exhibit as the 'art' of other cultures and ancient times are religious, magical, and household utensils exquisitely and lovingly made."[6] In other words we have imposed upon earlier cultures a conception of high art that justifies *our* value system — not theirs. The problem gets knottier as we see discrepancies between contemporary conceptions of high art. Judging different kinds of art by different criteria is one solution. Multiple value systems, however, were not what James had in mind. As long as there are conflicting experiences, James would insist upon a moratorium. Pragmatism is the recognition that science and technology have fragmented the traditional value structure beyond repair. Thus enclaves of protected values, including art, are fast disappearing.

In societies where existing values adequately deal with the environment, there are no comparative values — only the existing way of life. Values are nonexistent in metabolically stable societies. Hopefully such a metabolic reorganization is underway and will lead to a convergence of global information structures with parallel rather than linear processing. Such is the implication of McLuhan's assertion that the world is on the verge of tribalism, at this stage taking the form of similar patterns of global unrest. In this sense, the image of transcontinental tribalism through electronic technology is far from fanciful hyperbole:

At the global level, as in man's natural symbiotic relations with plants and animals, his relationship to cybernetic systems has been subtly changing toward a more closely woven organic interdependency resembling his other ecological ties.
The point reached recently when such systems were combined with the remote sensing, monitoring, and control capacities of the orbiting satellite marks the extension of this symbiosis to include the entire planetary ecology.

6 Watts, Alan (with essay by) (January 19-March 23, 1969): *Electric Art*, exhibition catalog (Los Angeles: UCLA Department of Art).

The most pervasive aspect on earth has been the automation of production, services, and information flow in the advanced economies. Man's social role and position in society becomes less and less determined by the part he plays in direct production of material wealth goods, the organizing of routine information, or the performance of some standard physical service.[7]

Quite evidently, where advanced technology takes over, our values are chosen for us — if survival remains high on our list of priorities. Moreover, such a reversal demolishes the Classical Ideal. Both in the sciences and in the humanities something is rapidly happening: we are beginning to see scientific "objectivity" as an illusion, as are the notions of independent scientific "disciplines," of isolating subjects of scientific inquiry from their settings, and of the possibility of making unobtrusive measurements.

Such symptoms point to a convergence of knowledge and activities; in a primitive fashion we are beginning to accept the Earth and its "guests" (to borrow from Buckminster Fuller) as a total organism with its own metabolism. Objectively we know very little about the rules of this metabolism. But we know that organic stability is predicated upon extensive communication networks, including memory, feedback and automatic decision-making capacities. The rudiments of such networks already exist, in the form of large-scale digital computer control systems. SAGE, the first computer-based air defense system; Project Mercury, the first real time digital support system for space flight; Telefile, the first on-line banking system; and SABRE, the first computerized airline reservation system are a few of many operating *real time* systems which gather and process data from environments, in time to effect future events within those environments.

Emotionally most humanists share an instinctive antipathy for these immensely complex computer systems; their Orwellian overtones far overshadow their conceivable use as artists' tools. But practically, it is imperative that artists do understand them — both technically and philosophically. These computer systems deal with *real time* events, events that are uncontrived and happen under normal circumstances. All of the data processing systems I have referred to are *built into and become a part* of the events they monitor. Already a large part of the metabolic information used to run the military and commercial interests of the United States is real time oriented. It is not proposed that artists have the choice between traditional media or using the computer. What I am saying is that the realtime information processing mode is rapidly becoming the routine style of handling information.

To date, most artists have been archivists doing the bulk of the art historian's task. The greater implication of this is that since the Renaissance the self-metaprogram of art has been predicated upon nostalgia. Recapturing a real or imagined classical past

7 McHale, John (1969): *op. cit.*, p. 123.

has been its goal. Modern art is the trauma of moving further and further away from that ideal. The public has been taught to buy and hold on to historical records in the guise of art. What a few artists are beginning to give the public is real time information, information with no hardware value, but with software significance for effecting awareness of events in the present. As long as museums refuse to acknowledge this transformation, they will remain in a peripheral and potentially obsolete role in relation to the most advanced aspects of contemporary art.

Deftness is the mark of the more sensitive artists using real time — the way in which they acknowledge systems. Here I think the work of Hans Haacke has consistently developed since 1963. His first works with water, emulsions, steam, and air had elements of strong geometric containment. These were plainly gallery objects. This cannot be said of the early sail pieces and outdoor balloon lines. Here the decision to allow natural entities to "organize" themselves began. We see this in the artist's plans for the 1966 art festival at Scheveningen, Holland: .".. a 150' plastic hose, tightly inflated with helium, will fly high above the beach or sea ... And also, I would like to lure 1000 sea gulls to a certain spot (in the air) by some delicious food so as to construct an air sculpture from their combined mass."[8]

In much the same sense Haacke's *Spray of Ithaca Falls: Freezing and Melting on a Rope* depended upon environmental conditions. A nylon rope was wrapped in screening and suspended across the falls. Flowing water and freezing cycles quickly built a snow and ice configuration over a four day period. A desire to work in neutral, nonart circumstances was evident in Haacke's *Wind Room* (summer 1968) at the Mexico City University Museum. It consisted of an open, monochrome space bordered on two sides by heavy mesh screens, masking the air distribution system.

Some recent tendencies in Haacke's work intrigue me. One is a willingness to use all forms of organic life — from the most elementary to the most complicated. This seems a logical extension of his philosophy of natural systems. A work of last winter involved the incubation of chicks as an ongoing process. Already Haacke is planning more complete animal "ecologies" where information is derived from the normal activities of animals in their environments. For a museum, he is planning a steady output of statistical information about visitors involving a small process-control computer and a display device. Two years ago Haacke would have balked at using this kind of technology; today, working more closely with events, it becomes a necessity. As Haacke explains:

The artist's business requites his involvement in practically everything ... It would be bypassing the issue to say that the artist's business is how to work with this and that material or manipulate the findings of perceptual psychology, and that the rest

8 From a letter to the author (February 1966).

should be left to other professions ... The total scope of information he receives day after day is of concern. An artist is not an isolated system. In order to survive ... he has to continuously interact with the world around him. Theoretically, there are no limits to his involvement.[9]

John Goodyear has departed from Haacke's steam and ice pieces in a series of "heat tubes." Some of these are arrays of tubes with constant temperatures; others temporally fluctuate from hot to cold. As Goodyear has progressed, his constructions look less like sculpture and begin to resemble wall fixtures and unspecific utilities. One of the best is a semiburied series of plates and pipes entitled *Snowmelter, Measurer* (1968) which acts symbiotically with the weather, possessing no iconographic value.

I found Dennis Oppenheim's exhibition last January the most provocative of the season. The models and documents presented moved beyond his previous "ground systems" to a broad use of interacting ecologies. It included the farm systems of the previous summer, the Connecticut forest floor "removal" and "transplant" pieces of that fall, the New York Stock Exchange transplant, and the "time" and "border" activities of his December visit to Maine and Canada. Oppenheim's use of tractors, snowplows, airplanes, and seacraft are normal uses of available technology. This makes real sense compared to most hardware exotica out of the studio.

In July, 1968, Oppenheim directed the harvest of a 300 by 900 foot oat field in Hamburg, Pennsylvania. Cutting, gathering, baling, and trucking of bales were stages of the art process documented. At that time the artist planned a work for the summer of 1969 in which "isolated episodes will be directed towards a core network involving every permutation (from planting to distributing the product)."[10] This began last April in Finsterwolde, Holland, and is still to be completed. The parameters of this project are more complicated than the one in Pennsylvania, but Oppenheim does specify that "a portion of this crop will be selected by the artist and sold in 25-pound sacks. Also four carloads of wheat will be purchased from the Dutch commodity exchange in Amsterdam, and sold short in the United States."[11]

The significance of this project is that Oppenheim is using the untapped energy and information network of the day-to-day environment. Such situations produce abundant information with a minimum of reorganization. Seen from the artist's point of view, Oppenheim explains that:

In ecological terms what has transpired in recent art is a shift from the "primary" homesite to the alternative or "secondary" homesite. With the fall of the galleries, artists have sensed a similar sensation, as do organisms when curtailed by disturbances of environmental conditions. This results in extension or abandonment of

9 From a talk by Hans Haacke at the Annual Meeting of the Intersocietal Color Council, April 1968.
10 From a statement by the artist to the author (September 1968).
11 From a statement by the artist to the author (March 1969).

the homesite. The loft organism, stifled by the rigidity of his habitat, works on, not recognizing that his output is waning, by contemplating new ways to work within old bounds.[12]

Signal recognition that art is information processing appeared with Conceptual Art. In Sol LeWitt's words, "Since no form is intrinsically superior to another, the artist may use any form, from an expression of words (written or spoken) to physical reality, equally."[13]

One of the early conceptualists, Douglas Huebler has recounted his gradual withdrawal from the making of art objects. As a "second generation" Minimalist, he was forced to consider context. Some works diminished substantially outside the gallery, raising the question of sculpture competing with "real things" in the outdoor environment. He saw art objects as a series of strategies for reducing ambient dominance, while, paradoxically, such rivalry seemed out of place:

An object may defeat or suspend the competition of other things by being made more "interesting" : larger and/or with intensification of color, formal complication, etc. However, I see such adjustments as a kind of "mannerism"...

I choose not to make objects ... instead I have set out to create a quality of experience that locates itself "in the world" but is not called upon to "judge" or to infer "meaning" from particular appearances. I now make work that consists of "documents" that form a conceptual "frame" around a ... location.[14]

Huebler's November 1968 catalog may become the most important "show" of that year. His documentation is less visual than Oppenheim's. *42° Parallel*, involving the sending and receiving of postal receipts to ten towns on the 42° latitude, is simply an annotated map of the United States, photographs of the dated receipts, and a written description.

Rock #2 was "found" while D. Burgy was walking in the fields and woods of Bradford, Massachusetts, on September 4, 1968. It exists as a collection of about thirty documents "... from the geologic past to the present moment; and in material size, from the continental to the atomic. The techniques of recording are appropriate to the kind of information presented and include visual, verbal, and mathematical data."[15] The rock is no capitulation to Dada notions about sculpture. Burgy maintains that it is "objective information about his experience in the world," it could be any rock, but it isn't; and it presents in uncompromising terms the nexus of art information, namely focus on experience. Visually this is manifested at a number of resolution levels: the rock appears under an electron microscope at 1250 power, and then from 2 feet, 10

12 Ibid.
13 LeWitt, Sol. "Sentences on Conceptual Art" in *0 to 9* (Bernadette Mayer and Vito Hannibal Acconci, eds.) (New York: Vito Hannibal Acconci 1969), p. 4.
14 From a statement by the artist to the author (May 1969).
15 From a statement by the artist to the author (June 1969).

feet and 20 yards, from 500 feet in an airplane, from 500 miles in a space satellite, and from an assortment of official survey maps.

Focus for Robert Barry is reversed: it is what we know about an environment without seeing or experiencing it. Radiation from a vial of Barium-133 buried in Central Park is simply Central Park. Most "air art" is air-supported hardware. But Seth Siegelaub's poster for Barry's "Inert Gas Series" is eminently software, a blank white 22$^{1}/_{2}$ by 35 inch sheet with one small line of information at the bottom. On another level Joseph Kosuth and Steven Kaltenbach have used printed media with an eye for all possible spinoffs. Kosuth's present exhibition of duplicate advertisements in ten different cities, and their museums, is the essence of data dispersion.

For over a year Siegelaub has been "gallery director" for the best of the conceptualists. His publications of calendars and catalogs are already collector's items. That he has already evolved a nonstyle was demonstrated by his exhibition of Barry, Huebler, Kosuth, and Weiner last January. Held in a rented office of the McLendon Building on 52nd Street, the room contained catalogs on a coffee table and a few places to sit. Siegelaub is obviously one of the best artists in his gallery, and in a sense his artists know it. They are subcontracting to his prime contract as a data organizer.

Art as information processing leaves little in the way of protection for the artist. Style used to be the art system's equivalent to patent rights. And even among the conceptualists one senses a certain degree of deference and respect for each other's ideas. But if the output of artists continues to be based upon nonsequential ideas, it may be impossible to support the notion of "ownership." Such ownership amounts to who *amplifies* original data first so that it becomes information. For instance, a particular electronic circuit may be discovered a dozen times before it is invented. "Invention" takes place only when a large firm uses the circuit in a major production, and then has it entered into an electronic handbook. The design engineers of that particular company then become "inventors."

As an information organization principle, this has been expressed by the ecologist, Ramon Margalef. According to Margalef, boundaries between systems in nature are usually asymmetrical. More organized systems always gain information and energy from less organized systems. This pertains to the relations between plants and animals, atmosphere and sea, environment and thermostat, enzyme and RNA molecule, biotope and community, prey and predator, agrarian communities and industrial societies. In each case the last named system feeds on the energy surplus of the first:

It is a basic property of nature, from the point of view of cybernetics, that any exchange between two systems of different information content does not result in a partition or equalizing of the information, but increases the difference. The system

with more accumulated information becomes still richer for the exchange. Broadly speaking, the same principle is valid for persons and human organizations: any exchange increases to a greater extent the information of the party already better informed.[16]

Little imagination is needed to realize how this principle operates within the art system. As the fame of a living artist grows, he ceases simply to make data. His subsequent output is information since it is already art history. Plagiarism of existing information, *i.e.*, the work of well-known artists, has minimal energy — unless original information becomes the object of new data in a very convincing way. On the other hand, famous "avant-garde" artists may capitalize upon the work of their lesser-known contemporaries. Being better organized systems, established artists have greater access to museums and media. It is important, however, that they use such material while it is still data, *i.e.*, before it becomes art information.

On a personal level Margalef's cybernetic principle remains a matter of ethics and practicality. But its implications for the total art information system are far-reaching. As information processing becomes more generally understood, institutions and persons — other than artists — will insist upon creating their own art information. Specifically I am thinking about projects, which demand money, planning, and technical support far beyond the individual artist's means. Artistic endeavor is thus brought up (or down) to the level of corporate research. We have only to think of that saga of lonely enterprise, the inventor-hero capitalist. Such a social ideal was only possible in a society with no scientific grasp of the nature of information.

The altruism of artist groups has rarely survived the commercial success of one member. Pulsa, of New Haven, may be different — if it can hold on economically. With members ranging from mathematicians and computer specialists to painters, their focus is on computer-based programs of light and sound output. But it is in the realm of group interaction that Pulsa projects, hopefully, a new breed of artists. The group does not produce conglomerates of separate works by individuals, but rather common projects. As much as possible, all aesthetic and technical decisions are shared equally. Ego frictions between technicians and artists seem to have been brought to a minimum.

Like the human brain, Pulsa operates on principles of parallel processing ... approaching a point at which specialization becomes irrelevant due to the fact that the operating control system speaks a simplistic environmental language or even operates autonomously. In this sense their objective is an intelligent system which in itself embodies the optimum state of the group's and the system's interactive functioning, which itself constitutes the ultimate work of art.[17]

JACK BURNHAM REAL TIME SYSTEMS

16 Margalef, Ramon. *Perspectives in Ecological Theory* (Chicago: The University of Chicago Press 1968), pp. 16-17.
17 From a statement by Pulsa to the author (April 1969).

Having witnessed Pulsa's activities over a year, I am convinced that there is substance behind these words. Ultimately Pulsa see themselves as planners and coordinators, functioning in the industrial, urban and natural environments. However, the full impact of taking art out of its socially acceptable surroundings did not reach me until last winter. I flew in a plane over the Pulsa installation on the outskirts of New Haven, circling into their light configurations for about ten minutes before heading east for Boston. Five minutes away I overheard a radio conversation between a small plane and air control at New Haven airport. The plane reported a "disturbing" light phenomenon ort the ground. Air control told the pilot to file a complaint with the Civil Aeronautics Administration (CAA).

There are two kinds of artists: those who work within the art system, and those few who (work with) the art system. Les Levine epitomizes the second type. Few people grasp this fact, or its implications, and to dismiss Levine's work as Dada or kitsch is missing the point. Where industrialists think of art as a good tax dodge or as a kind of pastoral retreat, Levine considers business and industry to be art in its most essential form.

Every artist of any substance sells his art through shrewd advertising and press agentry. For Levine these are legitimate art forms. Artists are beginning to use signed releases, contracts, and sales conditions as supplementary art information; Levine has done so for years. The fact that he uses them so blatantly, with no deference to the professional gentility of the art system, is the equivalent of style. The worst mistake would be to read taste or style into objects, which he has fabricated. Despite the fact that all successful commodity art has to be uncommonly "pretty" and have a convincing pedigree, Levine's plastic shapes are neither. They are direct, raw, neutral results of quantity production. Neither should his objects be considered multiples or merely small-sized quality art works. Levine, I feel, has set out to vindicate the art system, namely that anything can be sold with enough public relations energy behind it. His integrity lies in the fact that he has refused to feed collectors' neuroses with illusions of permanence and quality. Levine states:

All process-oriented works rely on the viewer and the art critic for their final definition as works of art. If it is neither photographed nor written about, it disappears back into the environment and ceases to exist. Many serious artists at this time, are for the most part involved in making art producing systems. The works themselves are not to be considered as art, rather systems for the production of art.[18]

On March 27, 1969, Levine bought five hundred common shares of stock in the Cassette Cartridge Corporation; when resold the profit or loss became the work of art.

18 Levine, Les. *"For Immediate Release"* in *Arts and the Artist,* May 1969, pp. 46-50.

His coin and airline projects have been conducted similarly, using existent societal systems. Inflation-wise, prestigious commodity art is better than money. As I see it, Levine is simply circumventing the roundabout process of producing paintings and sculptures for sale and, instead, making the message — money — becomes the medium. Some artists involved in "process" announce their projects in archaic art formats; Levine's typically is a press release. In an age when technological processes define lifestyle, "Choice and taste can only be considered neurotic."[19] He goes on to write:

I've never seen a work of art I didn't like. Good or bad are irrelevant in terms of process. On a process level being totally excited is of no more value than being totally bored. If you run around in your backyard and make a good painting, it's just the same as running around in your backyard and making a bad painting. Running around is running around.[20]

Levine's Restaurant at 19th Street and Park Avenue South *is* a Levine; which is to say, it is refractory, plastic, and the ultimate real time art work devised to date. The restaurant is process in all its vicissitudes. For my taste, his closed-circuit television and color scheme leave much to be desired, but the food is very reasonable. Levine worries and tinkers with the software, and appears to be more concerned with writeups in *Restaurant News* than in *Art News*. *Levine's* lacks that much-admired Howard Johnson sterility, but he keeps trying. On the art level, it has to be accepted for what it is: a self-organizing, data generating system. What other artist has a gallery showing his work fourteen hours a day, seven days a week, always changing, charging no commission, and allowing him to eat free?

At present the art communication and education structure is hardly prepared to handle such a broad conception of art as Levine's. For that matter, it breaks down frequently with current definitions. Any fundamental shift will probably involve the complete absorption of art into the media. But the reality of art continues to reside in its unreality. Any progress in the development of real time art recognizes that conceptual focus must keep the two apart. In this respect, the hoax of treating artists as social beautifiers should be exposed once and for all. As McLuhan insists, the artist is fundamentally antisocial. To use another cybernetic analogy, artists are "deviation-amplifying" systems, or individuals who, because of psychological makeup, are compelled to reveal psychic truths at the expense of the existing societal homeostasis. With increasing aggressiveness, one of the artist's functions, I believe, is to specify how technology uses us.

19 Ibid.
20 Ibid.

Art is becoming a matter of ecological insight. The Berkeley *People's Park* is a real time work of art. Even as a decimated cyclone-fenced lot, it challenges societal norms in the most fundamental way. As thirty thousand people marched from the *People's Park Annex* for the Memorial Day Protest last May, dozens of grass plots appeared on concrete and asphalt. A loudspeaker played "Why Don't We Do It in the Road?" In a country of 100,000,000 vehicles, what better gallery could you find?

Reprinted from Burnham, J. W. *Great Western Salt Works: Essays on the Meaning of Post-Formalist Art*. New York: George Braziller, 1973.

CHARLIE GERE

JACK BURNHAM AND THE WORK OF ART IN THE AGE OF REAL TIME SYSTEMS

No account of "real time" art, or even art in an age dominated by real time technologies can be undertaken without acknowledging the importance of the work of critic and theorist Jack Burnham. It can be said that Burnham is to art in the age of real time systems what Walter Benjamin was to art in the age of its mechanical reproducibility. Born in 1931, Burnham spent the early part of his career, from 1955 to 1965, working as an artist, making light sculptures. He then turned to art criticism, for *Arts* magazine, to which he contributed from 1968 and where he was Associate Editor from 1972 to 1976, and *Artforum*, for which he wrote from 1971 to 1973, and where he was contributing editor from 1971 to 1972. In 1968 he published the book for which he is best known, *Beyond Modern Sculpture: The Effects of Science and Technology on the Sculpture of This Century* (Burnham 1968). *Beyond Modern Sculpture* ends with a chapter devoted to what he saw, at that time, as a possible future for sculpture and art in general, with works that invoked or operated as systems. These ideas are taken up and extended in two essays he wrote for *Artforum*, "Systems Esthetic," published in 1968 and "Real Time Systems," published a year later (both reprinted in his 1973 collection of essays, *Great Western Salt Works*). The first proclaimed the advent of the eponymous "systems esthetic [sic]." He claimed that we are "now in transition from an *object-oriented* to a *systems-oriented* culture. Here change emanates not from *things*, but from *the way things are done*." (Burnham 1973: 16) He expanded this definition thus:

The priorities of the present age revolve around the problems of organization. A systems viewpoint is focused on the creation of stable, ongoing relationships between organic and non-organic systems, be these neighborhoods, industrial complexes, farms, transportation systems, information centers, or any other of the matrixes of human activity. All living situations must be treated in the context of a systems hierarchy of values. Intuitively many artists have already grasped these relatively recent distinctions and if their 'environments' are on the unsophisticated side, this will change with time and experience.

(BURNHAM 1973: 16)

Out of this idea Burnham constructed a radical vision of the role of the artist in an "advanced technological culture." He saw the notion of a systems aesthetic as a more useful way of understanding current artistic practice than concepts such as "theatrical" or "literalist" art, or the idea of a "post-formalistic esthetic":

The systems approach goes beyond a concern with staged environments and happenings; it deals in a revolutionary fashion with the larger problem of boundary concepts. In systems perspective there are no contrived confines such as the theater proscenium or picture frame. Conceptual focus rather than material limits define the system. Thus any situation, either in or outside the context of art, may be designed and judged as a system. Inasmuch as a system may contain people, ideas, messages, atmospheric conditions, power sources, and so on, a system is, to quote the systems biologist, Ludwig von Bertalanffy, a 'complex of components in interaction,' comprised of material, energy, and information in various degrees of organization. In evaluating systems the artist is a perspectivist considering goals, boundaries, structure, input, output, and related activity inside and outside the system. Where the object almost always has a fixed shape and boundaries, the consistency of a system may be altered in time and space, its behavior determined both by external conditions and its mechanisms of control.

(BURNHAM 1973: 17)

Burnham looked at the work of a number of artists who exemplify these ideas, including Marcel Duchamp, Laszlo Moholy Nagy, the GRAV group, Robert Morris, Robert Smithson, Carl André, Dan Flavin and Hans Haacke. These artists repudiate the traditional craft function of art as a means of producing material entities. Instead their aesthetic impulse manifests itself through a concern with "the means of research and production." Haacke's work in particular, which at the time was mostly concerned with systems and feedback, rather than with politics, exemplifies the systemic and cyber-

netic ideas that Burnham was interested in. "Systems Esthetics" was Burnham's attempt to understand and delineate the shape and form of the art practices emerging in the late 1960s, which would later become known as "conceptual art," "land art" and "minimalism." For him they prefigure humankind's necessary transformation, in the emerging technocratic "superscientific culture," from *homo faber* to *homo arbiter formae*, the "maker of aesthetic decisions" (Burnham 1973: 24), and the arbiter of how the increasingly advanced tools of industrial civilization will be used. This will "control the quality of all future life on earth." In such a situation, "the most important artist best succeeds by liquidating his position as artist *vis-à-vis* society." (Burnham 1973: 16)

A year after he published "Systems Esthetics" and following a period as Fellow at Gyorgy Kepes' Center for Advanced Visual Studies at the Massachusetts Institute of Technology, where he used a time-sharing computer at the Lincoln Laboratory, Burnham followed up some of the same ideas in another paper, also published in *Artforum*, entitled "Real Time Systems." Here he developed a full-blown systems theory of art, starting with the trenchant observation that "[P]resently it will be accepted that art is an archaic information processing system, characteristically Byzantine rather than inefficient." (Burnham 1973: 27) He compared art to a large computer system in which artists are "programs and subroutines" which "prepare new codes and analyze data in making works of art." Such activities are supervised by "metaprograms," which "consist of instructions, descriptions, and the organizational structures of programs." Examples of metaprograms include "art movements, significant stylistic trends, and the business, promotional and archival structures of the art world." (Burnham 1973: 27) Finally the top level of this hierarchical command structure contains…

…a self-metaprogram which, on a long-term basis, reorganizes the goal of the art impulse. The self-metaprogram operates as an undetected overseer, establishing strategies on all lower levels in terms of societal needs. Because we have no comprehensive picture of human life, these needs remain rather obscure (Zeitgeist is not sufficiently teleologic to express the anticipatory monitoring function of the self-metaprogram).

(BURNHAM 1973: 27)

Burnham extended this informational metaphor by describing art in terms more familiar from business management, as he admits. The self-metaprogram is the source of values, but they in turn are simply the result of "long-term information processing structures," such as galleries, museums and art historians. The survival strategy of such institutions is to transform "preferred information into values." Thus "critics, magazines, galleries, collectors and historians exist to create information out of unprocessed art

data [i.e., the stuff that artists produce]. History is uncertainty about art minimized." This understanding of art as an information system allowed Burnham to dispense with a "major illusion of the art system," that "art resides in specific objects." He pointed out that without the support system of the institutions that process art data to make information, the object ceases to be defined as a work of art, but the system can continue to operate and support the notion of art without objects. Thus art is no longer restricted to "canonical or given forms" but can embrace "every conceivable experiential mode, including living in everyday environments." (Burnham 1973: 27)

Burnham compared this to the difference between computer hardware and software. He suggested that if one recognizes the distinction between the message and its material substrate, analogous to that between software and its "physical transducer," then all the means by which the "information processing cycle of art, books, catalogs, interviews, reviews, advertisements, sales and contracts can be recognized as the software extensions of art. This meant that

the art object is, in effect, an information "trigger" for mobilizing the information cycle. Making, promoting, and buying art are real time activities. That is to say, they happen within the day-to-day flow of normal experience. Only Art Appreciation happens in ideal, nonexistential time.

(BURNHAM 1973: 28)

Burnham contrasted the real time activities of the art cycle to the idealized notion of art derived from the classical frame of reference, which simplifies and idealizes art experience and removes it from the flow of time. But this view, which is consonant with the idealizing and isolating activities of classical science, is no longer adequate to the emerging cybernetic and systems view of the world, or to the rapid development of information and communications technologies. Following the Futurologist (and artist) John McHale and media theorist Marshall McLuhan, Burnham proclaimed the then-fashionable idea that, through such developments, the world is both becoming recognisable as a "total organism with its own metabolism." (Burnham 1973: 29)

Objectively we know very little about the rules of this metabolism. But we know that organic stability is predicated upon extensive communications networks, including memory, feedback and automatic decision-making capacities. The rudiments of such networks already exist, in the form of large-scale digital computer control systems. SAGE, the first computer-based air defense system: Project Mercury, the first real time digital support system for space flight; Telefile, the first on-line banking; and SABRE, the first computerized airline reservation system are a few of many opera-

ting real time systems which gather and process data from environments, in time to effect future events within those environments.

(BURNHAM 1973: 29)

Thus Burnham's software metaphor was also intended to be taken literally:

Emotionally most humanists share an instinctive antipathy for these immensely complex computer systems. Their Orwellian overtones far overshadow their conceivable use as artists' tools. But practically it is imperative that artists do understand them — both technically and philosophically. These computer systems deal with real time events, events which are uncontrived and happen under normal circumstances. All of the data processing systems I have referred to are built into and become part of the events they monitor. Already a large part of the information used to run the military and commercial interests of the United States is real time oriented. It is not proposed that artists have the choice between traditional media or using the computer. What I am saying is that the real time information processing mode is rapidly becoming the routine style of handling information.

(BURNHAM 1973: 30)

For Burnham the emergence of real time systems challenged the role of art as traditionally perceived since the Renaissance, which has been "predicated upon nostalgia." He continued that "[W]hat a few artists are beginning to give the public is real time information, information with no hardware value, but with software significance for effecting awareness of events in the present." (Burnham 1973: 30) He presented a number of examples of what he means by artists such as Hans Haacke, Denis Oppenheim, Douglas Huebler, Joseph Kosuth, the art-engineering group Pulsa, and Les Levine, as well as a description of the Berkeley People's Park as a "real time work of art." Near the end of the essay, following a description of Les Levine's *Levine's Restaurant* project, which involved opening a fully functioning Irish-Jewish-Canadian restaurant, Burnham stated that

at present the art communication and education structure is hardly prepared to handle such a broad conception of art as Levine's. For that matter it breaks down frequently with current definitions. Any fundamental shift will probably involve the complete absorption of art into the media. But the reality of art continues to reside in its unreality. Any progress in the development of real time art recognizes that conceptual focus must keep the two apart … To use [a] cybernetic analogy, artists are "deviation-amplifying" systems, or individuals who, because of psychological

makeup are compelled to reveal psychic truths at the expense of the existing societal homeostasis. With increasing aggressiveness, one of the artist's functions, I believe, is to specify how technology uses us.

(BURNHAM 1973: 37-38)

Many of these ideas were also expounded in a lecture Burnham gave at the Guggenheim in 1969, entitled "The Aesthetics of Intelligent Systems," which also followed from his experiences as a Fellow the Center for Advanced Visual Studies. In the talk he made the connection between emerging art practice and developments in computing technology even more explicit:

Although the art of the future could take any one of a number of directions, it seems to me that, with the steady evolution of information processing techniques in our society, an increasing amount of thought will be given to the aesthetic relationship between ourselves and our computer environments — whether or not this relationship falls into the scope of the fine arts.

(BURNHAM 1970: 95)

For Burnham the example of such technologies offered an entirely new form of aesthetics:

The continued evolution of both communication and control technologies bodes a new type of aesthetic relationship, very different from the one way communication of traditional art appreciation as we know it... [t]he "aesthetics of intelligent systems" could be considered as a dialog where two systems gather and exchange information so as to change constantly the states of each other.

(BURNHAM 1970: 96: BURNHAM'S EMPHASIS)

As our involvement with electronic technology increases, however, the art experience may undergo a process of internalisation where the constant two-way exchange of information becomes a normative goal. We should rightfully consider such a communication shift as an evolutionary step in aesthetic response.

(BURNHAM 1970: 100)

It must be noted that Burnham was writing at a time when the potential for computers to be communications and control devices was far from generally obvious. As Burnham himself points out...

...We tend to think of the computer at its present stage of development as a superfast calculator or data file: few of us conceive of it as a system which can reorganize many remote environments and channel them into a sustained and coherent experience.

(BURNHAM 1970: 100)

But the actual potential of computers for making art was not Burnham's only concern, even if he did devote much of the talk to current developments, as was the case with the work of computer scientists such as A. Michael Noll and the *Cybernetic Serendipity* exhibition at the ICA, as well as work going on in artificial intelligence and cybernetic systems, including work by Nicholas Negroponte and Marvin Minsky at MIT. He was as interested in the more general shift in art practice that mirrored developments in computing technology, and that reflected upon the world it was bringing about. To this end he discussed the work of Dennis Oppenheimer, Douglas Huebler, Hans Haacke and other artists involved in constructed environments and responsive works of art, as well as those more explicitly involved with technology, such as James Seawright, Pulsa and Les Levine. He also admitted that

it is unrealistic to expect to expect artists to begin to use computers the way they use paints, canvas and wielded steel. As a rule, new and exotic technology has not led to the production of great or even good art. Somehow the aesthetic implications of a technology become manifest only when it becomes pervasively, if not subconsciously, present in the lifestyle of a culture. In terms of a public utility, we are at least ten to fifteen years away from the kinds of machine creativity I have discussed. But if I have tried to make an argument for an eventual evolution toward two-way communication in art, it is because present circumstances point in that direction.

(BURNHAM 1970: 119)

He continued in similar prescient mode to point out that

computers will radically reorganize social values, although in the first stages they may do it badly. I believe that they will be seen as one of the few reasonable alternatives to continued social, technical and ecological chaos. My hope is that the initial complexity of these information systems will not prevent substantial numbers of artists from thinking about and using them.

(BURNHAM 1970: 120)

It was a result of hearing this talk that Karl Katz, Director of the Jewish Museum in New York, invited Burnham to curate a show that would embody his ideas. This resulted in *Software, Information Technology: its new meaning for art*, which opened in 1970. The title derived from Burnham's metaphorical description of the difference between an artwork's material substrate and its message in terms of computer hardware and software. In *Software* Burnham was able to put into practice his ideas about the future of art in a world increasingly dominated by information communication technologies. As Burnham wrote in the catalog:

It demonstrates in a limited sense the effects of control and communication techniques in the hands of artists. Most importantly it provides the means by which the public can personally respond to programmatic situations structured by artists... In just the past few years, the movement away from art objects has been precipitated by concerns with natural and manmade systems, processes, ecological relationships and the philosophical-linguistic involvement of Conceptual Art. All of these interests deal with art that is transactional in that they deal with underlying structures of communication and energy exchange instead of abstract appearances.

(BURNHAM 1970B: 10)

True to his earlier proclamations Burnham refused to distinguish between art and nonart in his choice of exhibits, though he did divide the show structurally according to a scheme derived, somewhat jocularly, from Marcel Duchamp's *Large Glass*. The bottom two floors were mostly "computers and experiments," while the third floor consisted of work by conceptual artists. Such an apparently simple description fails to convey the peculiarly eclectic mix of exhibits that made up the show, which, far from being simply divided into two approaches, ran along a spectrum between straightforward technological application and nonmaterial conceptualism. At one end of the spectrum were a number of research applications of computing and electronic technology, including the Smith-Kettlewell Institute of Visual Sciences' *Vision Substitute System*, which aimed to

turn visual imagery into some form of tactile sensation, and Sonia Sheridan's *Interactive Paper Systems*, which demonstrated various artistic uses of a 3M Thermofax Machine, an early color photocopier.

At the other extreme there were a number of works of conceptual art, including John Baldessari's *Cremation Piece*, in which he proposed to have all his extant art works burned in a mortuary and interred in the Jewish Museum; Douglas Huebler's *Variable Pieces* and *Location Pieces*, which are composed entirely of instructions to the viewer/participant; Donald Burgy's *Selected Mental Characteristics of Donald Burgy*, which consisted of a range of medical and scientific data about the artist; Burgy's *Question-Answer*, which was a transcript of a conversation along with the results of a polygraph (lie detector); Lawrence Weiner's text piece, *An Accumulation of Information Takes from Here to There*; Alan Kaprow's happening, *Work*, in which a hall was painted and repainted over three weeks; and, perhaps the most extreme, Vito Acconci's *Room Situation*, in which Acconci proposed to stand near people visiting the show and intrude on their personal space. (Though Nam June Paik's contribution may be considered more immaterial, consisting as it did, of a polite and poetic refusal to participate, which was reproduced in the catalog.) Perhaps the most highly developed conceptual work was Joseph Kosuth's *The Seventh Investigation (Art as Idea as Idea) Proposition One*. This work displayed the same text in a number of different contexts; a billboard in English and Chinese in the Chinese neighborhood of Lower Manhattan; an advertisement in *The Daily World*; and a banner in Turin (in Italian, which was temporarily on display at the Museum of Modern Art's *Information* exhibition.)

In many ways the most interesting work in *Software* was that which lay between the two extremes. Part of the interest lay in how difficult it is to respond to these works and to place them in an art historical context. Unlike the purely technical exhibits, which can be considered as research, or the conceptual pieces described above, which have been enfolded into the canon of contemporary art history, these works remain strangely intriguing and provocative. For example Agnes Dene's *Dialectic Triangulation: A Visual Philosophy* is almost impossible to grasp, from the catalog at least, even from its instantiation as a computer display called *Matrix of Knowledge and Trigonal Ballet* (though it is also described in Lucy Lippard's *Six Years*). Dene is now best known for her extraordinary ecological art project, *Wheatfield — A Confrontation*, in which two acres of wheat were sown and harvested in the Battery Park landfill in Downtown Manhattan in 1982, as an incentive for people to think about the relationship between capitalism and world hunger. (This work now gives an added frisson in that it took place, as the photographic documentation shows, almost directly under the twin towers of the World Trade Center.) Other works included Theodosius Victoria's *Solar Audio Window Transmission*, in which the windows of the Jewish Museum were

connected up to solar batteries and radio units, in order to transmit broadcasts from various public service channels; Scott Bradner and Jack Nolan's *Floor Show*, in which computer-controlled and interactive spots of light were projected onto the floor to mimic the behavior of fish; Allen Razdow's and Paul Conly's *COMPOSER*, which used the latest in synthesizer technology to present an interactive, random music-making machine; or Robert Barry's *Ultrasonic Wave Piece*, in which ultrasonic waves were reflected by interior surfaces, filling the selected area with invisible changing patterns and forms. Carl Fernbach Florsheim's *Boolean Image/Conceptual Typewriter* showed the potential of a computer to produce concrete poetry, while John Giorno set up a series of daily radio transmissions to broadcast programs of poetry readings within the museum.

The most important works that explored the use of technology at a practical as well as theoretical level were probably Ted Nelson's *Labyrinth*, Nicholas Negroponte and the MIT Architecture Machine Group's *Seek* and the two works by Hans Haacke, *Visitor's Profile* and *News*. In retrospect the first would appear to be little more than an electronic database, or what Nelson called an "interactive text retrieval system/catalog," but was also described as "the first public demonstration of a hypertext system." In this it anticipated many of the developments in computing that would take place over the next few decades, including that emerging out of XeroxPARC, later taken up by Apple, which led to the first commercial instantiations of hypermedia or what later became known as multimedia, as well as the structure of the World Wide Web. *Seek* is a curious art/research hybrid involving a collection of metal cubes, a computer-controlled grabber arm and a number of gerbils. The idea was that the gerbils would disrupt the ordered cubes and the arm would reorder them. In some ways it is a paradigmatic cybernetic piece. Of Haacke's two pieces, *News* is comparatively banal, involving some ticker tape machines that ceaselessly spew out tape. *Visitor's Profile*, on the other hand, was far more ambitious. The idea was to collect, collate and tabulate data gathered from visitors by questionnaires via a DEC PDP 8 computer. Unfortunately the computer, which also controlled a number of the other exhibits, failed to work properly for the first month. This, along with other problems, including budget overruns and the fact that the gerbils used for *Seek* fought with each other, meant that the show did not transfer to the Smithsonian as planned, and was widely considered to be a failure. Agnes Denes was so disgusted by both the absence of adequate computing equipment and the attitude of the technicians that she wrote to Studio International, lodging a protest supported by a number of other artists. The letter was published in the same issue. The show also drew fire on account of its sponsorship by American Motors Corporation.

Burnham certainly considered it to have failed and in the end refused to have

SEEK

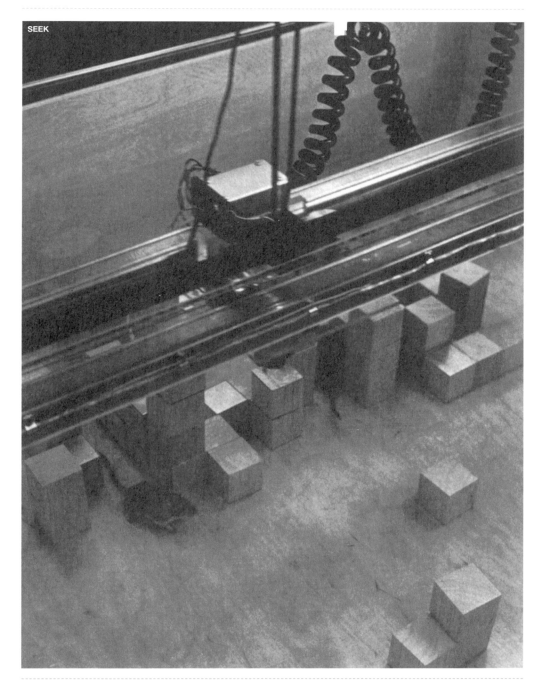

anything to do with it. In the mid-'70s he published a melancholy and even bitter essay entitled "Art and Technology: The Panacea that Failed." In it he describes the major art and technology initiatives of the late sixties and early seventies, including *Cybernetic Serendipity*; Maurice Tuchman's five-year-long *Art and Technology* project at the Los Angeles County Museum; the work of Experiments in Art and Technology; and of the Center for Advanced Visual Studies at MIT as well as *Software*. In each case he speculates why they had not succeeded and, more generally, why the use of new technologies and related ideas such as cybernetics by artists had failed to be the, or even a, future of art. Though prepared to accept technical or aesthetic incompetence as part of the problem, he also proposes that, at a deeper level, between art and technology there is a "radical dissimilarity as systems of human semiosis." He suggested that

my experiences with semiology and iconography lead me to believe that the enormous vitality and will-to-change behind Western Art is in a sense an illusion, just as technology harbors its own illusionary impulses. Only within the past ten years have we begun to accept the possibility that technological solutions are not universal panaceas. Gradually but surely, much of it in unspoken terms, we are beginning to accept evidences that scientific research and technological invention have their boundaries. Such a speculation would have been nearly unthinkable fifteen years ago when scientific grants were plentiful and the avant-garde was the key to artistic success. Perhaps technology is only a matter of manmade or artificial negentropy which because of its enormous productive capacity and ability to aggrandize perception into convenient and coherent package of "information," we perceive as invincible, life-stabilizing, all-meaningful and omnipotent.

(BURNHAM 1980: 212)

At the time, however, the failure of art and technology and of the systems aesthetic was not so obvious. In the early 1970s artists, theorists and critics were still suggesting that the coming together of art and information communications technologies represented the future of art. In 1970 Gene Youngblood published *Expanded Cinema*, one of the most futurist conceptions of the future of art and technology, in which systems theory, cybernetics, the ideas of Buckminster Fuller (who wrote the introduction) and John McHale are invoked in relation to examples of experimental film and video work. In 1972 Thames and Hudson published Jonathan Benthall's *Science and Technology in Art Today* as part of its World of Art series. A year later *Artforum* published a dialog between John McHale and Alvin Toffler discussing the "future and functions of art" in distinctly futurological terms. Also in 1973 Douglas Davis published *Art and the Future*, which unabashedly presented the future of art as likely to develop from art and technology initiatives.

In one sense the coming together of art and real time technology was part of a broader set of movements and strategies that Adrian Henri described as "total art," which also included performance, multimedia environments, installation art, video art, destruction in art, land art, mail art as well as what was beginning to be known as conceptual art. In his 1974 Thames and Hudson book *Total Art: Environments, Happenings, and Performance*, Henri devotes four or so pages, out of about two hundred, to art and technology. In one sense this is a perfectly adequate reflection of the comparative status of such work, as it was perceived at the time, and considerably more generous than more recent histories of the period, which tend to ignore or at least completely marginalize such art and technology initiatives. But, at another level, work of this sort came closest to expressing the "systems consciousness" that permeated much of the art of the period, but which was mostly disavowed. Whatever its acknowledged or explicit intentions the post-war avant-garde strongly reflected the context in which it developed, in which new systemic, cybernetic, and informational ways of thinking and new forms of technology, were of increasing importance. It is possible to speculate that part of the problem with art and technology and its apparent disappearance after the early 1970s was that it revealed and even celebrated the technical and technocratic nature of avant-garde art, especially in light of the increasing criticism of the instrumentality of modern technology and technological thinking by pundits such as Herbert Marcuse and Martin Heidegger, as well as the use of high tech instruments in the Vietnam War and elsewhere.

Nevertheless, art involving the explicit use of technology continued to be made, by Roy Ascott, Stelarc, Robert Adrian, and others. But by 1970 the writing was, in one sense quite literally, on the wall. Earlier in the same year as *Software,* the Museum of Modern Art put on a show that, ostensibly at least, was looking at very similar ideas. The introduction to the catalog of *Information*, written by its curator Kynaston McShine, suggested, in the light of "the general social, political, and economic crises that are almost universal phenomena in 1970," that

one necessity is … to move with the cultural stresses and preoccupations (as if you had a choice), particularly with the obvious changes in life style. The art cannot afford to be provincial, or to exist only within its own history with its own history, or to continue to be, perhaps, only a commentary on art. An alternative has been to extend the idea of art, to renew the definition, and to think beyond the traditional categories — painting, sculpture, drawing, printmaking, photography, film, theater, music, dance and poetry. Such distinctions have become increasingly blurred. Many of the highly intellectual and serious young artists represented here have addressed themselves to the question of how to create an art that reaches out to an audience

larger than that which has been integrated in contemporary art in the last few decades. Their attempt to be poetic and imaginative, without being either aloof or condescending has led them into the communications areas that INFORMATION reflects.

(MCSHINE: 1970)

This reflects the aspirations Burnham had for *Software*, and some artists exhibited in both shows. Yet *Information* showed none of the more technologically-oriented work that had been such a feature of *Software*, and which was being actively pursued by Maurice Tuchman with his Art and Technology project at LACMA, or by Experiments in Art and Technology. Though video and film were included, the majority of the work could be described as conceptual art, and as such was concerned with a critical engagement with language and systems of signification. *Information* can thus be thought of as the moment when art and technology and conceptual art went their separate ways, the former to a couple of decades of obscurity and the latter to become the dominant paradigm of art practice. Recent scholarly work, most particularly by Edward Shanken (1999, 2002) and Simon Penny (1999), has been dedicated to recovering the forgotten heritage of art and technology and to show its disavowed relation to conceptual art.

Perhaps the real issue about art and technology was not that it failed, but rather than it succeeded too well. Or rather that the promises made by art and technology for the future of technology were realized to such an extent that the role of the artist, as a mediator between society and accelerating social change, became irrelevant, or even impossible. In his 1969 essay "Real Time Systems" Burnham had written about the emergence of the eponymous "real time systems," such as SAGE and SABRE, which "gather and process data from environments, in time to effect future events within those environments." Burnham imagined the role of the artist as also giving the public "real time information, information with no hardware value, but with software significance for effecting awareness of events in the present." He suggested that this would lead to a situation in which "the most important artist best succeeds by liquidating his position as artist *vis-à-vis* society." Burnham was unusually prescient, but even he could not have foreseen the rate at which real time and network computing was developed and became part of everyday life. When he was writing such statements, computers were still largely inaccessible and esoteric. It is possible that, for Burnham and other advocates of their use in art, it was that very inaccessibility that made them interesting. They were as much fantasy objects upon which utopian ideas about the future could be projected since they were practical tools for artist to use in their everyday practice.

It is with this in mind that we can understand the relation between art that uses new technologies and conceptual art. At the end of the 1960s it was sometimes hard to distinguish between the two. Burnham certainly conflated them and regarded both as similar kinds of responses to a world increasingly mediated and dominated by complex real time systems of technology. But, by the early 1970s conceptualism was becoming the dominant mode of practice within contemporary art, while art using new technologies was beginning to disappear. This was partly because much of what such art represented or sought to achieve was coopted by the computer industry, as part of its pursuit of more effective in its operations. Hypertext, inter/multimedia and the fostering of networks of communication all became part of the "expanded field" of computing as it developed in the 1970s and 1980s. Meanwhile, confronted with the possibility of real time systems, conceptual art represented a strategy of resistance to the performativity and instrumentality of the use of language they represented. Concentration on the problems of communication and language conceptualism led to delay in the processes of information transmission, a node at which they were interrupted and diverted, or, in Shannonian terms, "noise." By interrupting the smooth transmission of information it was possible to interrogate the structures and systems of power by which transfer of information was enabled.

Despite his being a supporter and sensitive critic of conceptualism, Burnham's reputation did not survive the art scene of the 1970s and 1980s. His contribution to the debate about the current and future status of sculpture was almost entirely ignored by influential critics such as Rosalind Krauss and Charles Harrison. At the time of writing Burnham is still alive and well, but has apparently long given up any engagement with the question of art and technology. He now devotes his time to the study of the Kabbalah. Yet, with the increasing ubiquity and importance of the real time systems he wrote about so presciently in the late 1960s, Burnham's ideas are once again highly relevant. The emergence of net.art — with all the questions it raises concerning the artist's position in society, the art object, the use of technology, and the role of process and time in art — makes Burnham's ideas seem extraordinarily visionary. Any artist producing work with or about real time systems, or anybody wishing to engage with that work, would do well to read Burnham.

REFERENCES

Burnham, J. W. *Beyond Modern Sculpture*. New York: George Braziller, 1968.
Burnham, J. W. *Software, Information Technology: its new meaning for art*. New York: The Jewish Museum, 1970a.
Burnham, J. W. "The Aesthetics of Intelligent Systems" in Arnold J. Toynbee et al: *On the Future of Art*. New York: The Viking Press, 1970b.
Burnham, J. W. *Great Western Salt Works: essays on the meaning of Post-Formalist Art*. New York: George Braziller, 1973.

Burnham, J. W. "Art and Technology: The Panacea that Failed" in Kathleen Woodward (ed.): *The Myths of Information*. Madison, Wisconsin: Coda Press, 1980.
McShine, K. *Information*. New York, MOMA, 1970.
Penny, S. "Systems Aesthetics + Cyborg Art: The Legacy of Jack Burnham." In *Sculpture*, January/February, Vol. 18 No. 1, 1999.

Shanken, E. "The House That Jack Built: Jack Burnham's Concept of "Software" as a Metaphor for Art" in Roy Ascott, ed.: *Reframing Consciousness: Art and Consciousness in the Post-Biological Era*. Exeter: Intellect, 1999.
Shanken, E. "Art in the Information Age: Technology and Conceptual Art," in *Leonardo*, Vol. 35, No. 4., 2002, pp. 433–438.

PERTTU RASTAS

BECAUSE REAL IS BORING, WE NEED ART!

An art museum tries to understand art by collecting works of art, organizing them into collections and then arranging them into exhibitions.

When the Beeoff group from Stockholm embarked on its streaming media project, i.e., real time based art, and when Kiasma became a place for a nonTVTVstation that received transmissions from Stockholm, I often asked myself (as I often do ask myself) what is actually art about this? What makes a live TV transmission art? It is art just because it is being presented as art in a museum? But what makes live pictures into an art form that can be shown in an art museum and not called, for example, a documentary or fiction film or a live local TV broadcast? What is the meaning of these different media concepts? Media culture has taught us that we must always look at media content as well as media context.

Museums are spatial media. With the help of increasingly practical and variable solutions, the metaphor of the white gallery can now be transferred into a conceptual series of exhibition spaces that can continually renew themselves, and that all have something similar and familiar, yet at the same time are always something new. If you compare, for example, a cinema and an art museum, it is significant that museums have changed much more radically than cinemas — where the presentation concept is still the same as it was a hundred years ago.

But museums are not designed for the new media. In fact, apart from a few valiant attempts, I do not know of any structures created for a museum context that are

specially equipped for presenting new media (digital media) with the particular approach that is used in museums. Museums are still being built for the purposes of exhibiting traditional object-based artworks and for building up collections.

But do digital media works of art need museums? What can museums offer the creators of the new media and new media artworks? We can probably already provide a few answers:

1. Museums can provide an idea of history, a section of a continuum, a chance to participate in the chain of inheritance of the arts, i.e., for finding a place in the history of memory in the aesthetic chain. So if we talk about digital art, or its newest forms like program art, then the responsibility of museums is the same as it has always been: to link works of art and their cultural context to the history of art, as a part of what is pleasing and significant in each period and to preserve this for the future.

2. Museums can provide a relationship with the audience, a channel for bringing artworks and their audiences together in a way that is accepted for museums and pedagogies, and is significantly different from the selection of commercial images and brandnames.

3. Museums can provide a technological arsenal that is as advanced as the technology that was used to create the artworks. Museums can also provide more server capacity, communication connections and expert knowledge on presentation methods.

4. Art today is always experimental in some way, so in order for museums to be considered creative in society, they must also be experimental in relation to contemporary traditions and interpretations of presentations. The media have collectively formed the central reality of cultural content for the late twentieth century, so museums have no choice but to work together with artists within these media. There is no other real alternative.

REAL TIME ART
FIELDS OF MEANING IN MEDIA CULTURE

Real time art consists of three concepts, which separately and together offer interesting cultural fields of meaning.

REAL/LIVE

According to our observations if something exists, we can examine it as part of our reality. But in the media, real means the same thing as live, something that is happening at the same time as the viewer is watching it. Real/live is a captivating concept of time because it is something that is very strongly connected with reality. But it is also

problematic, for most of the time reality is boring. The media need to be condensed as demonstrated by so-called reality TV, or even better, a TV series such as *24*. But if as much happened in real life as in this condensed media time, we would be on the verge of a cultural nervous breakdown. In conclusion, reality in itself is too slow and boring most of the time.

TIME

Time is a concept with which we divide reality into the past, present and future. Time is an essential cultural and philosophical concept for our existence. The concept of time in media art is either condensed or elongated. When Bill Viola talks about his works of art, he explains that, although the information society is attempting to squash more and more information into an increasingly shorter length of time, in his opinion the aim of the artist can be the opposite — less information into a longer timeframe.

The concept of time in the media (such as cinema and television) is different: to shorten time. It condenses the boring parts of real life, uneventful times, and deals time's deck of cards in front of us into a different order, giving the continuum of time a beginning, a middle and an end. But media art has brought another addition to the equation, a radical alternative, which says that time has its own place in art. Slowness is a state of mind, which functions as a separating factor within Western culture. The hiatus of time is now usually seen as an Eastern concept. Stopped time refers to religious meditation as a contrast to the Western world's focus on achievement and consumption; stopped time is a kind of spiritual connection with a greater reality than our real time, which can be found beyond the concise, eventful artificial reality produced for the Western market.

ART

In this context, art is a concept, which is best taken as a claim that we are dealing with art rather than a television broadcast. The concepts of media art are borderline states drawn on the surface of water where the borders are made up of a continuous interaction between "work in progress" and "concept in process." "What is art?" is no longer a loaded or interesting theme of conversation these days. The fact that something is called art in one context while some process or time–space product is not, is a fundamental state of a society based on cultural contract.

To paraphrase Brian Eno, art is everything that we do not have to do. It is precisely this, within the information and media society, which puts forward a technological apparatus and modus operandi as a medium between humans and reality, between humans and nature, and as a sort of socially pervasive paradigmatic mantra, that the concept of time in media art, which is in fact made up of the slowness of real time, can be a true identifier of art. Slowness forces us to stop.

Real time art therefore brings to the fore the great question of the fundamental character of art, not as an actual work of art or art object, but positions the significance and idiom of art amid the most central processes of our time.

ANDREAS BRØGGER

TIME TO GET REAL (AGAIN)
SOFTWARE AND REAL TIME SYSTEMS IN LATE 1960s AMERICAN ART

Faced with the imperative to "Get Real" one may indeed be tempted to investigate current phenomena such as real time information flows on the World Wide Web, the ambiguities of "reality TV" (featuring real people having plastic surgery), the level of reality achieved in digital special FX, or the reasons behind the recent success of documentary movies. Or one may, of course, choose to retreat, if only for a brief period, from the "tyranny of real time" in order to investigate whether the notion of real time has presented itself with similar urgency at other periods throughout history? After all, media of the nineteenth and twentieth centuries, such as photography, the telegraph, the telephone, radio, television and cinema, have been described as "technologies of time" due to their compression of established notions of time and space.

Resisting the temptation to trace the notion of real time through the history of art and telecommunication, I have chosen to focus on a rather brief moment: the discourse on real time systems in American art of the late 1960s. In many respects the 1960s were an important step on the way to our current notions of what is "real" and the implications of real time, especially our notion of what it would mean to "get real" in terms of art. Minimalism and hyperrealism, of course, seem to be driven by two different interpretations of the real, the former aiming to make sure that what-you-see-is-what-you-see in a radically nonrepresentational way, while the latter causes us to question representation through "hyperreal" gestures. With body art and process art, notions of stability and timelessness give way to an awareness of the "liveness" of

events and the observation of changes imposed by environments on objects over time. On a broader cultural level, many critics identify the 1960s as the period when the impact of mass media and the accellerated speed of communication effectively gave rise to post-modern notions of "simulation" and the "loss of the real," only to be counteracted, according to critic Hal Foster, at the end of the century by the so-called "return of the real." In early video art of the late 1960s there was much talk about "real time" as an alternative to the simulated reality of the carefully edited news programs broadcast by the television networks. Armed with portable video equipment made available at the time, artists and activists documented counter-cultural manifestations and demonstrations *in medias res*, often without much post-production. Video shot in real time offered an unfiltered view of reality. As Marita Sturken has pointed out, however, the real time aesthetics of early video art should be seen as a combination of political choice (to offer a critique of the media and various issues), aesthetic preferences of the time (the attempt to "keep things real" can be observed in minimal art, process art, performance and other movements of the time), and practical-technological circumstances (the lack of high-end editing equipment in the artist-activist communities).[1]

It is equally significant that the 1960s marks an important step in the development of today's information society, not least with the birth of the Internet, then known as Arpanet, but also with the increasingly widespread use of computer technology. With exhibitions such as "The Machine as Seen at the End of the Mechanical Age" at MoMA (1968), "Art by Telephone" at the Museum of Contemporary Art in Chicago (1969), "Information" at the New York MoMA (1970), "Software" at the Jewish Museum in New York (1970), and the "Art and Technology" program at Los Angeles County Museum of Art (1967-1971), the late 1960s and early 1970s saw a number of interesting artistic experiments with information technology alongside the more well-known developments known as conceptual art and video art. In fact, while numerous accounts of art in the 1960s focus on, for instance, the relationship between serial production and minimal art, consumerism and pop art, television and video art, the affluent society and the dematerialization of the art object, they often deemphasize a significant dimension: the cybernetic discourse of 1960s art, or what one might call the "information paradigm."[2] This may well be because some historians believe that the interest in cybernetics, systems theory, and the fashionable concepts of Marshall McLuhan were merely "symptomatic of a search for a cultural home away from the staid precincts of high art," as Michael Corris has recently stated, rather than a sustainable way of perceiving art then and in the future.[3] Today, however, the information paradigm is once again attracting the attention of artists and art historians who look to the past to understand today's developments. They seem to agree with this prediction by critic Jack Burnham in a text from 1970:

1 Marita Sturken: "Paradox in the Evolution of an Art Form: Great Expectations and the Making of a History" in Doug Hall & Sally Jo Fifer: *Illuminating Video. An Essential Guide to Video Art*, Aperture in association with the Bay Area Video Coalition, 1991.
2 Johanna Drucker suggests the term "information paradigm" in her article "The crux of conceptualism: Conceptual art, the Idea of idea and the information paradigm" in Michael Corris: *Conceptual Art: Theory, Myth, and Practice*, Cambridge University Press, 2003.

3 See Michael Corris: "Recoding Information, Knowledge, and Technology" in Michael Corris: *Conceptual Art: Theory, Myth, and Practice*, Cambridge University Press, 2003.

Information processing technology influences our notions about creativity, perception, and the limits of art [... It] is probably not the province of computers and other telecommunication devices to produce works of art as we know it; but they will, in fact, be instrumental in redefining the entire area of esthetic awareness.

(BURNHAM, "NOTES ON ART AND INFORMATION PROCESSING," *SOFTWARE* CATALOG, 1970)

The cybernetics of Norbert Weiner, the systems theory of Ludwig von Bertalanffy, and the information theory of Claude Shannon and Warren Weaver had entered the art world in the 1960s through various channels, including the writings of Marshall McLuhan. They provided important concepts for understanding current developments, along with McLuhan himself, the social science of Gregory Bateson, the architectural futurism of Buckminster Fuller, and the economical theories of J. Kenneth Galbraith. No longer willing to rely on traditional notions of art's importance and role in society, a number of artists sought to reposition art in relation to developments on a broader scale, deciding it was time to move from the "tower of babel to the control tower of society" (to quote McLuhan).

To successfully perform this move and succeed in their new role, artists would have to understand how the new systems of information technology actually functioned, and what lay ahead in terms of future risks, and artistic and cultural possibilities. Some of the clearest expressions of this new situation can be found in the writings of artist and critic Jack Burnham. Inspired by many of the discourses mentioned above, and covering the work of a large number of artists of the 1960s, such as Donald Judd, Hans Haacke, Joseph Kosuth, Dennis Oppenheim and Les Levine, Burnham published three books and a number of articles in *Artforum* in the late 1960s and early 1970s. The articles "Systems Esthetics" and "Real Time Systems" are of special interest in the following. Jack Burnham's first book, *Beyond Modern Sculpture: The Effects of Science and Technology on the Sculpture of this Century* from 1968, predates Rosalind Krauss' related, but far more widely read account of the development within sculpture of the 20th century by almost a decade, namely *Passages in Modern Sculpture* from 1977. Despite showing the signs of datedness which typically accompany texts heavily inspired by visions of the future, Burnham's book may seem more relevant to today's readers than Krauss'.

Considering his career as a "light artist" since the 1950s and his later activities as a writer and curator, Burnham updated himself to an "information worker" in the post-industrial late 1960s. Burnham managed to get some hands-on experience with computers through a fellowship at MIT's Center for Advanced Visual Studies in 1968, and went on to curate the highly noteworthy (but until recently largely forgotten) exhibition "Software — Information Technology: Its New Meaning for Art" at the Jewish Museum

in New York in the fall of 1970. (Although it opened immediately after the famous "Information" show at the Museum of Modern Art, the "Software" show supposedly predated the MoMA show in terms of concept development and planning.) These two exhibitions brought the "information paradigm" to center stage at the turn of the decade.

ART AS INFORMATION PROCESSING

In his article "Real Time Aesthetics," Burnham described the art world as an information producing system involving various levels of processing. In this way, he brought the perspective on art up to date with the rapidly expanding information technology. On a basic level, artists were comparable to "programs" and "subroutines," the creation of art involving analysis of data and production of new codes. This production would be supervised by "metaprograms" consisting of instructions, descriptions and organizational structures, in other words, the institutional level where art is described, organized into stylistic trends and archived under various labels by critics, galleries, museums, and historians. The highest level of information processing, namely the level of the "self-metaprogram," provides longer-term reorganization of developments on the lower levels. More than a Zeitgeist, aesthetic values emanate from the self-metaprogram based on "societal needs" that remain unknown and uncontrollable on the two lower levels.

Symptoms of a change in values could of course be registered sooner or later by keen observers, and at the time of Burnham's writing, new values were indeed emanating from the self-metaprogram. Burnham's cybernetic perspective was in line with the preference for interdisciplinarity in the art of the 1960s and with the idea of art as information to be distributed and exchanged across media, formats and other boundaries. The abstraction of art into a textual statement in Fluxus "event scores" and later in conceptual art is largely contemporaneous with the abstraction of information in information theory; Burnham did include text-based work in his "Software" show.[4] Burnham's understanding of the art world as an information processing system also followed the idea of harmonizing systems central to cybernetic theory, focusing on the analogies among, for instance, artistic, economical, and biological processes.

Among the implications of the cybernetic analogy was the idea that in the information processing system of the art world, art does not reside in isolated objects which can exhibited and sold, or upon which institutions confer value from a position outside of the creative proces itself. Instead, Burnham stated, "[...] all institutions which process art data, thus making information, are components of the work of art." (Burnham, "Real Time Systems," p. 27) This view significantly expanded the notion of

4 For a discussion of the links between information theory and Fluxus event scores, notably through John Cage, see Liz Kotz: "Post-Cagean Aesthetics and the 'Event' Score," in *October* 95, Spring 2001.

what is at play in the "creative process" and of what the "work of art" consists. According to Burnham, "Making, promoting, and buying art are *real time* activities. That is to say, they happen within the day-to-day flow of normal experience." (Burnham, "Real Time Systems," p. 28)

Burnham's perspective on the mechanisms at work within the art system resonated with the burgeoning "institutional critique" at the time. In Burnham's view, the art world functioned much in the same way as the business sector, selecting and managing data in such a way that they become useful information for decision-making: "As indicated, every artist produces data by making art. Critics, magazines, galleries, museums, collectors and historians exist to create information out of unprocessed art data. History is uncertainty about art minimized." (Burnham, "Real Time Systems," p. 27)

The interconnectedness of the different levels of the art world were crucial to Burnham's understanding of art as a *process* rather than as an *object*. Instead of embracing the traditional focus on objects and their visual appearances, Burnham saw many artists during the 1960s as working with art of a "transactional" nature, exploring established or alternative structures of communication and exchange. Rather than an aesthetics of form and appearance, art now called for what he described as a *systems aesthetic*, recognizing art as a process within larger systems. According to Burnham,

A systems viewpoint is focused on the creation of stable, on-going relationships between organic and nonorganic systems, be these neighborhoods, industrial complexes, farms, transportation systems, information centers, recreation centers or any of the other matrices of human activity.

(BURNHAM, "SYSTEMS ESTHETICS," 1968)

Given the emphasis on the notion of "connectedness" in 1960s discourse on international politics, economics, ecology, information technology and culture (as in McLuhan's "global village"), only a very conservative observer would insist on the art world, or the experience of art, as a separate sphere. Many people instead nourished the idea that art was not only subjected to the mechanisms at work in other systems, but could also potentially influence areas of these related systems. This idea has variously been described as the anthropological or ethnological turn in art since the 1960s, underlying recent phenomena such as relational aesthetics, kontextkunst and social aesthetics.

Burnham sought to capture this view of art with his idea of a systems aesthetic, connecting the "art system" with political, economic, natural and social systems. Making things more concrete and urgent, Burnham claimed that these operations could be said to take place as a real time exchange. Hans Haacke's elaborately titled project

Shapolsky et al. Manhattan Real Estate Holdings, A Real Time Social System as of May 1, 1971 is an example of the perspective offered by Burnham. The project investigated the realities of the Manhattan real estate business at the time and famously caused the Guggenheim to cancel a show of Haacke's work. The museum was apparently not prepared to acknowledge its role in the broader real time system of the early 1970s.

Perhaps as a consequence of the idea that messages should be compatible across platforms and systems, the art of the 1960s took the form of everyday objects and activities. As Burnham pointed out, "[...] the art experience attaches itself less and less to canonical or given forms but embraces every conceivable experiential mode, including living in everyday environments." (Burnham, "Real Time Systems," p. 27) In his famous article "Art and Objecthood" Michael Fried attacked the notion that art could take the form of any kind of experience, as the minimalist sculptor Tony Smith had implied after a car ride along an unfinished stretch of the New Jersey Turnpike. For Burnham, however, doing away with the art object did not necessarily negate the concept of art, nor cause the traditional value structures of the art system to dissolve. While art objects depend on the art world as a "support system" for their definition and evaluation, without actual objects this support system can still sustain the notion of art, as Burnham pointed out. It does so by continously producing information out of new data and recycled information (such as endless reproductions of the same works of art in magazines and books). Drawing an analogy to another popular concept in 1960s discourse on art, namely entropy, Burnham explains that the art system has counteracted informational entropy (the state of zero information) by continuously "reaching outside of itself for data." Modernist art in its avant-garde versions has indeed continously included "new subject matter, materials and techniques," as Burnham points out, even if it tried to actually break down the walls of the art world.

A "systems aesthetic," on the other hand, would recognize that art is already constantly connected with the "outside" world.

THE REAL TIME EXPERIENCE OF ART

Burnham's perspectives on the art system had implications for the role of the spectator and the notion of time involved in the spectator's appreciation of art. In the same way that art objects are products of the larger art world system, which runs in real time with all its minute and large-scale operations, the experience of art itself could also be described as a real time process. This contrasted with the notion of art appreciation as an "ideal moment" supposedly transcending the flow of the real time system known as "everyday life." Notions of the "ideal moment" were indeed prominent in the writings of Clement Greenberg, the most influential American art critic of the 1950s and 1960s,

even to the point of becoming the subject of paintings by conceptual artist John Baldessari. One of his paintings titled *Everything is purged from this painting but art; no ideas have entered this work* (1966-1968) features nothing but the words of the title painted in black on a white canvas by a professional sign painter. The words point to the traditional function of the picture frame as delimiting the purified space and time of the work of art from the surrounding space and time. In "Real Time Systems" Burnham broadens the notion of the "frame":

Experimental idealism rests upon the intellectual and physical isolation of the esthetic experience. Its tools are picture frames, bases, spotlights, guards, galleries, hypostatic objects and the concept of 'high art' itself.

(BURNHAM, "REAL TIME SYSTEMS," P. 28)

Instead of the notion of artistic appreciation as an intimate affair between spectator and object which takes place "on a pedestal" above the everyday environment, Burnham's systems perspective emphasized the art experience as a "temporal immersion in a continuous contextual flow of communicated experiences." (Burnham, "Real Time Systems," p. 27) This emphasized the feedback loop between art work and surroundings, including the spectator who was often allowed to directly influence the system through the interactive dimension of many projects at the time.

REAL TIME AWARENESS

This is also where the importance of real time technology entered. Confirming Burnham's ideas, the late 1960s saw a growing number of artists providing spectators something more urgent than the isolated contemplation of beauty:

What a few artists are beginning to give the public is real time information, information with no hardware value, but with software significance for effecting awareness of events in the present.

(BURNHAM, "REAL TIME SYSTEMS," P. 30)

Following the move away from art objects (described by Burnham as hardware) artists were increasingly offering "procedures or programs for processing data" (Burnham's definition of software). Two projects by Hans Haacke, which were both included in the "Software" show a few years later, namely the installations "News" and "Visitor's Profile," provide good examples of what Burnham had in mind. "News" consisted of a number of teletype machines that made it possible for visitors to the museum to study

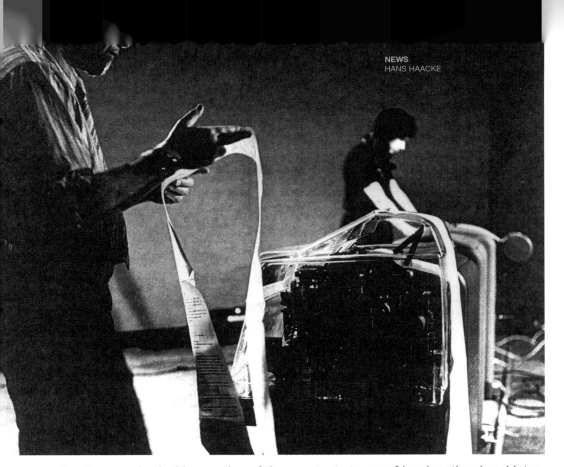

and get a rare physical impression of the constant stream of local, national and international news sent by U.S. and foreign news services, such as Reuters or the Associated Press, to editors and journalists at newspapers, and radio and television stations. "Visitor's Profile" was an opinion poll system prompting visitors to answer a series of questions, which could roughly be divided into two groups: factual information about the visitor, such as age, gender, educational background, income and so on, while the other questions asked for the visitor's opinion on a variety of subjects, for instance the Vietnam War. "Visitor's Profile" was shown in a number of different versions with and without computerized tabulation of statistical data, but ideally "Visitor's Profile" would make it possible for visitors to answer questions at a terminal, with the system in turn providing up-to-date statistical information on a screen, where the visitors' opinions were cross-tabulated with their demographic background. Thus the system provided real time information to visitors, ideally engaging them immediately in a feedback system.

Although a number of real time computer systems were in use at the time by the military and private business sectors, the art projects referred to by Burnham as involving "real time information" were not necessarily high-tech. Typical to this are Hans Haacke's projects investigating natural and manmade environmental conditions, such as ice sculptures melting during the exhibition period or chickens hatching, various text-based "instructions" or "documents" produced by artists like Douglas Huebler and Joseph Kosuth, or Les Levine's *Levine's Restaurant* at 19th Street and Park Avenue in New York, which Burnham described as "a self-organizing, data generating system." Similarly, Dennis Oppenheim's use of tractors, snowplows and aeroplanes to create landscape art may evoke an age of industrial machines rather than the real time systems of information society. Of course, artists may use any technology to create work which is *about* information technology. Indeed, following Burnham's analysis of the art world as an information processing system, even a painting or a sculpture could be viewed *as* information technology and as part of a real time system.

However, aside from the fact that information technology was generally not within the reach of artists at the time (there was no computer system offering the flexibility and relatively low cost of the Portapak in video art), there is another explanation for Burnham's choice of somewhat "organic" rather than computer-based examples. Taking his cue from the analogy frequently drawn between technology and biology by Weiner, McLuhan and others in the 1960s, Burnham compared real time systems and communication networks to ecological systems and metabolisms. A similar move can be traced in video art and related activities of the period as present in, for instance, the magazine *Radical Software*. Having linked art to technology by viewing the "art world" as a "cybernetic system," as described above, Burnham further understood real time systems and media technologies as akin to "organic systems," two theoretical moves which together made work by Hans Haacke, Joseph Kosuth, Dennis Oppenheim, Robert Barry, Les Levine and many others, compatible with the "cybernetic discourse" of the late 1960s.

Burnham's theories were soon put into practice as he curated the "Software" show in 1970, incorporating many of the artists already mentioned and a range of information technologies, such as the first publicly demonstrated hypertext system developed by Ted Nelson, experimental use of the new Xerox color photocopier, projects involving various types of sensors, radio and television technology, and last but not least, a colony of gerbils living inside a simple computerized architectural environment (done by the Architecture Machine Group of MIT). Among the other projects were instruction-based conceptual art by Douglas Huebler, Allan Kaprow, Lawrence Weiner and others. Vito Acconci's *Room Situation (Proximity)* consisted of a text instructing the artist to intrude on a visitor's personal space by standing close to him or her, much in the manner

of a real time bug disturbing the "ideal moment" of art appreciation. Unfortunately, quite a few of the installations that were to utilize computer technology did not work during the exhibition period, and instead stood as combined symptoms of the primitive state of the technology at the time contrasted with the advanced thinking of the curator and artists. The computer was far from the portable, powerful, versatile and relatively stable, artistic tool or medium we know today.

Considering the speed at which information technology has developed since the 1960s, it would perhaps be relevant at this point to rewind to the state of infomation technology in the late 1960s. By then, the development and implementation of information technology had already entered a significant stage in the United States, transforming the economical, political and cultural spheres in ways foreseen (and unforeseen) by influential observers such as economist J. Kenneth Galbraith and media theorist Marshall McLuhan since the mid-1950s. "Automation" had been the subject of much debate as workers feared the consequences of handing their work over to computerized machinery, while positive-minded observers of the economic and social effects of automation foresaw a new society where workers would contribute to the economy by shopping for consumer goods in their leisure time to a greater degree than through tedious assembly line work.

In the latter half of the 1960s the relation between hardware and software was undergoing significant changes. Until the mid-1960s computers were mainly synonymous with "big iron," and it was not until 1966 that a major business magazine ran an article highlighting the importance of software itself.[5] While manufacturers had previously provided software for their hardware products (already in the 1960s known as "bundling"), signs were abundant that a new market specifically for software was on the rise. By 1970, some estimates said, three-quarters of the productive energies of the computer industry were devoted to software. In many respects, then, the late 1960s foreshadowed the epicenter of today's debates on software monopoly, open source, piracy and the free software movement. The importance of software seems to have immediately registered on the finely-tuned seismographs of a number of artists and writers as the term gained currency at the end of the decade, in media theory and psychology, and in conceptual, video and cybernetic art circles.

In the mid-1960s, on-line computer systems were implemented and public consciousness of real time information exchange grew through newspaper and magazine articles, even through advertisements, as companies boasted about their use of computer technology as a way of providing better products and customer service. The military's employment of computerized defense systems such as SAGE and Project Mercury formed part of American Cold War ideology, touting the belief in the nation's technological power.

For Burnham these developments were not to be ignored, but acknowledged by the art world and, if possible, their aesthetic and cultural potential harnessed, even if he realized that "most humanists share an instinctive antipathy for these immensely complex computer systems." (Burnham, "Real Time Systems," p. 30) Burnham acknowledged that real time information processing was rapidly becoming "the routine style of handling information" (as it is indeed today). Although "their Orwellian overtones far overshadow their conceivable use as artists' tools," Burnham claimed that "practically, it is imperative that artists do understand them — both technically and philosophically." (Burnham, "Real Time Systems," p. 30)

Vito Acconci
Room Situation (Proximity)

Project:
Standing near a person and intruding on his personal space.

Possible realizations:
1. Every day, for the entire day, I will be present at the exhibition area, going randomly from room to room.
At various points, a subject will be chosen who is standing in relative privacy at one of the exhibits: I will stand beside him, or behind him—closer than the expected distance— crowding him. (I can stand near him until he moves away.)

2. When I cannot be present at the exhibition area, a substitute will be assigned to perform the activity.

3. I will be present at the exhibition area, performing the activity, whenever I can; when I cannot, the statement will continue to present the possibility of the piece.

5 For an account of the beginnings of the software industry, see Martin Campbell-Kelly: *From Airline Reservations to Sonic the Hedgehog: A History of the Software Industry*, MIT Press, 2003.

A DYSTOPIA OF DEMATERIALIZATION

While Burnham viewed the positive potential in real time systems, other theorists of information society have emphasized the threats they pose to art and culture. Burnham wrote his articles in a time of great optimism about the potential of information technology to alter the state of American society. Considering the value placed upon information technology by influential economist J. Kenneth Galbraith and influential media theorist Marshall McLuhan, information theory and cybernetics provided largely positive models for artists and critics wary of traditional aesthetic dogmas. Some recent critics, however, from Rosalind Krauss to Josephine Berry, have pointed out that the idea of liberating art from the market based on art objects through a strategy of "dematerialization" only had the effect of adapting art to the increasing commercialization of information taking place at the time. As already indicated, the market for software began in the late 1960s, and software soon gained the value of hardware. Similarly, art dematerialized into easily distributed information and only mimicked capitalism's increasing reliance on an accelerated circulation of signs. The art market quickly found out that dematerialized art forms could be collected and traded as well. The artist Robert Smithson, always ready to speak against both the conservative consensus and the latest hype, seems to have foreseen the dangers of art conforming completely to an ideology of dematerialization, describing conceptual art as a credit card without funds in the bank to back it up.

Burnham's texts do seem to offer a balanced view of things, recognizing the transformations in the economy and social life of the time and thus the need to continuously renegotiate the borders between art and business, art and technology, and art and social spheres. Although he predicted the "absorption of art into the media," he also insisted that "the reality of art continues to reside in its unreality." Using the terminology of cybernetics, he described artists as *deviation-amplifying systems*. (Burnham, "Real Time Systems," p. 38) And so, with the increased speed of information and the dematerialization of property, the deviation on the part of artists working with digital technology today often consists in critically repurposing real time data or lending them an unusual *material* side.

THE TYRANNY OF REAL TIME

"*A priori* real time resists the freedom of interpretation. It happens too fast," claims Paul Virilio, the French theorist of speed and communication technology.[6] The compression of time and space, already accelerated significantly in the nineteenth and twentieth centuries with the invention of the telegraph, radio, radar and television, now cause us once again, faced with the real time information flows of on-line systems, to question

6 Paul Virilio in an interview with Hans-Ulrich Obrist at http://www.ljudmila.org/scca/urbanaria/txt/e/virilio.htm.

what counts as reality. In a number of publications, Virilio has discussed what he calls "the tyranny of real time," offering us a pessimistic perspective from which to discuss any potential attributed to real time art. According to Virilio, the acceleration of communication to the point of real time information exchange has diminished the distance needed in order to be able to interpret the information we receive. Communication has in a certain sense alienated itself from us, its speed by far transcending the capacity of our perceptual and cognitive apparatus. Communication is dominated by what Virilio calls "electronics" rather than "optics." Much in line with other critics of "virtuality," such as Jonathan Crary and Friedrich Kittler, Virilio sees fiberoptic networks bypassing the "wetware" of the human mind, as invisible and intangible electronic communication takes place inside cables, machines and networks beyond our physical and mental grasp.

One escape from the tyranny of real time is offered by Virilio himself, as he discusses the notion of the *monument*. Real time communication has altered the notion of the monument that traditionally serves to remind us of a person or event in the past. Today, Virilio states, the monument is not necessarily a statue, a square or an edifice; the "monument is primarily a signal, a sign, an appeal [...] It is primarily a moment of stopping or pausing in the habits of everyday life."[7] Adapted to the speed of real time communications and freed of its connotations of permanence and concreteness, this notion of the monument makes it possible to consider real time art as a type of monument, breaking, as monuments traditionally do, with the everyday life of mobility, repetition, forgetting and so on.

In this notion of the monument we may recognize the awareness of real time events called for by Burnham. With the World Wide Web, artists are now able to plug into a wide range of real time data flows. Add to this a clever use (or coding) of software, and what we see is a number of experiments with the otherwise paradoxical concept of *remixing* data in *real time*. Sampling and remixing now takes place in real time, and often consists of a *detournement* of data. Some artists adapt the real time-flow of data to humanly accessible forms by means of physical interfaces and installations. In this way, we literally *realize*, in our own space and time, what is otherwise an often unreal flow of communication, even if some of them also aim to dazzle us with the speed and immensity of the datascape into which they plug.

Some of the most interesting artistic experiments with digital technology today seem to continue the systems and real time aesthetics of the late 1960s, updating it to current technological developments and cultural issues. By transforming real time data into unexpected, inventive forms, artists have the potential to create moments of surprise and a break in the habits of an everyday life increasingly saturated by intangible real time information.

7 Ibid.

REAL TIME + ART + IMAGES

GET REAL. KIASMA. NOV 2004.
+
H.C. GILJE / KREUTZERKOMPANI
BEEOFF
PETER HAGDAHL
MOGENS JACOBSEN

KIRKEGAARD + MAGNUSSON
SÖNGVAR SÓLVINDANNA

GET REAL. KIASMA. NOV 2004.

(PP. 124-129)

PHOTO: sgl

STEVEN DIXON + TORE NILSSON
CHANNELING 3
2004

GET REAL. KIASMA. NOV 2004.

(PP. 029-042 + DVD)

PHOTO: sgl

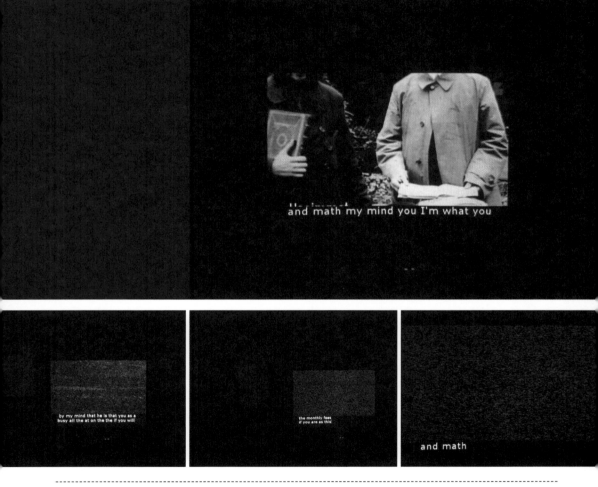

ARIJANA KAJFES
MASS TRANSACTION
1998

GET REAL. KIASMA. NOV 2004.

(P. 097)

PHOTO: sgl

2,500
6,000
EVIDENCE
STRAIN
140,000

DESTRUCTIO
DISASTER
HELL
HELP

FO
N
ST
MA
DA

MILITARY
TALKS

UCK
FRIGHTEN
LOYAL
CAMPS

FIR
DANC

MICHAEL KIRKEGAARD
OBSERVING THE WORLD IN THE R
MIRROR MAKES YOUR HEAD SPIN

GET REAL. KIASMA. NOV 2004.

(PP. 079-081)

PHOTO: sgl

GET REAL REAL T

CONTROL
TANKS

INSTALLATION VIEW
(STEINA VASULKA. **BENT SCANS.** 2002)

GET REAL. KIASMA. NOV 2004.

(P. 087-093 + DVD)

PHOTO: Jacob Kirkegaard

JUHA HUUSKONEN
THE MOMENT OF LONG NOW
2002

GET REAL. KIASMA. NOV 2004.

(P. 107 + DVD)

PHOTO: sgl

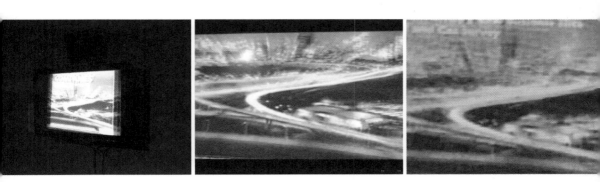

PINK TWINS
LET IT BEEP
2002-04

GET REAL. KIASMA. NOV 2004.

(P. 095)

PHOTO: sgl

H.C. GILJE
VIDEO + SET FROM THE PERFORMANCE
TWINN BY KREUTZERKOMPANI
2004

(PP. 059-089/064)

BEEOFF
ATARASHI YUME
2002

(PP. 131-133)

PETER HAGDAHL
SIMULATED SOCIAL MODEL NO 2
(SENSORIC TRANSFORMATION)
2002

(P. 103 + DVD)

MOGENS JACOBSEN
TATI. FRAME 340. 5 MIN. (SECTIONS OF)

(P. 053)

A REAL TIME LINE
A SELECTION OF REAL TIME + ART

When working with the transdisciplinary field of real time art, focus tends to be on recent and mediated art forms. However, it is important to emphasize that, although the issue of real time is intensified by the infusion of new media in the late 1980s and onwards, real time art has a history that includes elements from antiart, happenings, performance as well as live art, radio and concerts — just to mention a few. From many of the texts in this anthology, not the least Jack Burnham's classic essay from 1968, it is clear that the artistic and theoretical activities in the '60s are important parameters when discussing real time art practice today. Of course we could have chosen to go back even further: e.g., to the Futurists, the Dadaists and the surrealist movement. Transdisciplinary experiments in the field between art and life were also taking place in Russia; at the Bauhaus in Germany artists explored the "new unity" of art and technology in the late 1920s/early 1930s through performance and "live art."

We want to close this anthology with a listing of some of the most important historic pieces/ productions of art in real time, and we choose to start in the 1960s with the advent of the unprecedented integration of media, art and real life that in our view has provided the inescapable framework of artistic practice ever since.

It should be noted that important works by John Cage like *Untitled Event* (1952) and Alan Kaprow, like *18 happenings in 6 parts* (1959), in more than one sense initiated the artistic evaluation of this process. Without those, and the experiments from the beginning of the twentieth century, the selected pieces/productions of art listed would perhaps not have been as real and alive as they were — and continue to be.

"SOMEDAY ARTISTS WILL WORK WITH CAPACITORS, RESISTORS & SEMICONDUCTORS AS THEY WORK TODAY WITH BRUSHES, VIOLINS AND JUNK."

NAM JUNE PAIK, **ELECTRONIC VIDEO RECORDER**, 1963

JEAN TINGEULEY
HOMMAGE A NEW YORK
1960

Tinguely was asked to create something for the garden of MoMA NYC. He asked Billy Klüver to help him with an installation that consisted of a numerous of bicycle wheels and other street finds. The idea was to create a machine that would destroy itself and the installation collapsed in an inferno of smoke and small explosions. The whole thing ended in 27 minutes.

YOKO ONO
CUT PIECE
1964

The first cut piece was performed in Kyoto in 1964. A man/woman sitting onstage with a scissors in front of her asks the audience to cut a piece from her clothes. She then sits perfectly still, staring right in front of her. People cut pieces and in the end she is naked or in her underwear. It depends on the public.

NAM JUNE PAIK
MAGNET TV
1965

A silent black-and-white television has a magnet placed on top of it. The magnet interferes with the signal on the television and creates various patterns in real time.

JOSEPH BEUYS
HOW TO EXPLAIN PICTURES TO A DEAD HARE
1965

Performance at Galerie Alfred Schmela in Düsseldorf where Beuys, his head covered with honey and gold leaves, talks to a dead hare.

BILLY KLÜVER
9 EVENINGS
1965

An event created & curated by Billy Klüver that also can be seen as the start of EAT. The events combined art and technology, performance, installations, video, etc. The whole event in itself is one of the most important comprising art and technology. Some of the works are also important for real time art.

9 EVENINGS:
JOHN CAGE
VARIATIONS VII

Thirty photocells were mounted at ankle-level around the performance area. The cells activated a variety of sound sources as the performers moved. These sounds came from contact microphones placed on a blender, juicer, fan and toaster, 20 radio channels, and two Geiger counters. In addition Cage had ten open phone lines to sites in New York City like Luchow's restaurant, the Aviary, and the 14th Street Con Edison electric power station.

9 EVENINGS:
ROBERT RAUSCHENBERG
OPEN SCORE

A tennis match between the artist Frank Stella and a tennis professional where a FM radio transmitter was built into the handle of each tennis racquet. Each time the ball hit the strings, a contact microphone picked up the "BONG," which was amplified through 12 speakers. One of the spotlights at the location was switched off with each "BONG." When the scene was completely dark, a crowd of 300 people entered. Infrared television cameras picked up the group's movements and projected these images onto three large screens.

YOKO ONO
SKY TV
1966

The first version of Sky TV — a real time TV art piece was released in 1966. Later versions have shown up to nine video cameras and eighty-one TV monitors pointed toward the sky. Yoko Ono: "The sky shines equally on all of us so it doesn't care who is rich. Everyone can share the sky all the time. When we get poor and have a hard time, the sky shines eternally."

PETER WEIBEL
TV TUBE
1967

According to Rudolf Frieling (ZKM), Peter Weibel was the first European to explore media-specific and communicative possibilities, both in technical and aesthetic terms, and systematically consider the ephemeral video medium's inherent attributes.

HANS HAACKE
NEWS
1969
Haacke: "A telex machine installed in the Düsseldorf Kunsthalle prints all the news communicated by the German press agency DPA. The printouts will be put on display for further reading one day after being communicated, and on the third day the rolls of paper will be labelled and dated, then stored in plexiglass containers."
Concept for the exhibition *Prospect 69* at Kunsthalle, Düsseldorf.

EAT
PEPSI PAVILLION
1970
Built in Osaka for the Expo´70, a performance arena filled with technology and a half-sphered ceiling covered by mirrors. Produced by Billy Klüver, Robert Whitman, Robert Breer, Frosty Myers and David Tudor and including about 75 engineers and artist.

DAN GRAHAM
PAST FUTURE SPLIT ATTENTION
1972
Graham: "Two people who know each other are in the same space. While one continuously predicts the other person's behavior, the other person recounts (by memory) the other's past behavior. Both performers are in the present, so knowledge of the past is needed to continuously deduce future behavior (in terms of causal relation). For one to see the other in terms of the present (attention), there is a mirror reflection or closed figure-eight feedback/feedahead loop of past/future. One person's behavior reciprocally reflects/depends upon the other's, so that each one's information is seen as a reflection of the effect that their own just-past behavior has had in reversed tense, as perceived from the other's view of himself."

DAN GRAHAM
PICTURE WINDOW PIECE
1974
This is a good example of Dan Graham's interactive video concepts. *Picture Window Piece* worked like a kind of "two-way surveillance": a camera and a monitor were to be set up both inside and outside a building, so that the observers standing on both sides could watch the other people, and themselves as they were being watched as well.

NAM JUNE PAIK AND CHARLOTTE MOOREMAN
TV CELLO
1975
A cello transformed through television created for Charlotte Mooreman. Also transmitted live by Satellite from Kassel to L.A. at the Documenta in 1977.

BILL VIOLA
HE WEEPS FOR YOU
1976

This is a video installation in which a water drop emerges from a small brass valve. A camera filmed a close-up, which was projected on a large screen in real time. The spectator became a part of the installation since s/he was mirrored in the drop. The drop swelled and fell onto an amplified drum creating a loud sound and a new drop began to form.

STEINA VASULKA
ALLVISION
1976

AN ELECTRO/OPTO/MECHANICAL ENVIRONMENT BY STEINA

A mirrored sphere, positioned in the middle of a crossbar, reflects the image of surrounding space. Two video cameras attached to each end of the crossbar are looking at the mirrored surface. The crossbar — now an assembly of mirrored sphere and two cameras — slowly rotates on the turntable with cameras orbiting the sphere. Since each camera sees half of the reflected space, the whole space becomes observable.

The turntable, which sits on a low pedestal, holds the driving mechanism for the rotation — a slip-ring assembly and a DC motor. The slip-ring assembly provides uninterrupted video signals from, and power to, the cameras. The video signal from the two cameras connects to two (or more monitors) arranged in the exhibit space.

ULAY (UWE LAYSIEPEN)
THERE IS A CRIMINAL CONTACT IN ART
1976

In 1976, Ulay embarked on a risky, precisely engineered and politically motivated art action. After a fake art theft had been executed, journalists were summoned; the indignant press response was presumably part of the concept. Taken to court for his action, Ulay was given the choice of paying a fine or going to prison.

ULAY/ABRAMOVIC
RELATION IN TIME
1977

This performance at Studio G7 in Bologna is one of the earliest results of the cooperation between Marina Abramovic and Ulay: "In a predefined space without audience, we sit back-to-back, our hair tied together, motionless. Then the audience comes. We remain seated there for another hour."

MERCE CUNNINGHAM
LIFEFORMS
1980

Cunningham pioneered the use of the choreographic software *Lifeforms* in the late 1980s, where a computer generates movement possibilities beyond the imagination of the human mind and body. Cunningham: "I think it could affect choreographers' experience of movement in the same way electric light first altered the way visual artists saw the world." And: "It expands what we think we can do. I think normally the mind gets in the way and says 'you can't do that.'"

TEHCHING HSIEH
TIME PIECE
1980-81

Hsieh has made a number of famous one-year performances. *Time Piece* was made between 6 p.m. April 11, 1980 and 6 p.m. April 11, 1981. In his loft in Manhattan he installed a time clock, like those you find in factories, and every hour on the hour he punched the clock, 24 hours a day, for the whole year. The arrangement forced him to organize his life totally according to the performance. He could never go far from his home, so he could get back to the clock in time. He couldn't get a proper night's sleep since an alarm clock woke him up every hour. A camera was set up to shoot a single frame at every punch.

SKIP SWEENEY
**DIFFERENT EARLY EXPERIMENTS
WITH VIDEO FEEDBACKS**
1980
Video feedback is a dynamic flow of imagery created by the camera looking at its own monitor. It was often (and still is) the first phenomenon that seduced users of video by its sheer beauty. Although everyone who discovered feedback was transfixed by it, feedback seemed an uncontrollable, roiling effluent byproduct of technology — one of those natural mysteries, appreciated but untameable. The acknowledged master of feedback was Skip Sweeney, organizer of the first video festivals and founder of Video Free America in San Francisco. To Sweeney, feedback was "a religion — a wave to ride." Throughout his video work Sweeney has approached video as a real time tool with an ongoing involvement in video as live Performance.

DAN SANDIN
IMAGE PROCESSOR
1984
Dan Sandin created an analog processor for video signals and was the first to use it artistically.

CHRISTIAN MARCLAY
GHOST (I DON'T LIVE TODAY)
1985
(5 MIN.)
Performance at *The Kitchen*, New York, where Marclay uses his homemade "phonoguitar," a gramophone he uses as an electric guitar. While he imitates the movements of a guitarist, he plays with Jimi Hendrix playing at Woodstock, shown on giant screens.

LAURIE ANDERSEN
HERE
1996
Here at the *Under Capricorn — The World Over* exhibit, Stedelijk Museum Amsterdam and the Wellington City Gallery, June 28 to August 18, 1996. http://www.stedelijk.nl/capricorn/anderson/index.html

BEEOFF
HEAD
1996
The first art piece that Beeoff made. The creation of this art piece gave the idea for the nonTVTVstation as well as a focus on real time for both Beeoff and later Splintermind.

RYUCHI SAKAMOTO
DISCORD
1996
In the '90s Sakamoto included environmental noise, on-the-spot-sampling, and when *Discord* was performed live also the "remote piano." People were able to enter musical data onto the *Discord* website and it was played on stage as an additional instrument.

EDUARDO KAC
GFP BUNNY
2000
The piece consists of the creation of a green flourescent rabbit, the public dialog created by the project and the social integration of the rabbit. With the piece Kac proposes a new form of art, "transgenic art," based on the use of generic engineering.

RAFAEL LOZANO-HEMMER
BODY MOVIES
2001
Body Movies is an installation in real time involving an advanced projector and live computer processing. Still images from street life in Rotterdam, Madrid, Montreal and Mexico were projected onto a very large screen. Very strong spotlights were pointed at the screen as well, and the stills became invisible. When people passed by, their shadows were cast onto the screen and the stills became visible.

HANS HAACKE
POSTER PROJECT (CREATIVE TIMES)
2001
Hans Haacke's poster project — white posters featuring negative space of the World Trade Center towers' silhouettes — commemorates September 11. To extend the gesture to the surface of our computer desktops, the project is available on-line as a downloadable desktop application. In the desktop version, screensavers, browsers, files and applications become the shadows of the World Trade Center towers.

CONTRIBUTORS

EDITORS

MORTEN SØNDERGAARD (DK)
M.A. & MEDIA ART CURATOR, MUSEUM OF CONTEMPORARY ART IN ROSKILDE, DENMARK.

PERTTU RASTAS (FIN)
SENIOR MEDIA ART CURATOR AT KIASMA, MUSEUM OF CONTEMPORARY ART IN HELSINKI, FINLAND.

BJÖRN NORBERG (S)
CURATOR AT SPLINTERMIND, STOCKHOLM, SWEDEN.

TEXTS

LEV MANOVITCH (US)
AUTHOR OF *THE LANGUAGE OF NEW MEDIA* AND PROFESSOR AT THE UNIVERSITY OF CALIFORNIA, SAN DIEGO.

STEVEN DIXON (US)
PROFESSOR AT THE ROYAL ART ACADEMY IN STOCKHOLM.

MOGENS JACOBSEN (DK)
ARTIST AND CO-FOUNDER OF ARTNODE.DK, THE FIRST NET ART GALLERY IN COPENHAGEN, DENMARK.

HANS CHRISTIAN GILJE (NOR)
REAL TIME ARTIST AND VJ.

STEINA VASULKA (ICE)
CO-FOUNDER OF THE KITCHEN IN NEW YORK AND ONE OF THE PIONEERS OF REAL TIME ART.

PINK TWINS (FIN)
ARTISTS WORKING WITH SOUND AND REAL TIME MEDIA.

ARIJANA KAJFES (S)
VISUAL ARTIST, CO-INITIATOR OF CRAC — CREATIVE ROOM FOR ART AND COMPUTING IN STOCKHOLM AND MEMBER OF SMARTSTUDIO.

ELIN WIKSTRÖM (S)
ARTIST WORKING WITH PERFORMATIVE STRATEGIES IN REAL TIME.

JACOB KIRKEGAARD (DK)
DANISH COMPOSER, SOUND ARTIST AND LAPTOP ARTIST.

THOR MAGNUSSON (ICE)
ICELANDIC MUSICIAN, INVENTOR AND PROGRAMMER WORKING IN THE FIELDS OF MUSIC AND GENERATIVE ART OF ALL KINDS.

MICHAEL SCHERDIN (S)
ARTIST AND DIRECTOR OF SPLINTERMIND / NONTVTVSTATION IN STHLM.

JACK BURNHAM (US)
(1910-1976) THE MOST PROFOUND AND FARSIGHTED WRITER ON ART AND TECHNOLOGY IN THE 1960s AND 70s — NOT TO MENTION HIS IMPORTANCE AS A THEORIST, CRITIC AND CURATOR.

CHARLIE GERE (UK)
AUTHOR OF *DIGITAL CULTURE* (REAKTION BOOKS, 2002) AND READER AT NEW MEDIA RESEARCH AT THE INSTITUTE OF CULTURAL RESEARCH, LANCASTER UNIVERSITY AND THE CHAIR OF COMPUTERS AND THE HISTORY OF ART (CHART).

ANDREAS BRØGGER (DK)
PH.D. IN AMERICAN MEDIA ART FROM THE 60s AND LECTURER AT THE UNIVERSITY OF COPENHAGEN.

DVD CONTENTS

To burn a DVD with any kind of real time + art could seem paradoxical. It would be fair to ask, then, if this DVD is indeed a collection of real time art?

Of course it cannot be. But consider for a moment the choices.

Originally, several of the selected art pieces were running in real time — marking out a real interval, an hour, a week, or a month.

Still, in many cases, documentation is our best (and only) strategy to "save" and collect real time + art for the study of future audiences and historians, and others interested in the ongoing process of mediated and transdisciplinary art forms. The DVD it would seem, then, is primarily a collection of documentation of real time art.

However, we cannot help but believe that what this DVD also contains is much more than just "what happened." It is as much a showcase of an impressive range of technical imagination, conceptual thinking and aesthetic solutions. It is the combination of the practices, in real time, that knits it all together.

You may enjoy the DVD, as it is — a documentation of real time art — or you may see it as a way to distribute the discussion of theory, practice and history that you find in this anthology. Ideally, you should do both.

PINK TWINS	**PURPLE DRAIN**		2002
ILONA HUSS WALIN	**WHAT IF I WAS A RAT?**		2002
H.C. GILJE	**242.PILOTS** LIVE (IN BRUSSELS)	(EXCERPTS)	2002
KREUTZERKOMPANI	**SYNK** LIVE (IN OSLO)	(EXCERPTS)	2002
ELIN WIKSTRÖM	**WHAT DOES THE NUMBER SAY?**		2001
PETER HAGDAHL	**SOCIAL SIMULATED MODEL NO 2**		2002
	(SENSORIC TRANSFORMATION)		
STEVEN DIXON + TORE NILSSON	**CHANNELING 3**		2004
STEVEN DIXON + TORE NILSSON	**MENDEL'S LAST STAND**		2003
MOGENS JACOBSEN	**SMOKE — SCANMOVIE #12**		2004
BEEOFF	**HEAD**		1997
BEEOFF	**TENTACLE**		
	(DOCUMENTATION OF INSTALLATION)		2005
JACOB KIRKEGAARD + ELLEN RÖED	**YES/NO**		2003
JUHA HUUSKONEN	**THE MOMENT OF LONG NOW**		2002
STEINA VASULKA	**BENT SCANS**		2002